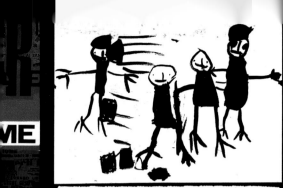
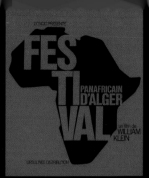
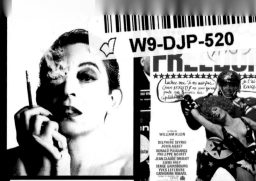
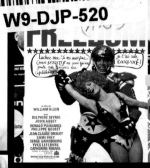
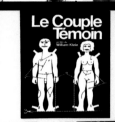
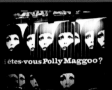
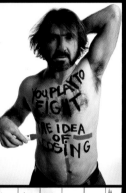

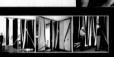

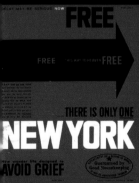
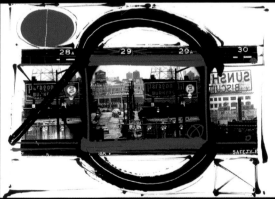
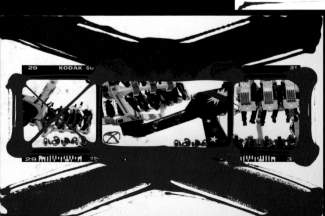
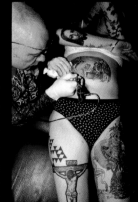

William Klein: ABC

With an essay by David Campany

Abrams, New York

WILLIAM KLEIN'S WAY
DAVID CAMPANY

FEW ARTISTS HAVE AN APPROACH THAT IS ALL THEIR OWN. EVEN FEWER WORKING IN FILM *AND* PHOTOGRAPHY *AND* DESIGN. YOU ARE HOLDING A BOOK THAT COULD ONLY HAVE BEEN PUT TOGETHER BY WILLIAM KLEIN. FROM HIS EARLY ABSTRACTIONS TO HIS DADA-POP TAKE ON 1950S NEW YORK. FROM ROME, TOKYO AND MOSCOW TO PARIS, LONDON AND ALGIERS. FROM THE PAGES OF *DOMUS*, *VOGUE* AND HIS PHOTOGRAPHIC BOOKS, TO HIS TWENTY-PLUS DOCUMENTARY AND FICTION FILMS. THIS IS KLEIN'S *ABC*. SIGNPOSTS TO SIXTY YEARS OF WORK AND A GUIDE TO THE TEEMING, VOLUPTUOUS, GHASTLY, LOVABLE, ABSURD, ANGRY, TENDER, GRUFF AND BEAUTIFUL DECADES WE HAVE LIVED SINCE THE SECOND WORLD WAR.

THESE DAYS, ANY ARTIST WITH A SINGULAR VISION IS PRESUMED TO BE AN OUTSIDER, ESPECIALLY ONE WHO IS MORE INTERESTED IN THE WORLD ITSELF THAN THE 'ART WORLD' OR THE 'FILM WORLD'. BUT THE LABEL IS AN ODD ONE FOR KLEIN, A MAN SO IMMERSED IN THE CONTRADICTIONS OF MODERN LIFE, SO PROFOUNDLY CURIOUS ABOUT HOW IT HAS LEFT ITS MARK ON US ALL. HE HAS COME UNFLINCHINGLY CLOSE TO THE HEART OF GLOBAL-IMPERIAL-PETROCOCADOLLAR CAPITALISM, AND SEEN HOW IT SHAPES DESIRES, IDEOLOGIES, EVEN OUR UNCONSCIOUS. KLEIN HAS BEEN INSIDE WHAT MATTERS AND OUTSIDE WHAT DOESN'T.

HE WAS BORN IN 1928, AT 5TH AVENUE AND 110TH STREET, ON THE EDGE OF HARLEM, NEW YORK. A JEWISH KID IN AN IRISH NEIGHBOURHOOD. HE WAS CLEVER, GOT A PLACE AT A GOOD SCHOOL AND COULD DO AS HE PLEASED SO LONG AS HE DID WELL. BY THE AGE OF TWELVE HE WAS SOAKING UP GREAT CINEMA AND ROAMING THE NEARLY EMPTY GALLERIES OF THE MUSEUM OF MODERN ART. TOO YOUNG TO SERVE IN THE WAR, HE STUDIED SOCIOLOGY. BUT IN 1946 HE JOINED THE ARMY AND WAS STATIONED IN GERMANY AS A RADIO OPERATOR ON HORSEBACK. THAT YEAR HE WON HIS FIRST CAMERA IN A POKER GAME. EVERY IMAGE SINCE HAS BEEN A LITTLE POKERISH: STREET-WISE, BLUFFING, ANTICIPATING. INTUITIVE AND SPONTANEOUS TOO: THE LAST THING YOU WANT IN POKER OR ART IS FORMULA.

FUELLED BY WHAT HE HAD EXPERIENCED AT MOMA, HE WAS KEEN TO GET TO PARIS. IN 1947 HE GOT A CHANCE TO ENROL AT THE SORBONNE. ON HIS SECOND DAY IN THE CITY HE ASKED A BEAUTIFUL WOMAN FOR DIRECTIONS. IT WAS JEANNE FLORIN AND THEY WERE SOON MARRIED. THERE WAS NO POINT PRETENDING PARIS AFTER THE WAR WAS PARIS BEFORE THE WAR. THE CITY WAS NO LONGER THE CENTRE OF CULTURE (ALTHOUGH IT DID OFFER THE DAILY GLORIES OF HENRI LANGLOIS'S CINÉMATHÈQUE FRANÇAISE). BRIEFLY, HE CAME UNDER THE TUTELAGE OF THE PAINTER-SCULPTOR-FILMMAKER FERNAND LÉGER. 'GET OUT OF THE GALLERIES', HE WARNED. 'THINK ABOUT ARCHITECTURE. THINK ABOUT THE STREET.' THE ADVICE WOULD PROVE RIGHT, BUT IT DID NOT HIT HOME RIGHT AWAY. KLEIN'S EARLY CAREER BREAKS CAME FROM EXHIBITIONS. HE WAS MAKING HARD-EDGED ABSTRACT PAINTINGS, WHICH WERE SEEN BY THE ITALIAN ARCHITECT ANGELO MANGIAROTTI. KLEIN WAS ASKED TO RECREATE THEM ON ROTATING ROOM DIVIDERS IN A MILANESE APARTMENT. IT WAS HIS FIRST COMMISSION. OUT OF THE GALLERY,

INTO ARCHITECTURE. WHILE PHOTOGRAPHING THE SET-UP, HE CAUGHT THE BLUR OF THE SPINNING PANELS. PAINTING MORPHED INTO KINETIC SCULPTURE. HARD EDGES BECAME FLUID. THE CAMERA DOCUMENTED AND TRANSFORMED.

BACK IN THE DARKROOM HE EXPLORED PURE LIGHT, FORM AND MATERIALS. IT WAS A SELF-EDUCATION GUIDED BY LÁSZLÓ MOHOLY-NAGY'S BOOK *VISION IN MOTION* AND GYÖRGY KEPES'S *THE NEW LANDSCAPE*. CUTTING HOLES IN SHEETS OF PAPER – CIRCLES, SQUARES, STRIPES – HE MADE HUNDREDS OF ABSTRACT PHOTOGRAMS. A BRIDGE BETWEEN THE PRE-WAR BAUHAUS AND THE GRAPHIC ARTS TO COME. IN NOVEMBER 1952 GIO PONTI'S ARCHITECTURE AND DESIGN MAGAZINE *DOMUS* BEGAN TO PUBLISH THE PHOTOGRAMS AS COVERS. IN EARLY 1954 KLEIN PRESENTED SOME OF THESE ALONGSIDE KINETIC PANELS IN A PARIS GROUP SHOW, LE SALON DES RÉALITÉS NOUVELLES. THE EDITOR OF AMERICAN *VOGUE*, ALEXANDER LIBERMAN, WAS IN TOWN FOR THE FASHION SHOWS AND SAW THE EXHIBITION. HE ASKED TO MEET. ENTHUSIASTICALLY, KLEIN SHOWED HIM MORE. *VOGUE* PUBLISHED HIS MONDRIAN-LIKE PHOTOS OF DUTCH BARNS IN ITS APRIL ISSUE. LIBERMAN WAS A PAINTER-SCULPTOR WITH A TALENT FOR MAGAZINE DESIGN. ART DIRECTING *VOGUE* SUBSIDISED HIS ART. KLEIN LIKED THAT. WOULD HE LIKE TO JOIN LIBERMAN AT THE MAGAZINE? DOING WHAT? ODD JOBS IN PHOTOGRAPHY. WHY NOT?

AFTER EIGHT YEARS AWAY, KLEIN RETURNED TO A NEW YORK THAT WAS FAMILIAR BUT STRANGE. A WORLD OF MCCARTHY AND MARILYN, ELVIS AND EXCESS, A-BOMBS AND ADMEN. THE ABSTRACTION WOULD HAVE TO GO, OR BE CHANNELLED INTO SOMETHING ELSE. *VOGUE* ALLOWED HIM TO INVENT AND INNOVATE FOR MORE THAN A DECADE. IN FACT, HE HAD NO CHOICE: HE WAS UNTRAINED AND JUST ABOUT EVERYTHING WAS NEW TO HIM. HE ADMIRED THE POLISHED BEAUTY OF THE BEST FASHION PHOTOGRAPHY BUT TOOK IT IN HIS OWN DIRECTION. EXPERIMENTS WITH LIGHTING. EMPHATIC POSES STOLEN FROM PAINTING AND CINEMA. STREETS COULD BE PHOTOGRAPHED AND THE IMAGES BLOWN-UP AND BROUGHT INTO THE STUDIO AS BACKDROPS. EVEN A SHOP FRONT COULD BE REPAINTED TO COMPLEMENT THE SEASON'S CLOTHES.

KLEIN WAS WELL PAID FOR THE FIRST TIME IN HIS LIFE. PLUS, *VOGUE* FUNDED HIM TO GO INTO THE STREETS AND PHOTOGRAPH THE URBAN SCENE. 'I FELT LIKE A MACY'S PARADE BALLOON FLOATING BACK AFTER A MILLION ORBITS', HE RECALLED. 'I KNEW THE CITY BUT IT WAS NOW IN A DIFFERENT FOCUS. ALL THE SIGHTS AND SOUNDS I HAD MISSED OR HAD FORGOTTEN OR NEVER EVEN KNEW SUDDENLY MOVED ME VERY MUCH. I WAS IN A TRANCE BUT I WAS ABLE TO DO SOMETHING ABOUT WHAT I FELT. I HAD A CAMERA BUT I BARELY KNEW HOW TO USE IT.' FOR SIX MONTHS HE SHOT WITH EXTRAORDINARY ENERGY, MAKING HUNDREDS OF IMAGES. IT WAS ALMOST A GAME TO SEE HOW MUCH ONE COULD PHOTOGRAPH, HOW MUCH ONE COULD INVENT. THE CAMERA WAS BEING USED TO DISCOVER THE CITY, THE CITY TO DISCOVER THE CAMERA – A MUTUAL EXPLORATION IN THE SPIRIT OF DZIGA VERTOV'S FILM *MAN WITH A MOVIE CAMERA* (1929).

NEW YORK HAD BEEN FALLING APART, BECOMING A SLUM, ALTHOUGH NEW YORKERS WERE NOT READY TO ADMIT IT. HE HARNESSED EVERY 'BAD' TECHNIQUE TO HIS EXPRESSIONIST VISION. NO RULES. NO GOOD MANNERS. WIDE ANGLE DISTORTIONS. BLUR. UNCONVENTIONAL FOCUS. OVER- AND UNDER EXPOSURE. QUICK REACTIONS. ACCIDENTS. PROVOCATIONS. THEN, WITH ALL THE LESSONS LEARNED IN THE DARKROOM, HIS NEGATIVES BECAME RAW MATERIAL. GRAINY ENLARGEMENTS. WILD CROPPING. MOVING THE FOCUS WHILE PRINTING. CHANCE. FUN. RISK. PHOTOGRAPHY HAD NEVER LOOKED DIRTIER, EDGIER OR MORE DELIRIOUS. NEITHER HAD NEW YORK.

KLEIN HAS NEVER MADE ANY PRETENCE TO OBJECTIVITY, BUT THERE IS A DEEPER PSYCHOLOGICAL REALISM. AN HONESTY OF FEELING ACHIEVED NOT BY RETREATING FROM THE WORLD TO A COOL DISTANCE BUT BY THROWING HIMSELF INTO IT. THE CAMERA WAS NOT SO MUCH A GLASS BARRIER AS A FLOODGATE. HIS CROWDED FRAMES PULSATE WITH HUMAN DRAMA IN CLOSE-UP. THE OBSERVER IS INSEPARABLE FROM THE OBSERVED, IMPLICATED AND COMPLICIT. A GREAT KLEIN PHOTO IS A SNATCHED MARVEL OF FORMAL ORGANISATION BUT IT NEVER LETS YOU FORGET IT IS A PHYSICAL ENCOUNTER. A KISS OR SLAP. AT BEST, *BOTH*.

IT WAS ALL TOO EXTREME FOR *VOGUE*. ANYWAY, KLEIN KNEW IT SHOULD BE A BOOK AND WORKED UP A LAYOUT THAT PUSHED EVEN MORE BOUNDARIES. THROUGH *VOGUE*'S PHOTOSTAT OFFICE HE REQUESTED HIS IMAGES IN MULTIPLE SIZES, FREEING UP THE DESIGN PROCESS. HE LIKED THE HARSH, GRAPHIC TONES OF THE COPIES TOO. THE RESULT WAS TOTAL KLEIN: THE UNNERVING PICTURES, THE 'LET'S-TRY-IT' LAYOUT, THE FOUND TYPOGRAPHY. NO TWO PAGES WERE ALIKE. CRASHING JUXTAPOSITIONS, ZIPPY SEQUENCES AND FULL-BLEED DOUBLE-SPREADS, HECTIC AND ELEGANT. THEN THERE WERE THE WISECRACKING CAPTIONS ON STREET LIFE AND HIGH SOCIETY: 'NEW YORK IS A MONUMENT TO THE $. THE $ IS RESPONSIBLE FOR EVERYTHING, GOOD AND BAD, AND IT IS THE BEST THING THE CITY HAS TO OFFER.' EVEN THE TITLE WAS A JUNK-HEADLINE-CUM-ADVERTISING-SLOGAN: *LIFE IS GOOD & GOOD FOR YOU IN NEW YORK: TRANCE WITNESS REVELS*.

BACK IN PARIS HE SHOWED THE DUMMY TO CHRIS MARKER, THE WUNDERKIND FILMMAKER/PUBLISHER WHO HAD SET UP THE PETITE PLANÈTE IMPRINT AT EDITIONS DU SEUIL. MARKER STAKED HIS JOB ON THE BOOK AND IT WAS PUBLISHED UNCHANGED IN PARIS (WINNING THE PRIX NADAR), IN ROME AND IN LONDON. BUT NOT IN THE USA, WHERE ITS BRASHNESS FELL OUTSIDE THE SEDATE FORMALISM AND MELANCHOLY ALIENATION THAT STILL DOMINATE. HAD IT BEEN ISSUED THERE, PERHAPS ROBERT FRANK'S *THE AMERICANS* (1959) WOULD NOT HAVE BEEN SO LONELY. STILL, MANY YOUNGER PHOTOGRAPHERS FOUND COPIES AND ITS INFLUENCE SPREAD, EVEN TO JAPAN WHERE DAIDO MORIYAMA AND OTHERS EMBRACED ITS GRAPHIC, ANTI-AUTHORITARIAN PUNCH.

'ONLY THE SEQUENCING COUNTS … LIKE IN A MOVIE', SAID KLEIN OF HIS BOOK. ENCOURAGED BY CHRIS MARKER AND THE FILMMAKER ALAIN RESNAIS HE MADE THE

INEVITABLE JUMP. HIS FIRST FILM WAS A VIVID, JAZZY DOCUMENT OF THE ILLUMINATED SIGNS OF MANHATTAN. ADVERTISING IS THERE TO CATCH THE EYE, SO KLEIN SIMPLY FILMED ITS FLASHING LIGHTS, SCROLLING WORDS AND ABSTRACT SHAPES IN CANDY COLOURS. THE INCANTATION OF COMMERCE EXAGGERATED AND ESTRANGED. THE FOURTEEN-MINUTE COLLAGE WAS CUT IN PARIS AND TITLED *BROADWAY BY LIGHT* (1958). RETURNING TO NEW YORK ON THE BOAT WITH THE FIRST PRINT, KLEIN MET ORSON WELLES. AT AN IMPROMPTU SCREENING, WELLES DECLARED IT THE FIRST MOVIE THAT NEEDED TO BE IN COLOUR. MOREOVER, ITS TONE WAS EXACTLY WHAT WOULD COME TO DEFINE POP ART. BUT THE REALISATION THAT THIS WAS THE FIRST POP MOVIE CAME MUCH LATER. KLEIN WOULD REMAIN FAR AHEAD OF THE GAME AND WAS NOT ONE TO HANG AROUND REPEATING HIMSELF. LIKE ALL PIONEERS, HE WAS DESTINED FOR HIGH PRAISE AND MISUNDERSTANDING.

HE BEGAN TO TRAVEL EXTENSIVELY AND THREE MORE PUBLICATIONS FOLLOWED: *ROME* (1959), *MOSCOW* AND *TOKYO* (BOTH 1964). THE IMAGES AND THE LAYOUTS WERE MORE CONTROLLED AND THE WRITING MORE INCISIVE. FOR KLEIN, A BOOK WAS NOT A VEHICLE FOR THE SALON-LIKE PRESENTATION OF PRECIOUS RECTANGLES. IT WAS A BOUNDLESS WORLD. NO 'I LIKE THIS ONE; THAT ONE NOT SO MUCH'. IT *INVOLVED* THE READER. HIS METHOD WAS REMARKABLE. IN ANY NEW CITY HE COULD FIND THE SUBJECTS AND IMAGES THAT REVEALED ITS NERVOUS SYSTEM. LIKE THE FILM DIRECTOR FEDERICO FELLINI (WHO HAD SEEN THE *NEW YORK* BOOK AND INVITED HIM TO ROME AS AN ASSISTANT) KLEIN SENSED THE CONNECTIONS BETWEEN THE POWERFUL AND THE DISENFRANCHISED, BETWEEN TRADITION AND POST-WAR ASPIRATION. NOT JUST THE OBVIOUS ECONOMIC CONNECTIONS, BUT THE PSYCHOLOGICAL ONES. HIS CAMERA, WHICH FINDS BEAUTY AND THE GROTESQUE EQUALLY PHOTOGENIC, WAS THE PASSPORT TO A SOCIETY'S HIDDEN ORDER.

TOGETHER THESE FOUR CITY STUDIES ARE NOW RECOGNISED AS A HIGHPOINT IN THE HISTORY OF THE PHOTOBOOK, A SUSTAINED AND NECESSARY EXPERIMENT. KLEIN'S HYPER-JOURNALISM TRASHED THE RULES OF REPORTAGE BUT IN DOING SO HE ANTICIPATED ITS REINVENTION. THESE BOOKS ARE GREAT WORKS OF JOURNALISM, COMPLEX RECORDS OF THEIR TIME, PLACE AND MAKER. AS THE MASS-MEDIA MAGAZINES LOST THEIR GRIP ON WHAT COUNTS AS A PHOTO ESSAY, PHOTOJOURNALISM HAD TO BE RETHOUGHT. ITS FORM WOULD NEED TO BE DISCOVERED AND SHAPED IN THE MIDST OF THINGS. KLEIN HAD FOUND A WAY TO MAKE INNOVATION AND RULE-BREAKING SERVE A DEEPER DOCUMENTARY IMPULSE. ONLY LATER COULD HIS NON-CONFORMITY BE SEEN FOR WHAT IT ALWAYS WAS: NOT A STYLE OR AN 'ATTITUDE' BUT A WAY TO DODGE QUICK JUDGMENT AND KEEP OPEN THE CHANNELS OF COMMUNICATION. FIFTY YEARS ON, YOUNG PHOTOGRAPHERS ARE STILL DESPERATE TO SEE THOSE BOOKS.

KLEIN WAS BECOMING A CONFIDENT SOCIAL EXPLORER, A CONSUMMATE IMAGE-MAKER AND CONFOUNDING ARTIST. WHAT NEXT? MORE FILMMAKING. FIRST, THE FOURTEEN-MINUTE *HOW TO KILL A CADILLAC* (1959); THEN HE WAS HIRED AS CREATIVE

CONSULTANT ON LOUIS MALLE'S VISUALLY DAZZLING *ZAZIE DANS LE MÉTRO* (1960). A STRING OF PROVOCATIVE FILMS FOR FRENCH TELEVISION FOLLOWED, INCLUDING THE CANDID EXPOSÉS *BUSINESS AND FASHION* AND *THE FRENCH AND POLITICS*, WHICH WAS CENSORED. BOTH THEMES WOULD REAPPEAR IN HIS LATER WORK.

IN 1964 HE WAS IN MIAMI TO MAKE A FILM ABOUT THE CASSIUS CLAY / SONNY LISTON TITLE FIGHT. AT THIS POINT CLAY WAS FEARED AND LOATHED BY AMERICA. A TALENTED AND SELF-ASSURED BLACK MAN WITH RAZOR WIT, SHARP LOOKS AND SHARPER RIGHT HOOKS. THE PARALLELS WITH THE ICONOCLASTIC JEWISH NEW YORK PARISIAN KLEIN ARE UNLIKELY BUT UNDENIABLE. BOTH MEN WERE IN THE PROCESS OF INVENTING THEMSELVES, OUTSMARTING THEIR CIRCUMSTANCE, WRONG-FOOTING EXPECTATIONS, TALKING THEIR WAY OUT OF CORNERS. AS THE REST OF THE WORLD SOON DISCOVERED, CLAY WAS MERCURIAL IN FRONT OF THE CAMERA, BUT KLEIN WAS JUST AS QUICK BEHIND IT. WHERE MOST CAMERAMEN WERE HYPNOTISED BY THE CHARISMA, KLEIN MOVED BEYOND THE MAN TO REVEAL HIS RELATION TO BOXING CULTURE, TO MALCOLM X, TO ISLAM AND THE FRENZIED CIRCUS THAT ACCRUES AROUND CELEBRITY. IT WAS THE STUFF OUTSIDE THE RING THAT WAS SIGNIFICANT. TODAY, THIS CIRCUMSPECT APPROACH TO DOCUMENTARY FILM IS STANDARD. KLEIN WAS AT THE FOREFRONT OF A NEW FORM AS IT DEVELOPED OUT OF *CINÉMA VERITÉ* AND ALONGSIDE THE *NOUVELLE VAGUE*. HE HAD ENOUGH MATERIAL FOR THREE FILMS. *CASSIUS THE GREAT* WAS RELEASED AS A TWO-HOUR FEATURE DOCUMENTARY. IN 1974 IT WAS RE-EDITED WITH NEW FOOTAGE FROM THE FIGHT WITH GEORGE FOREMAN IN ZAIRE, DISTRIBUTED AS *MUHAMMAD ALI THE GREATEST*.

ALL THE WHILE, KLEIN WAS STILL SHOOTING FASHION. THE BEST OF IT HAD THE UNPREDICTABLE ENERGY OF HIS STREET PICTURES. IN APRIL 1960, *VOGUE* CARRIED AN IMAGE THAT HERALDED THE ATTITUDES OF THE COMING DECADE. TWO MODELS IN BLACK AND WHITE DRESSES BY CAPUCCI PASS EACH OTHER ON THE BLACK AND WHITE CROSSWALK OF THE PIAZZA DI SPAGNA, ROME. IN TELEPHOTO COMPRESSION THE MOCK-ALOOF MODELS SPARK WITH THE CHAOS OF THE STREET – THE MEN WONDERING IF THEY ARE PROSTITUTES. PASSERS-BY BECOME EXTRAS AND THE WORLD BECOMES THEATRE. EVERYONE IS A POTENTIAL IMAGE, AS THE HIGH PRIESTS OF MEDIA PHILOSOPHY WOULD SOON DECLARE. KLEIN HAS NEVER THOUGHT MUCH OF HIS FASHION WORK BUT MAYBE THAT WAS THE KEY TO ITS SUCCESS.

PAUSE A WILLIAM KLEIN FILM ANYWHERE, NOTED CHRIS MARKER, AND YOU WILL SEE 'A KLEIN PHOTOGRAPH WITH THE SAME APPARENT DISORDER, THE SAME GLUT OF INFORMATION, GESTURES AND LOOKS POINTING IN ALL DIRECTIONS, AND YET AT THE SAME TIME GOVERNED BY AN ORGANIZED, RIGOROUS PERSPECTIVE'. *WHO ARE YOU, POLLY MAGGOO?* (1966) WAS HIS FIRST FICTION FILM, ALTHOUGH ONE MIGHT QUESTION JUST HOW FICTIONAL IT WAS. ON THE SURFACE IT IS A SLAPSTICK SATIRE ON THE EXCESSES OF THE FASHION INDUSTRY, A MILIEU HE KNEW ALL TOO WELL. THE VANITIES. THE MONEY WORSHIP. THE ELEVATION OF MARKET-DRIVEN TASTE INTO PSEUDO-MANIFESTO. MODELS IN LUDICROUS ALUMINUM OUTFITS: A JIBE

AT ANDRÉ COURRÈGES'S 'DRESS AS ARCHITECTURE'. DESIGNERS, JOURNALISTS, EDITORS AND ASSORTED FLUNKIES DRIFTING IN A DREAMSCAPE OF DELUSION AND SELF-DISGUST. THE HUMOUR CUTS DEEP, WITH ENOUGH FASHION-WORLD IN-JOKES TO MAKE IT A CULT HIT. BUT THERE IS A SAD, BITTERSWEET UNDERCURRENT. THE REDEEMING CHARACTER IS POLLY MAGGOO HERSELF, PLAYED BY THE MODEL DOROTHY MACGOWAN. A COMPLICATED WOMAN PLUCKED FROM OBSCURITY FOR HER LOOKS. WE SEE HER FACE EULOGISED, COMMODIFIED, EXPLOITED AND STOLEN TO BECOME PUBLIC PROPERTY. IT WOULD BE AN EASY 'POINT' TO MAKE, WERE KLEIN SO INCLINED. BUT THE FILM IS LESS CONCERNED WITH DENOUNCING THE SOFT TARGETS IN CULTURE THAN REVEALING THEM AS SYMPTOMS OF CONTRADICTORY DESIRES AND VERY HUMAN WEAKNESSES. STANLEY KUBRICK TOLD KLEIN HE WAS AT LEAST A DECADE AHEAD OF ANYONE WITH THIS FILM, MAYBE A LITTLE TOO FAR FOR HIS OWN GOOD. AT THE TIME IT WAS ANTONIONI'S FASHION FILM *BLOW-UP* (1966) THAT GRABBED THE CRITICAL ATTENTION AND BOX-OFFICE, BUT ITS NIHILISM AND CONDESCENSION DATED QUICKLY. *POLLY MAGGOO*, WITH ITS MORAL CENTRE AS UNLIKELY AS IT IS GENUINE, HAS REMAINED RELEVANT, WITH MORE ADMIRERS NOW THAN EVER.

DESPITE THE BLATANT MOCKERY OF *VOGUE*'S ICY EMPRESS DIANA VREELAND, *POLLY MAGGOO* DID NOT SPELL THE END OF KLEIN'S FASHION WORK. BUT IT WOULD COME SOON ENOUGH. IN ONE WAY OR ANOTHER, ALL OF HIS OUTPUT HAS LOOKED AT THE EFFECTS OF THE MASS MEDIA AND ITS RELATION TO POLITICAL POWER: THE HYPERBOLE, THE BULLSHIT, THE MANIPULATION OF OPINION. BUT WHAT LIFTS IT ABOVE CYNICISM IS ITS HUMAN DIMENSION, A TENDER CORE OF EMPATHY. HOWEVER, WITH THE GLOBAL UPHEAVALS AND POLITICAL INTENSIFICATION OF THE SECOND HALF OF THE 1960S, ALL ENGAGED ARTISTS OF HIS GENERATION WOULD BE TESTED.

IN 1967 KLEIN WAS IN NEW YORK TO SHOOT A SECTION FOR THE SEVEN-PART FILM *LOIN DU VIETNAM* (ALAIN RESNAIS, JORIS IVENS, CHRIS MARKER, CLAUDE LELOUCH, AGNÈS VARDA AND JEAN-LUC GODARD ALSO CONTRIBUTED). HE CUT TOGETHER HIS FOOTAGE OF PRO-WAR PARADES AND ANTIWAR RALLIES. 'BOMB HANOI!' SHOUT SOME. 'BIG FIRMS GET RICH! G.I.'S DIE!' SHOUT OTHERS. PRESENTED WITHOUT VOICEOVER, THE EFFECT IS STILL DISTURBING, PLACING THE VIEWER RIGHT IN THE MIDDLE.

HE PLUNGED DEEPER INTO THE UNEASE. SHOT THE SAME YEAR, *MISTER FREEDOM* IS ONE OF THE MOST UNCOMPROMISING AND ENERGETIC MOVIES EVER MADE. A RELENTLESS, VAUDEVILLE SCI-FI COMIC-BOOK DRAMA ON THE PSYCHOSEXUAL WARP OF AN AMERICAN IDEOLOGY TRAPPED BY IMPERIALIST FANTASY, RELIGIOUS REPRESSION, CELEBRITY WORSHIP AND A FATAL INABILITY TO GROW UP. DR FREEDOM (DONALD PLEASANCE) SENDS MR FREEDOM (A SLAB OF ARROGANT-VULNERABLE US BEEFCAKE PLAYED BY JOHN ABBEY) TO PARIS TO DEFEAT RED MENACE AND YELLOW PERIL. DELPHINE SEYRIG PLAYS AN UNHINGED, DOUBLE-CROSSING TEMPTRESS WITH EXPRESSIONS AND POSES THAT SET THE BLUEPRINT FOR MADONNA AND LADY GAGA. WE SEE THE OUTSIDE OF THE FREEDOM EMBASSY, THEN CUT TO THE

INTERIOR OF A SUPERMARKET. POLICY HAS BEEN REPLACED BY PRODUCT. THE SCRIPT PLUNDERS EVERYTHING FROM POLITICAL THRILLERS TO CHUCK JONES CARTOONS. CONSUMERISM, PARANOIA AND IMPOTENCE ARE DISSECTED AND LEFT SCATTERED ON THE FLOOR. WHERE *POLLY MAGGOO* CONCERNED THE GAP BETWEEN THE FEMININE AND ITS IMAGE, *MISTER FREEDOM* TAKES ON MASCULINITY AND IT SELF-DECEPTIONS. KLEIN'S GARISH MARKER-PEN STORYBOARDS WERE TRANSLATED TO THE SCREEN AS LITERALLY AS POSSIBLE. COSTUMES WERE MADE FOR THE ENTIRE CAST, COMBINING PLASTIC DETRITUS WITH SPORTS AND INDUSTRIAL EQUIPMENT. DISUSED INDUSTRIAL FACILITIES WERE PAINTED TO MATCH. THE HIGH-ENERGY MIX OF CULTURAL SYMBOLS MAKES FOR AN UNCLASSIFIABLE FILM. THIS IS CINEMA AS GUERRILLA SEMIOTICS. THE WHOLE DESIGN OF *MISTER FREEDOM* WAS VISIONARY. IT PIONEERED THE SEAMLESS MISE-EN-SCÈNE OF COSTUME, CHARACTER AND LOCATION WE SEE IN STANLEY KUBRICK'S *A CLOCKWORK ORANGE*, RIDLEY SCOTT'S *BLADERUNNER*, TERRY GILLIAM'S *BRAZIL* AND THE VIDEO ART OF MATTHEW BARNEY AND NATHANIEL MELLORS, TO NAME JUST A FEW.

THE EDITING OF *MISTER FREEDOM* WAS INTERRUPTED BY THE EVENTS OF MAY 1968. IN THE MIDDLE OF THAT MONTH KLEIN ATTENDED AT THE REVOLUTIONARY MOVIE SUMMIT IN MEUDON. IT WAS NON-STOP TALK AND KLEIN COULD ONLY TAKE SO MUCH. HE WANTED TO BE IN THE STREETS AND WHAT HE FILMED WAS TALK ITSELF: DEBATES, GENERAL ASSEMBLIES, ANALYSIS, CONVERSATIONS, CONFESSIONS, ARGUMENTS, SPEECHES, STATEMENTS, GATHERINGS FORMAL AND INFORMAL. THE CIRCLE OF PROGRESSIVE FILMMAKERS WAS SUPPOSED TO POOL ITS EFFORTS FOR ANOTHER UNITED-LEFT PRESENTATION, BUT EACH WENT HIS OWN WAY. TEN YEARS ON, KLEIN'S *MAYDAYS* (*GRANDS SOIRS ET PETITS MATINS* 1978) WAS FINALLY RELEASED. FEW OTHER FILMS HAVE GIVEN SUBSEQUENT GENERATIONS SUCH A FEELING FOR THE POLITICAL FERVOUR, INTELLECTUAL INTENSITY AND BODILY EXPERIENCE OF THAT MOMENT. IT SEEMED TO CONFIRM ONCE AGAIN THAT THE VIEWERS KLEIN REALLY HAS IN MIND ARE NOT HIS PEERS OR CONTEMPORARIES, BUT AN AUDIENCE THAT DOES NOT QUITE EXIST – AN AUDIENCE YET TO COME. WHEN *MISTER FREEDOM* WAS FINALLY RELEASED IN 1969, CRITICS AND PUBLIC ASSUMED IT WAS A RESPONSE TO MAY 1968, WHEN IN FACT IT WAS A PREDICTION. EVEN THE FILM'S RIOT SCENES LOOKED LIKE NEWS FOOTAGE FROM THE STREETS OF PARIS.

THE MILITANCY CONTINUED. KLEIN WAS INVITED TO ALGIERS TO FILM THE PAN-AFRICAN CULTURAL FESTIVAL OF 1969, A LANDMARK GATHERING OF ARTISTS, MUSICIANS, FILMMAKERS AND INTELLECTUALS FROM ACROSS AFRICA AND THE WORLD. THE CASSIUS CLAY FILM HAD BEEN A BIG HIT THERE, RUNNING IN CINEMAS FOR SIX MONTHS. SHOOTING THE FESTIVAL WAS A HUGE UNDERTAKING, WITH EVENTS HAPPENING ACROSS THE CITY AT ALL HOURS. KLEIN HAD TO CO-ORDINATE MULTIPLE CREWS, EACH WITH A DIRECTOR-CAMERAMAN LIKE HIMSELF. THE FESTIVAL INVITED LIBERATION MOVEMENTS FROM OUTSIDE AFRICA. THE BLACK PANTHERS WERE PRESENT, INCLUDING THEIR 'MINISTER OF CULTURE' ELDRIDGE CLEAVER (ON THE RUN FROM THE FBI). KLEIN AND CLEAVER MET, AND THE RESULT WAS A SPONTANEOUS

FILM PORTRAIT. IT SHOWS CLEAVER'S MIX OF SHREWD SOCIAL ANALYSIS AND UNPREDICTABLE BEHAVIOUR. OVER THE COURSE OF THREE DAYS AND NIGHTS WE WATCH HIM BUY A SWITCHBLADE IN THE CASBAH, EXPLAIN HIS POLITICS, GET STONED AND PLOT THE DOWNFALL OF THE US GOVERNMENT. THE MOST INCENDIARY FOOTAGE WAS LEFT ON THE CUTTING-ROOM FLOOR. ALWAYS SYMPATHETIC TO OUTSIDERS, UNDERDOGS AND MAVERICKS, KLEIN WAS ESSENTIALLY IN SUPPORT OF THE BLACK PANTHERS' CAUSE. BUT, AS IN ALL HIS FILMS, IT IS THE NUANCES OF PERSONALITY, THE NERVY BALANCE OF RATIONAL AND IRRATIONAL FORCES THAT IS COMPELLING. A MAN IS NOT A POLITICAL PARTY. CENSORED IN FRANCE *ELDRIDGE CLEAVER, BLACK PANTHER* (1970) SCREENED IN NEW YORK WITH SEATS AT 'REVOLUTIONARY PRICES', WITH FIFTY PERCENT OF PROFITS GOING TO THE PANTHERS.

THE FILMS IN ALGERIA ROUNDED OUT KLEIN'S PASSAGE THROUGH POLITICALLY CHARGED TIMES AND PLACES. IN THE COMING DECADE, HE WOULD SHOOT MORE THAN TWO HUNDRED AND FIFTY TV COMMERCIALS IN AN ATTEMPT TO FUND HIS OWN PROJECTS ON HIS OWN TERMS. HERE TOO, HE INNOVATED: HIS SPOTS FOR DIM AND CITROËN BECAME LANDMARKS. OUT OF THIS CAME THE IDEA FOR HIS THIRD FICTION FILM, *THE MODEL COUPLE* (1975–6). IN ONE OF THOSE LATE GAULLIST FANTASIES OF URBANISM, FRANCE WAS PLOTTING SEVERAL NEW CITIES, DESIGNED FROM SCRATCH – NO HISTORY, NO EVOLUTION, NOTHING ORGANIC. KLEIN AND HIS WIFE PLANNED A FILM ON AN EQUALLY GRAND SCALE, BUT IN THE END IT BECAME SMALLER (AND ALL THE MORE EFFECTIVE). A YOUNG COUPLE WINS A COMPETITION TO LIVE IN A NEW CITY APARTMENT. THE INTERIOR IS WHITE AND EMPTY. WE WATCH THEM CHOOSE FROM BROCHURES ALL THE DÉCOR, FURNISHING AND DOMESTIC GADGETS THEY DESIRE. AS THE APARTMENT FILLS UP, THEY ARE MONITORED BY PSYCHOLOGISTS, INTERVIEWED BY PRODUCT DEVELOPERS, VISITED BY POLITICIANS, FILMED BY A TELEVISION CREW AND WATCHED BY A NATION. UNDER NON-STOP SCRUTINY THEY BEGIN TO FALL APART. IN FACT, EVERYONE INVOLVED LOSES PERSPECTIVE. WHEN HUMANS MONITOR HUMANS, OBJECTIVITY BECOMES IMPOSSIBLE. TO SEE THE FILM NOW, IN OUR ERA OF 'REALITY TV' IS SHOCKING AND REVELATORY. HOW DID KLEIN, THIRTY-FIVE YEARS AGO, GET HIS PREDICTION SO RIGHT? MAKING COMMERCIALS MAY HAVE GIVEN HIM THE DETAILS, BUT WHAT ABOUT THE BIGGER PICTURE? THE INCREMENTAL ERASURE OF PRIVACY? THE CONVERSION OF CITIZENS INTO COLLECTIONS OF DATA FOR COMMERCIAL EXPLOITATION? THE INSIDIOUS CREEP OF CORPORATE POWER INTO DEMOCRATIC GOVERNMENT? MOST PROFOUNDLY, KLEIN FORESAW THE SHRINKING OF THE IMAGINATION, THE VERY RESOURCE THAT MIGHT HELP US CRAWL OUT OF THE TRAPS OF TECHNOCRATIC SOCIETY. THE NEAR FUTURE OF *THE MODEL COUPLE* IS CHILLING. BUT ONCE AGAIN, BELOW THE SURFACE OF THE FILM'S EXTRAORDINARY DESIGN AND NARRATIVE ARC THERE ARE TWO SOULS. ANXIOUS. ENDEARING. FUNNY. HUMAN.

MORE DOCUMENTARIES FOLLOWED, SOME SHORT, SOME FEATURE LENGTH. IN THE *LITTLE RICHARD STORY* (1980) THE EPONYMOUS SINGER IS AT A LOW POINT IN HIS LIFE AND CAREER. HE DISAPPEARS, LEAVING KLEIN TO AUDITION IMPERSONATORS TO TAKE

HIS PLACE. YOU CAN SEE OUR CULTURE OF KARAOKE AND *AMERICAN IDOL* TAKING SHAPE. A LIFELONG SPORTS FAN, KLEIN THEN FILMS BEHIND THE SCENES AT THE FRENCH OPEN TENNIS TOURNAMENT (*THE FRENCH* 1982), WHEN THE GAME WAS STILL FULL OF PERSONALITIES.

MODE EN FRANCE (1986) MARKED A RETURN TO FASHION AFTER TWENTY YEARS. AN ESSAY FILM IN THIRTEEN CHAPTERS, LIKE FEATURES IN A MAGAZINE, EACH A COLLABORATION WITH A DESIGNER. FIRST: A HIGH-SPEED DASH THROUGH A CENTURY OF WOMEN'S FASHION; THEN A MARKET STREET-SCENE IN WHICH EVERYONE IS DRESSED IN THE POSTMODERN FRIPPERIES OF JEAN-PAUL GAULTIER. A PARISIAN SOIRÉE WITH CLOTHES BY CLAUDE MONTANA. A BOOTH IN WHICH LEGGY MODELS CRAM THEMSELVES TO MAKE CONFESSIONS. GRACE JONES AND LINDA SPIERRING PERFORMING A PLAY BY MARIVAUX, DRESSED BY AZZEDINE ALAIA. IN LESSER HANDS IT WOULD HAVE BEEN MERE THEATRE, BUT AN EYE FOR TELLING DETAIL AND A REFUSAL TO MAKE CRUDE JUDGMENTS PRODUCES A FILM THAT OUTLIVES THE STYLES AND BODY LANGUAGES IT CATALOGUES.

BY THE MID-1980S, AUDIENCES WERE BEGINNING TO CATCH UP WITH JUST WHAT KLEIN HAD ACHIEVED IN HIS FIRST THIRTY YEARS. PHOTOGRAPHY WAS BECOMING A MAJOR MUSEUM ART AND THERE WERE INVITATIONS TO MAKE EXHIBITIONS. OF COURSE, HIS CAREER HAD GOT GOING WHEN HE LEFT THE GALLERY WALL FOR THE PRINTED PAGE AND THE SCREEN, BUT HE TOOK THESE INVITATIONS AS AN OPPORTUNITY TO REVIEW THE HUGE BODY OF WORK HE HAD MADE WITH SUCH VITALITY.

THIS MEANT RETURNING TO HIS CONTACT SHEETS, THOSE GRIDS OF THIRTY-SIX EXPOSURES THAT SAY SO MUCH ABOUT A PHOTOGRAPHER'S UNCONSCIOUS DECISIONS. AN EARLIER LIFE OF THE MIND AND THE EYE CAME FLOODING BACK. HE NOTICED THE ANNOTATIONS IN RED AND BLACK GREASE PEN THAT MARK WHICH FRAMES HAD BEEN CHOSEN AND WHICH LEFT BEHIND. WHY THIS IMAGE? WHY THIS CROPPING? WHY WAS THIS ONE OVERLOOKED? DISCOVERIES WERE MADE. (WHY DID THAT SHOT OF THE YOUNG MAN SMILING WITH A BOTTLE OF PEPSI NOT MAKE IT INTO THE *NEW YORK* BOOK?)

TWO IMPORTANT THINGS CAME OUT OF THIS. IN 1989 KLEIN INITIATED *CONTACTS*, A SERIES OF INNOVATIVE SHORT FILMS IN WHICH PHOTOGRAPHERS SPEAK ABOUT THEIR WORKING PROCESSES. WE HEAR THEM IN VOICEOVER WHILE A ROSTRUM CAMERA SCANS ACROSS THEIR CONTACT SHEETS. KLEIN KICKED THINGS OFF WITH HIS OWN FOURTEEN-MINUTE PIECE. HE IS FAMOUSLY ELUSIVE ABOUT ANY 'PHILOSOPHY OF PHOTOGRAPHY' BUT THIS FILM IS AS CLOSE AS HE HAS COME TO DEFINING HIS OWN: 'A PICTURE IS TAKEN AT 125TH OF A SECOND. WHAT DO YOU KNOW OF A PHOTOGRAPHER'S WORK? A HUNDRED PICTURES? LET'S SAY A HUNDRED AND TWENTY-FIVE. WELL THAT'S A BODY OF WORK. THAT COMES TO, ALL TOLD, ONE SECOND ... THE LIFE OF A PHOTOGRAPHER, EVEN A *GREAT* PHOTOGRAPHER AS

THEY SAY: TWO SECONDS.' THROUGHOUT, HIS CHOICE OF WORDS IS AS SEEMINGLY OFF THE CUFF AS HIS PICTURES. SOUNDING NEITHER FRENCH NOR AMERICAN, HIS DISTINCTIVE TONES HAD NOT BEEN PUT TO SUCH EFFECTIVE USE SINCE 1962, WITH HIS VOICEOVER FOR THE ENGLISH VERSION OF CHRIS MARKER'S PHOTO-FILM *LA JETÉE* (THAT OTHER GREAT PHILOSOPHY OF PHOTOGRAPHY).

HE ALSO BEGAN TO BLOW UP EXTRACTS FROM HIS CONTACT SHEETS, PRINTING THEM TO THE SIZE OF HIS EARLY PAINTINGS. FOR TOO LONG, PHOTOGRAPHERS HAD BEEN HAPPY TO EXHIBIT AT THE SCALE OF THE PAGE, MAKING PRINTS THAT GLEAMED LIKE PRECIOUS LITTLE JEWELS BEHIND GLASS. NOT FOR KLEIN. SOME OF HIS NOW-FAMOUS IMAGES COULD BE SEEN IN THE FLOW OF WHAT CAME BEFORE AND AFTER. ON THESE MURAL-SIZED PRINTS THE PEN WAS REPLACED BY PAINTED BRUSH MARKS IN THE SAME PRIMARY COLOURS SEEN IN *THE MODEL COUPLE* AND *MISTER FREEDOM*, ALL THE WAY BACK TO HIS TO *BROADWAY BY LIGHT* AND HIS ABSTRACT WORK. CONSCIOUSLY OR NOT THIS WORK RECALLED THE MOMENT IN 1952 THAT HAD STARTED IT ALL, WHEN THE BRUSHSTROKE AND THE CAMERA CAME TOGETHER BY ACCIDENT IN THAT MILANESE APARTMENT.

KLEIN BEGAN TO MAKE PHOTOGRAPHS AGAIN, AFTER NEARLY TWENTY YEARS. FIRST, A RETURN TO A FAVOURITE THEME: THE CONTROLLED CHAOS BACKSTAGE AT FASHION SHOWS; THEN, A SERIES OF NARRATIVE FASHION SHOOTS INSPIRED BY B-MOVIES, IMELDA MARCOS AND ASSORTED CULTURAL PARIAHS. IN MANY WAYS HE FOUND THE FASHION SCENE MORE OPEN TO EXPERIMENTATION, AND MAGAZINES WERE JUST AS KEEN TO WORK WITH HIM. FRENCH *VOGUE*, *ESQUIRE*, *JARDINS DES MODES*, *VANITY FAIR*, *HARPER'S BAZAAR*.

HE WENT BACK ON TO THE STREETS WITH HIS 35MM CAMERA, PICKING UP RIGHT WHERE HIS CITY BOOKS HAD LEFT OFF. THE RESULT WAS THE PUBLICATION *CLOSE UP* (1989), MIXING OLDER PHOTOGRAPHS AND NEW. ALL THE SHARP-EYED DYNAMISM WAS STILL THERE, A RARITY IN STREET PHOTOGRAPHERS PAST THE FIRST FLUSH OF YOUTH. THE FOLLOWING YEAR, HE PUBLISHED A BOOK ON THE SOCCER WORLD CUP IN TURIN. WHILE RETROSPECTIVE FESTIVALS OF HIS FILMS SCREENED IN EUROPE AND AMERICA HE CONTINUED TO MAKE DOCUMENTARIES. *BABILEÉ '91* IS A SIXTY-MINUTE PIECE ON THE ENFANT TERRIBLE OF FRENCH DANCE. JUST LIKE KLEIN, JEAN BABILÉE HAD REINVENTED HIMSELF SEVERAL TIMES, GOING IN AND OUT OF FAVOUR IN THE PROCESS, AND BACK TO DANCE AT THE AGE OF SIXTY-EIGHT.

IN AND OUT OF FASHION (1994) WAS KLEIN'S FEATURE-LENGTH REVIEW OF HIS OWN CAREER TO DATE. HE KEEPS THE COMMENTARY TO A MINIMUM, LETTING SEQUENCES OF PHOTOS AND EXTRACTS FROM HIS FILMS DO MOST OF THE WORK. IT'S A DAZZLING COMPENDIUM. ALONG WITH A BOOK OF THE SAME TITLE, IT INTRODUCED A REMARKABLE OEUVRE TO NEW AUDIENCES. KLEIN'S STANDING AS A MAJOR FIGURE IN POST-WAR CULTURE WAS UNARGUABLE. HE PICKED UP A STRING OF MAJOR AWARDS AND CONTINUED WITH EXHIBITIONS WORLDWIDE. MANY ARTISTS WOULD HAVE BEEN

MORE THAN HAPPY TO CLOSE SHOP AT THAT POINT, AND MANY MORE WOULD HAVE EXHAUSTED THEMSELVES DECADES BEFORE. BUT WILLIAM KLEIN HAS REMAINED RESTLESS, SATURATED IN THE CULTURE AND POLITICS OF HIS TIME.

OF HIS RECENT WORK THE EPIC *MESSIAH* (1999) IS A HIGHLIGHT, A SUMMARY OF ALL HIS MAJOR THEMES. GEORGE FRIDERIC HANDEL'S GREAT WORK IS FASHIONED INTO A MILLENNIAL STATEMENT FOR HEATHENS. THE ORATORIO IS PRESENTED IN ITS ENTIRETY BY A SUCCESSION OF PERFORMERS, AMATEURS AND GREAT PROFESSIONALS. A CHOIR OF GOSPEL DRUG ADDICTS. A CHOIR FROM SUGARLAND PRISON. A CHOIR OF DALLAS POLICE OFFICERS. ARTS PATRONS. MUSCLE MEN. FOR JESUS. A WOMAN SEEKING REDEMPTION GETS HER BODY TATTOOED WITH SCENES FROM THE BIBLE. THESE AND COUNTLESS OTHER VIGNETTES FROM AMERICAN LIFE ARE INTERCUT WITH FOOTAGE OF SOME OF THE BEST MUSICIANS AND SINGERS IN THE WORLD. THE SACRED AND THE PROFANE ARE JAMMED TOGETHER. THE HIGH AND THE LOW. THE RAW AND THE REFINED. THE AMATEUR AND THE EXPERT. WHO ELSE WOULD HAVE DARED TO DREAM UP SUCH A FILM *AND* GOT IT MADE? MAYBE HIERONYMUS BOSCH IF HE'D HAD A CAMERA. KLEIN UNDERSTOOD THAT IF HANDEL'S *MESSIAH* SPEAKS TO US TODAY IT IS BECAUSE IT'S NOT REALLY ABOUT ANY COMING SAVIOUR. IT'S ABOUT WHAT WE DO IN THE HERE AND NOW. WHILE SOME HANG AROUND, OTHERS ARE HAMPERED BY CIRCUMSTANCE AND A DANGEROUS FEW LUST FOR AN APOCALYPSE TO BRING THEIR VEIL OF TEARS TO AN END. KLEIN WAS NEVER INTERESTED IN THE AFTERLIFE, OR WAITING FOR IT. HE HAS USED HIS FREEDOM TO SHOW WHAT MODERN LIFE IS. NOT WHAT IT COULD BE, OR SHOULD BE, BUT WHAT IT IS.

IT HAS BEEN A REMARKABLE ARTISTIC LIFE. NO DOUBT WILLIAM KLEIN'S WAY IS UNREPEATABLE BUT HIS ENDURING INFLUENCE SUGGESTS IT IS AT LEAST A MODEL, A BEACON OF INDEPENDENCE. ENDLESSLY CURIOUS ABOUT PEOPLE. FEARLESS, RISKY AND PRONE TO MISINTERPRETATION. OPTIMISTIC TOO.

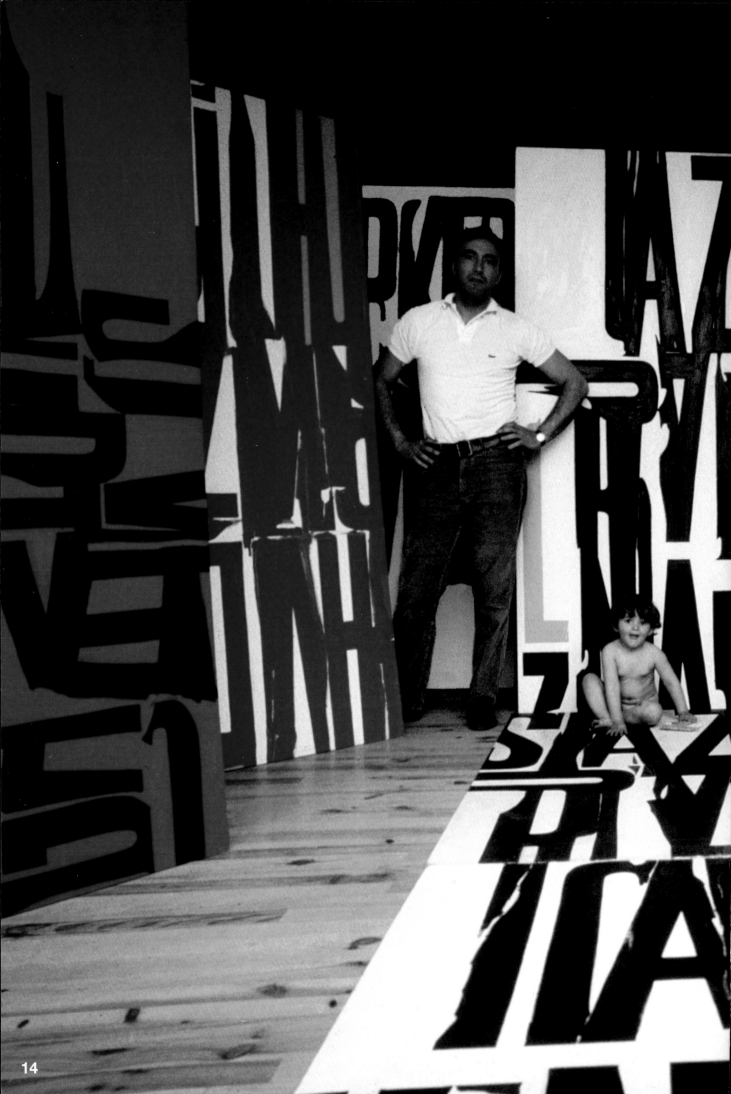

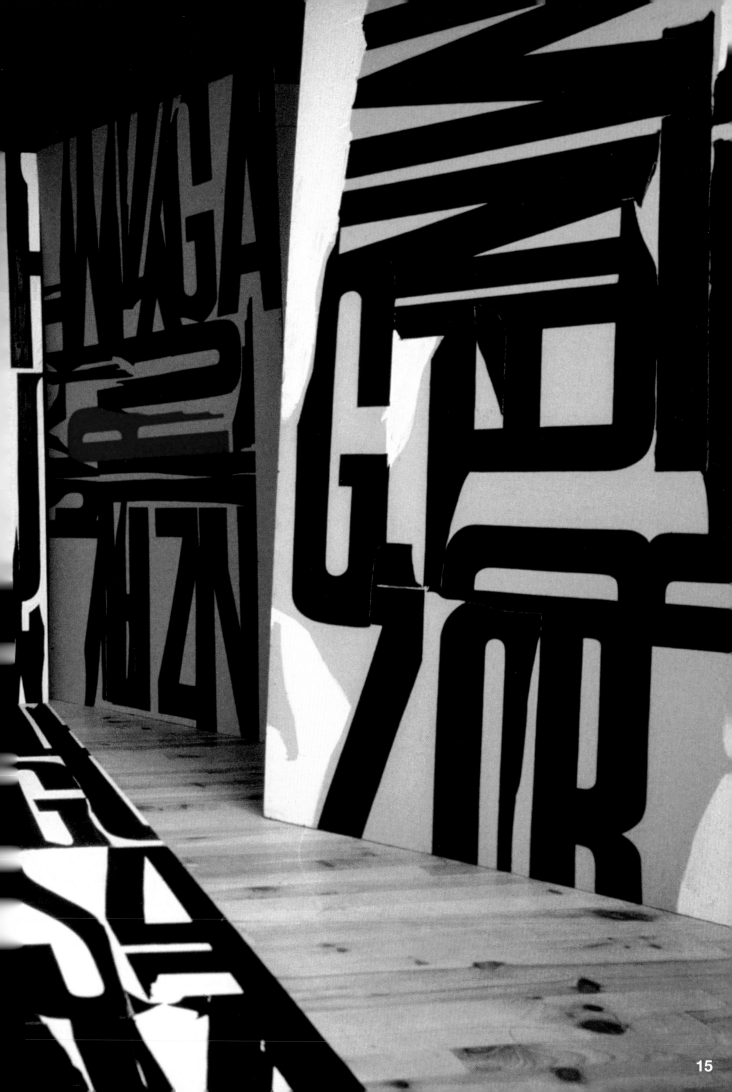

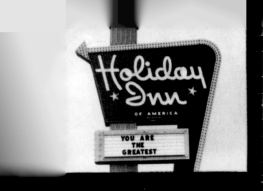
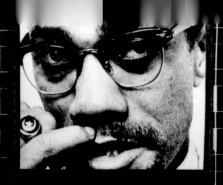
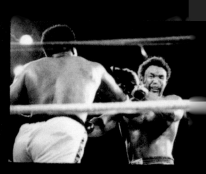
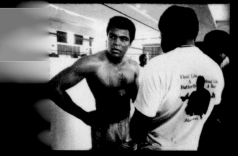
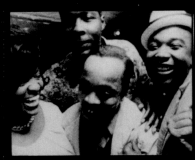
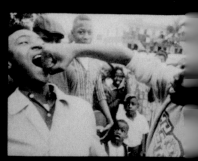
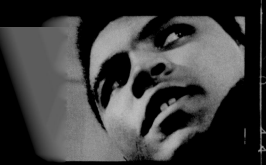
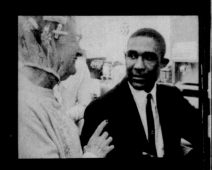
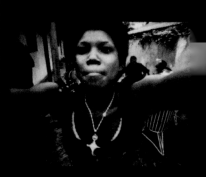
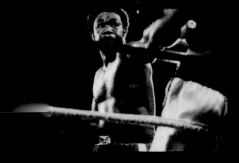
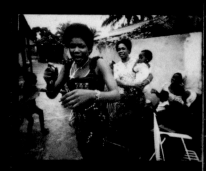
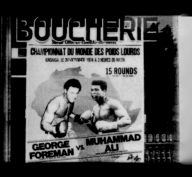
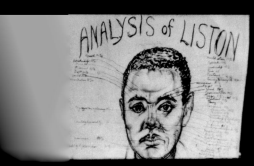
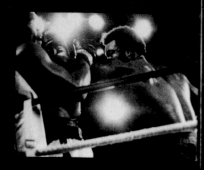

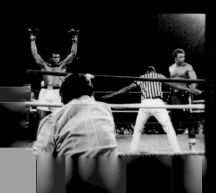
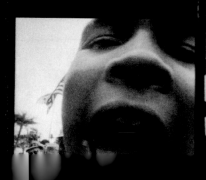
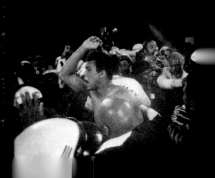

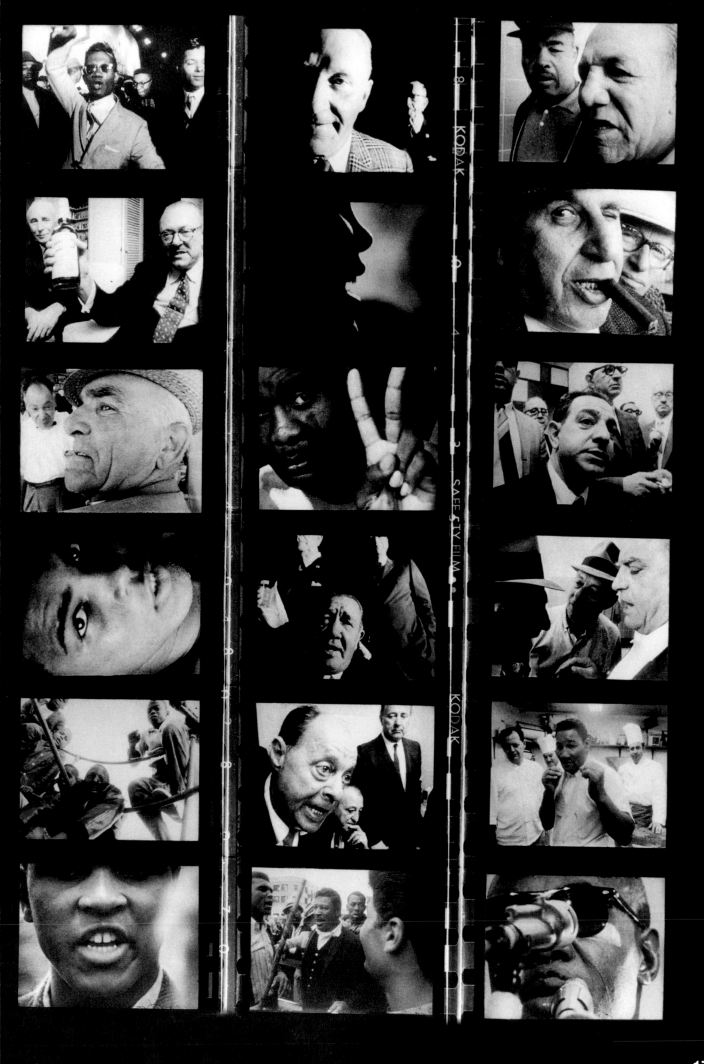

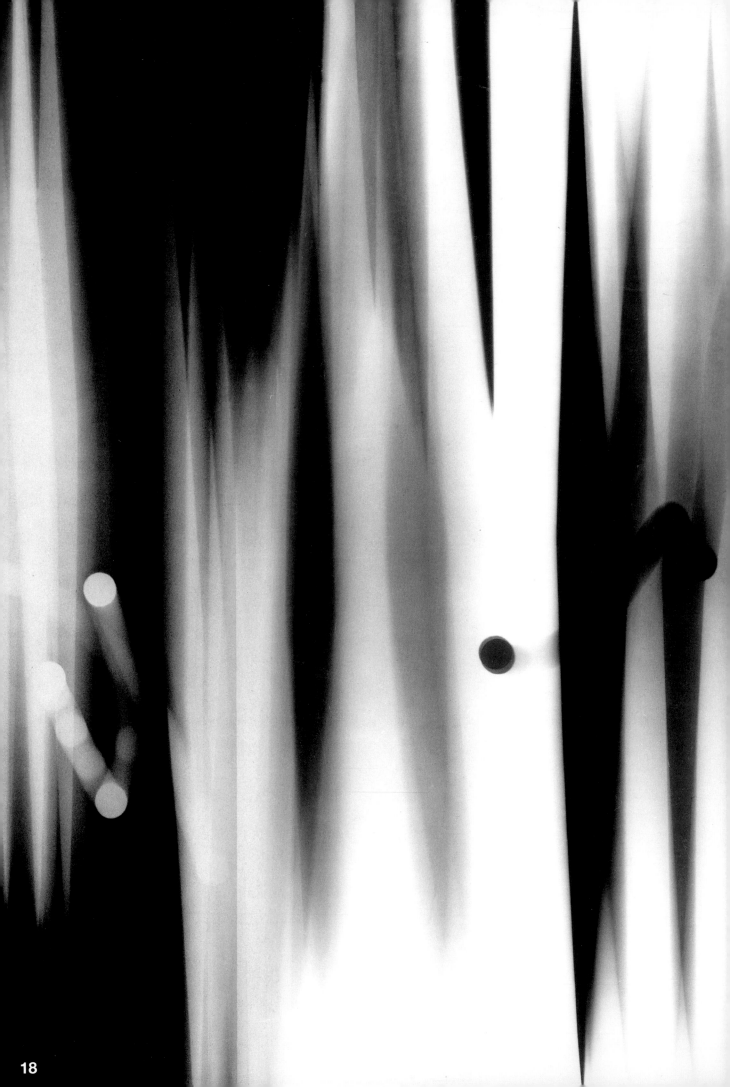

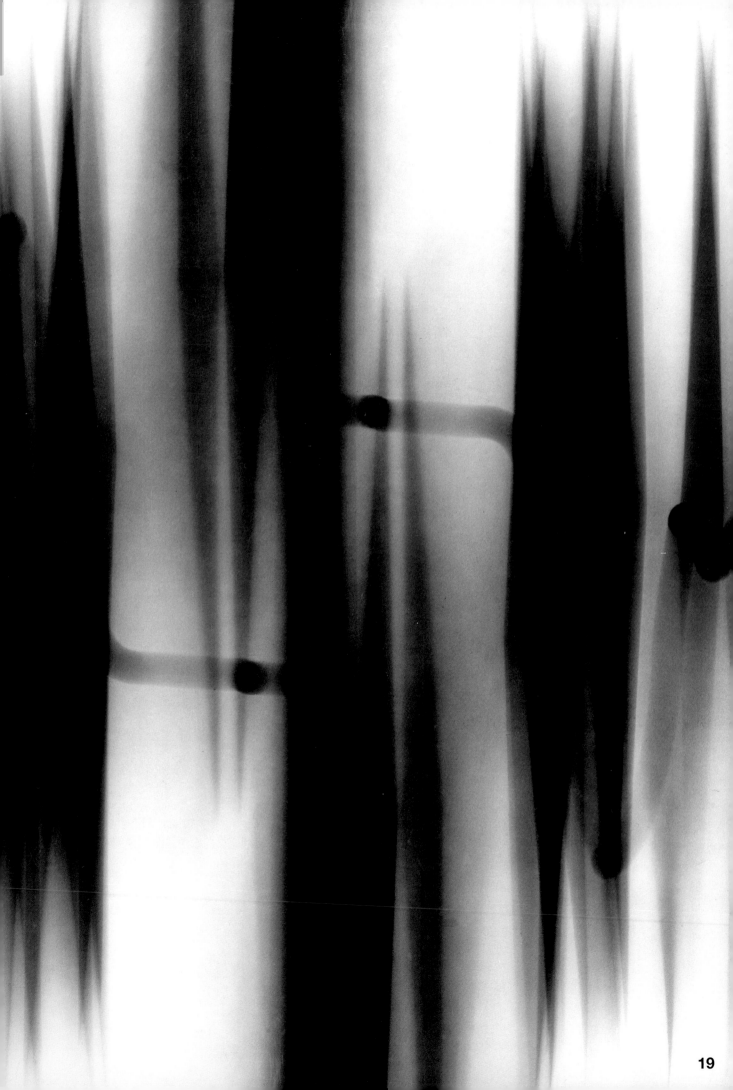

DELAY MAY BE SERIOUS NOW

FREE

FOR ONL

FREE THIS WAY TO HEAVEN FREE

S-A-A-Y these are good GOOD
pure and better, my new medical
discovery you my tangy goodness
you with the secret KLEEN-
KLEER-VU my blended you my
heaping HOT my MILK FED
my MIGHTY mound so FLAVOR
so REALLY oh S-A-A-A-Y my
GIANT HOT THRILL you you're
my GOODNESS my HOTNESS
you oh YOU MY GOLDEN

REMEMBER **THERE IS ONLY ONE**

NEW YORK

Now wonder life designed to
AVOID GRIEF

REPLACEMENT OR REFUND OF MONEY ★ **Guaranteed by Good Housekeeping** IF NOT AS ADVERTISED THEREIN

FOR ONLY

CONTAINS FLUOROMYCIN TYROTHRICYN THE NE

WILLIAM KLEIN

NEW YORK

1954.55

MARVAL

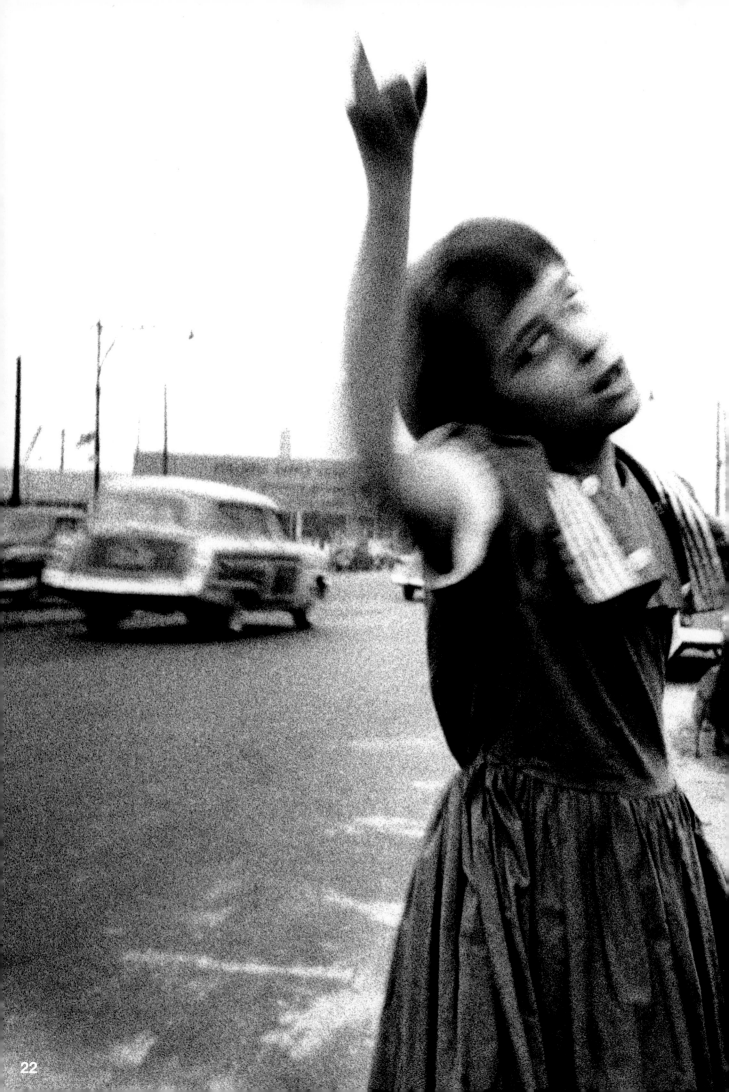

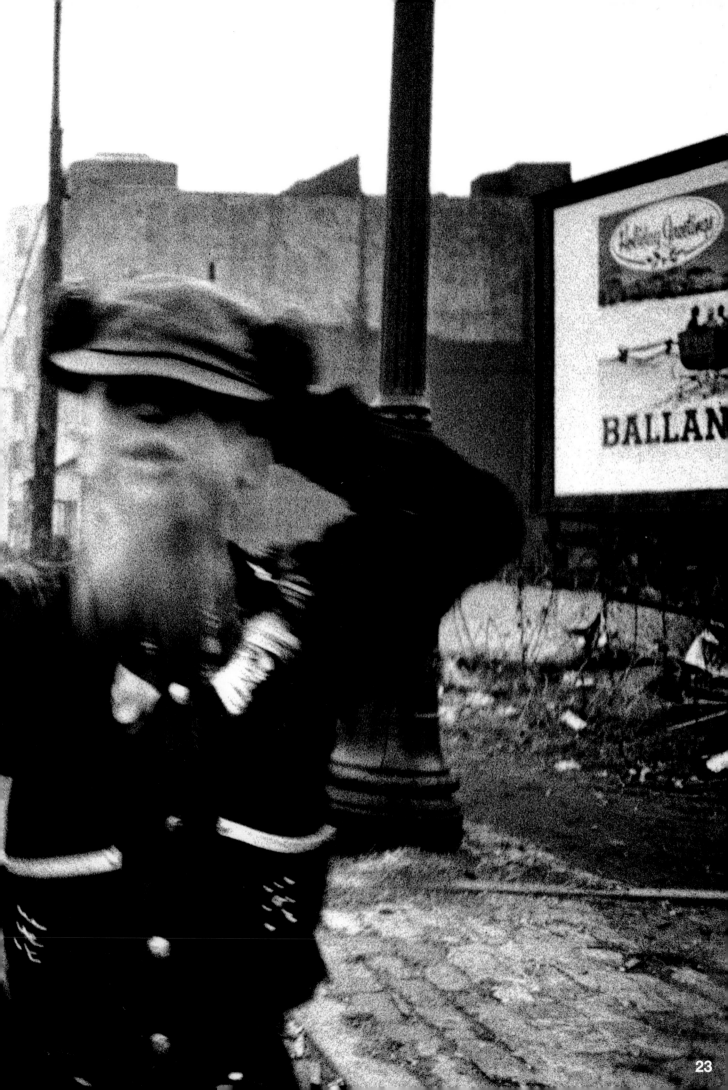

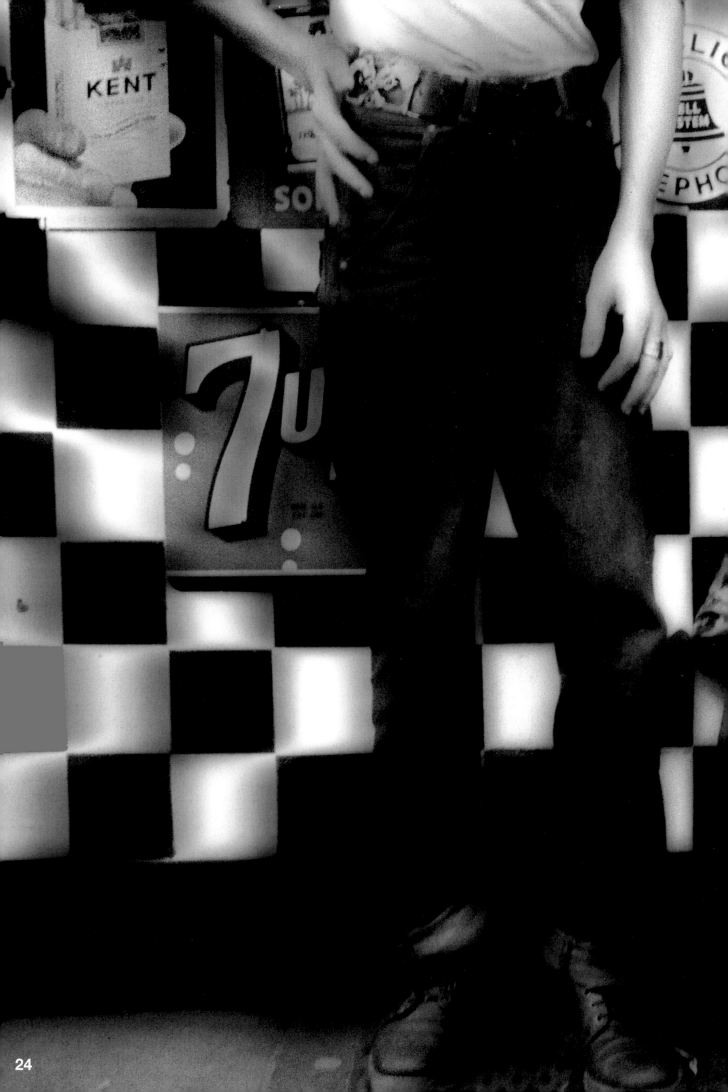

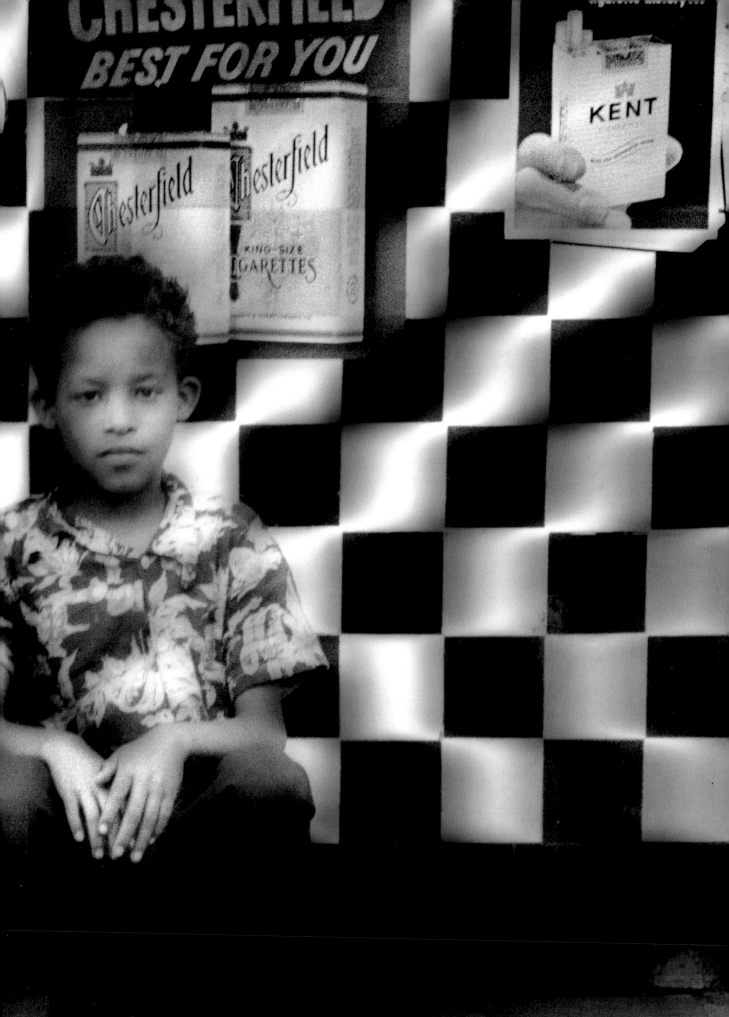

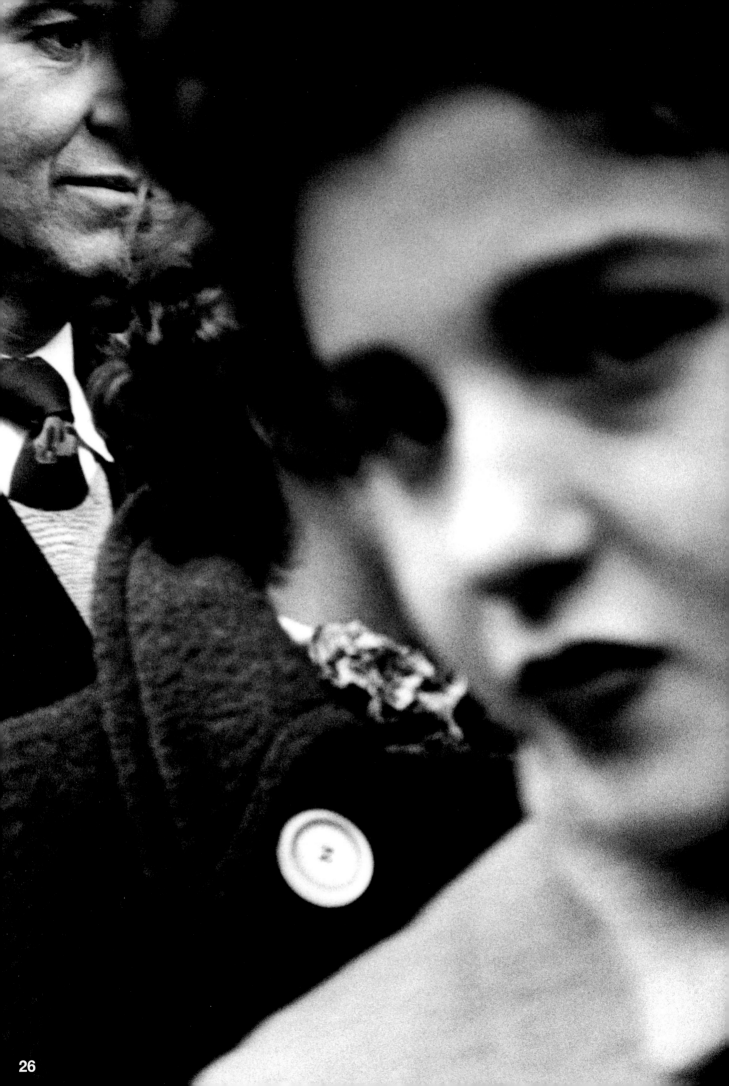

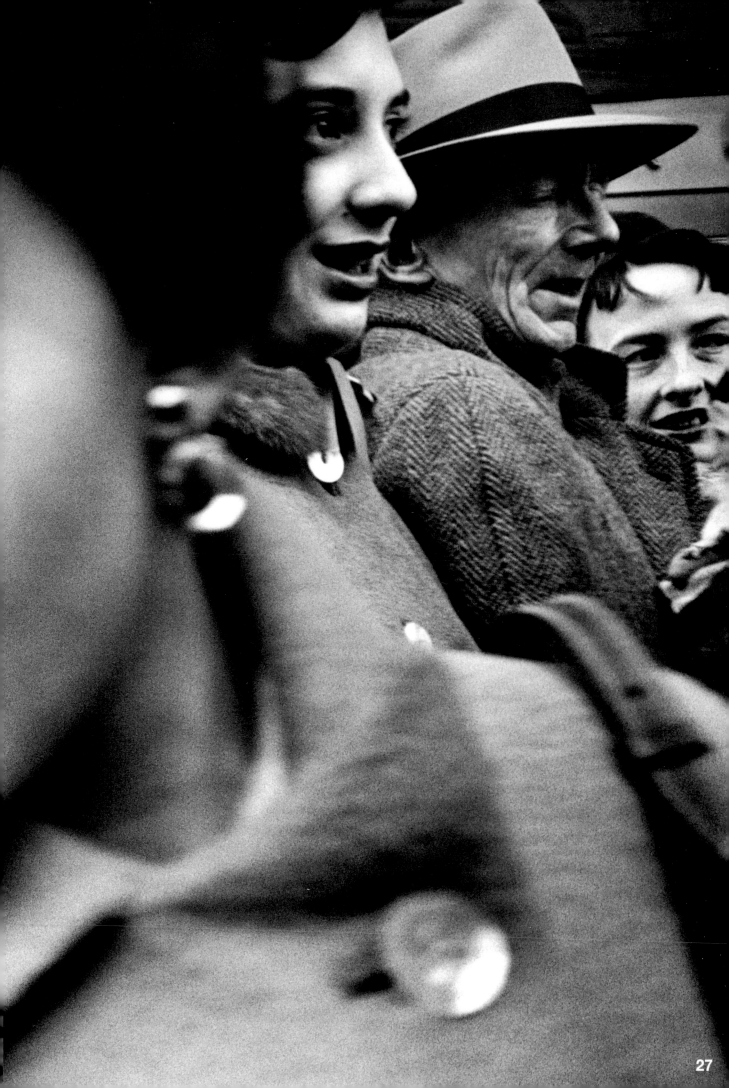

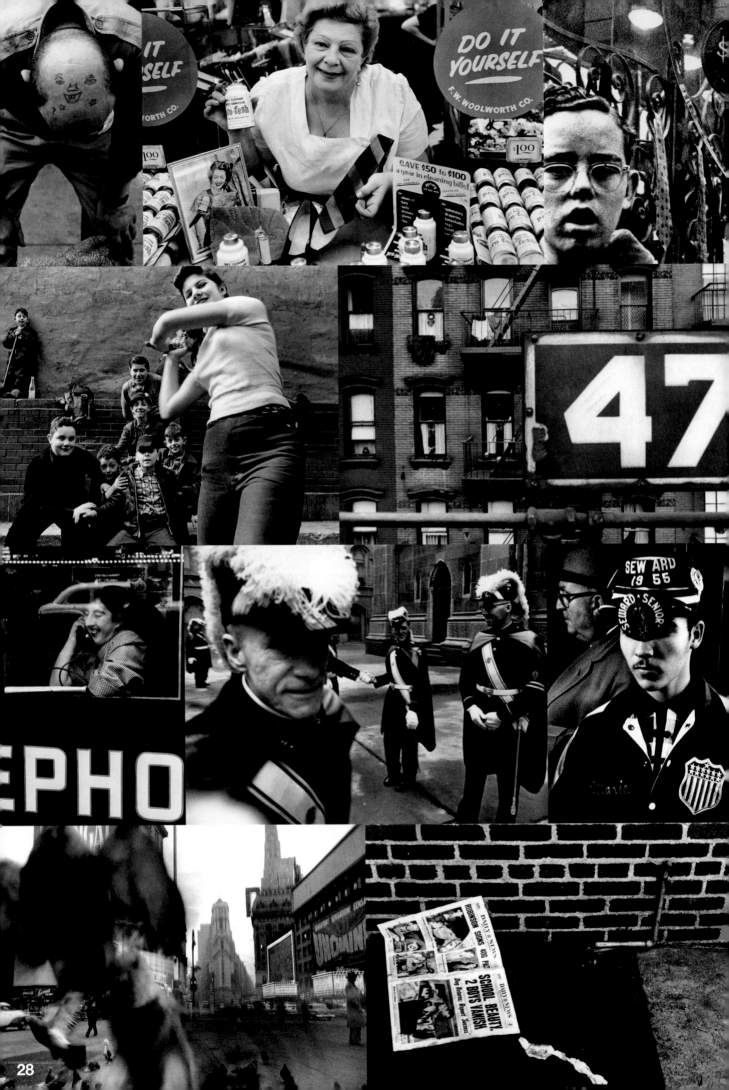

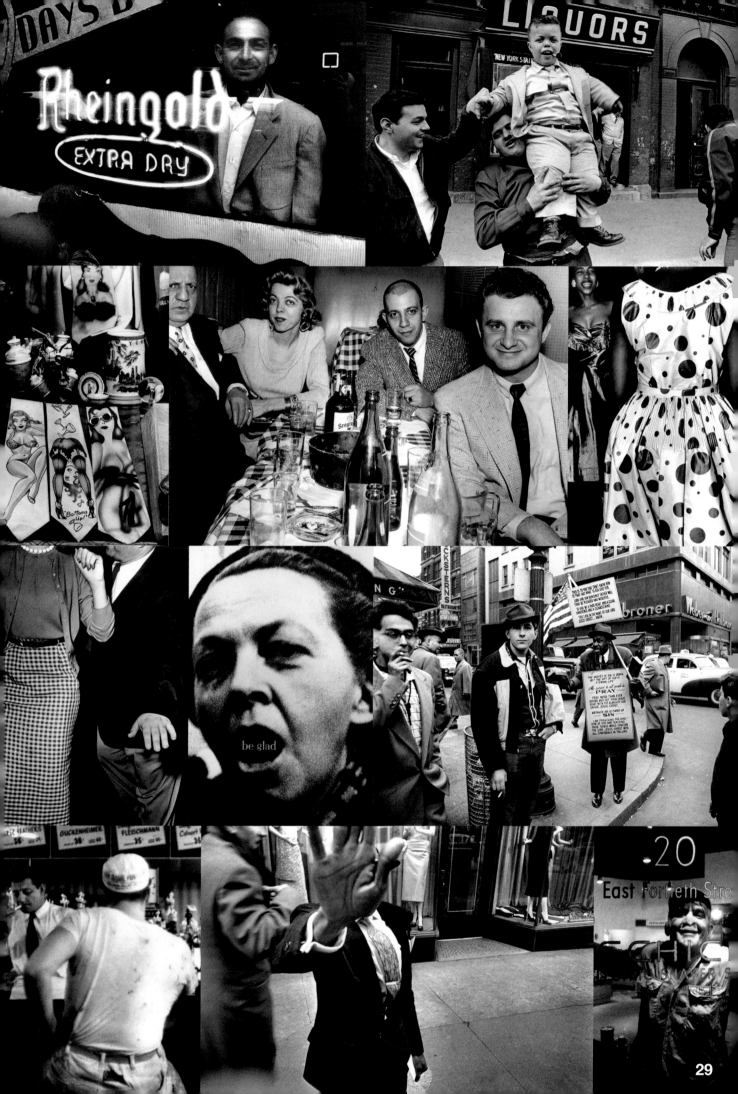

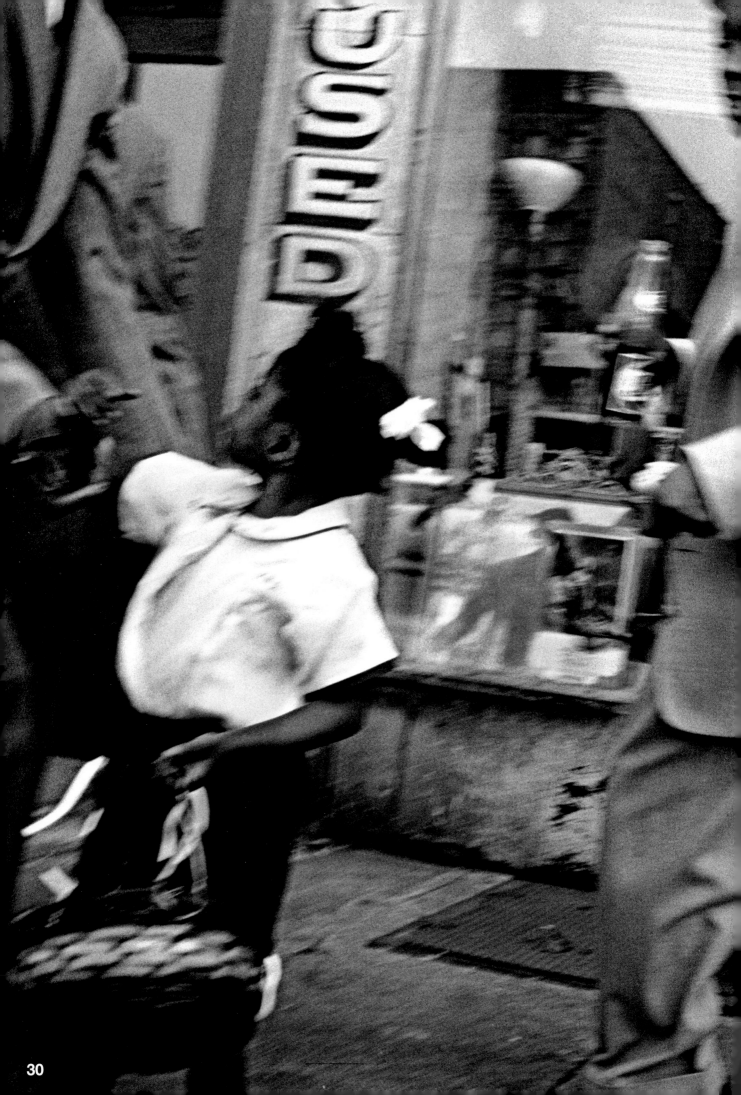

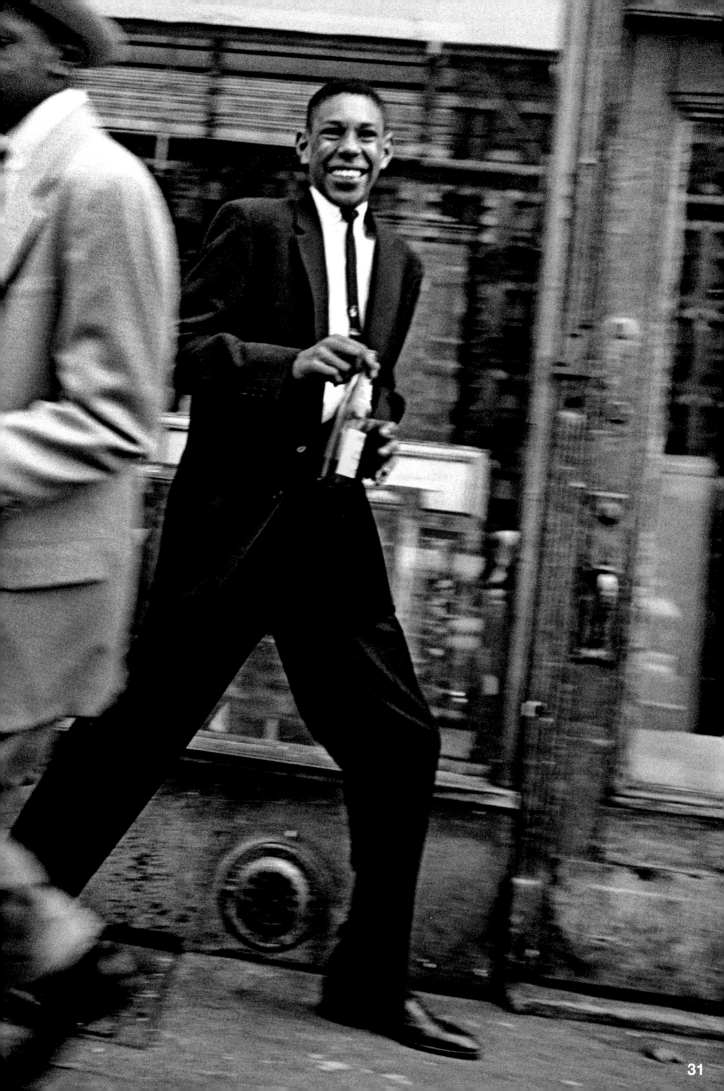

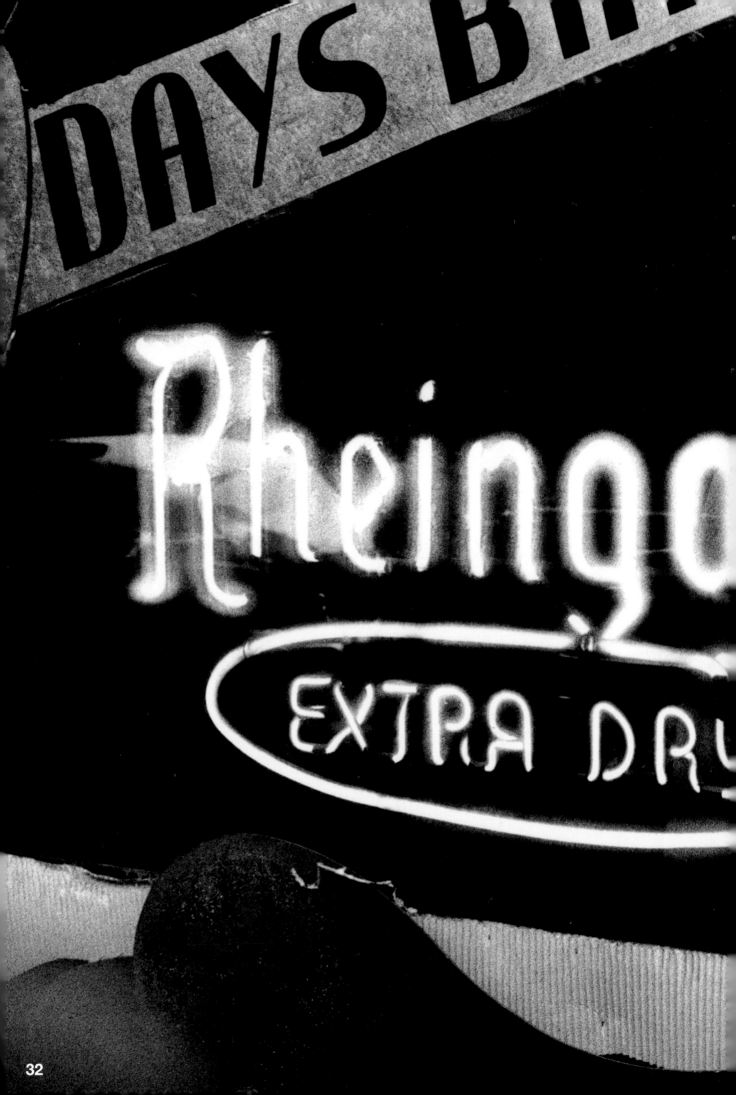

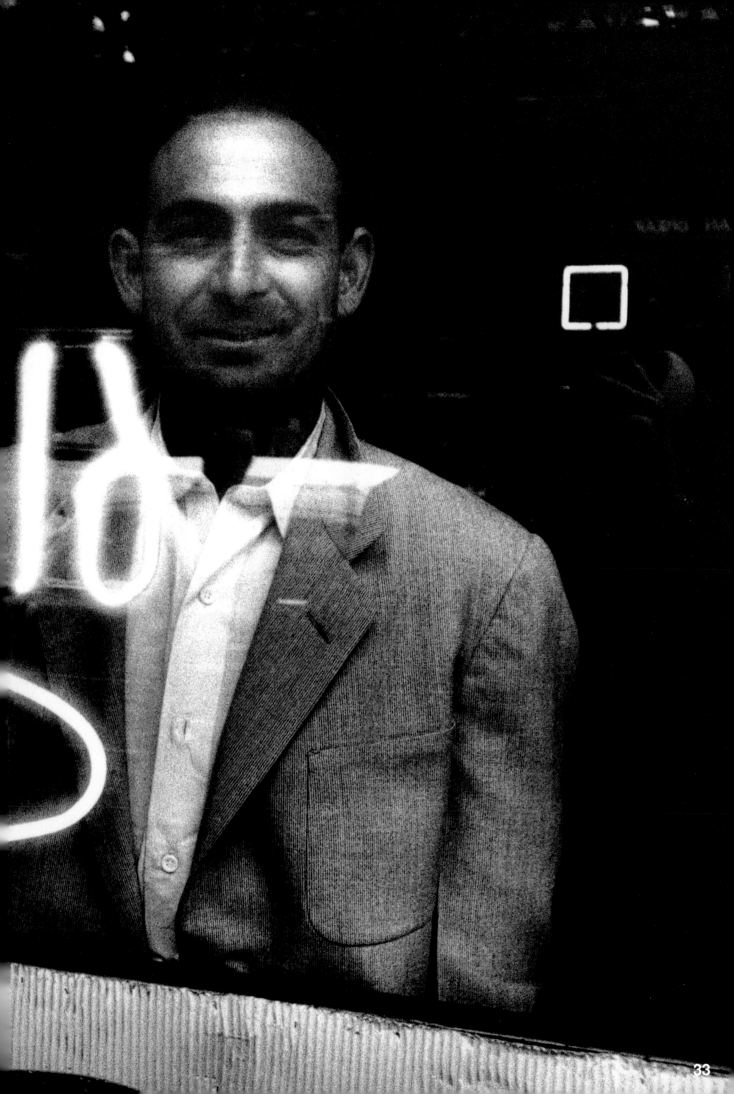

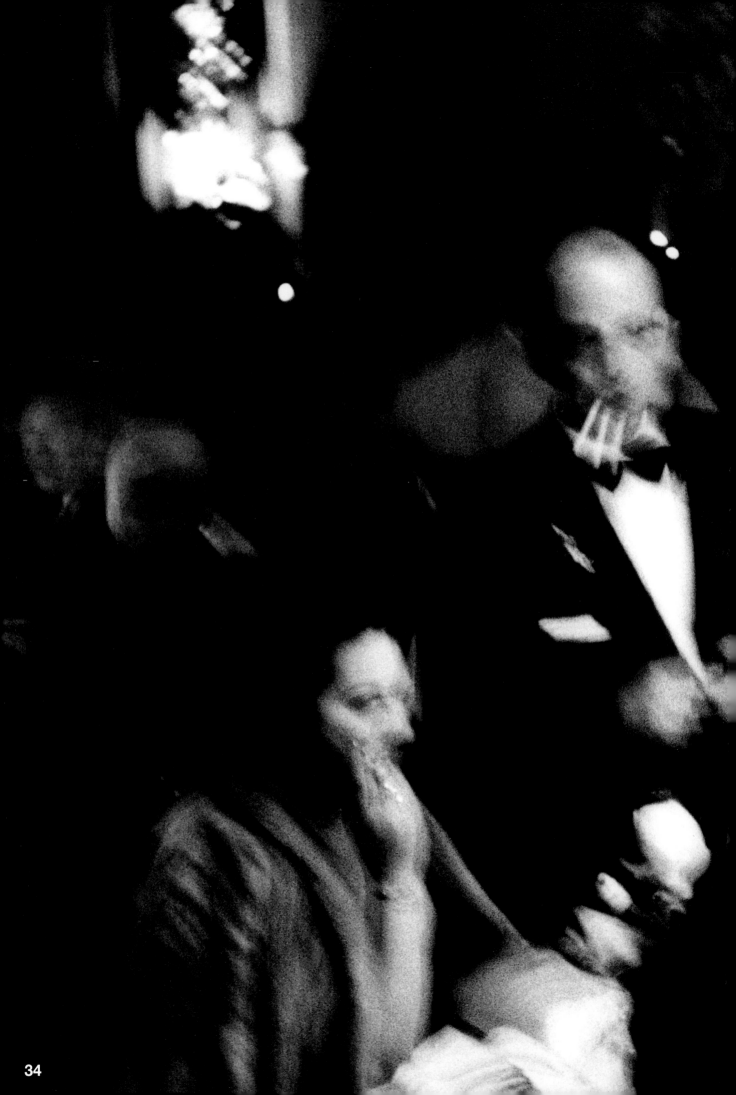

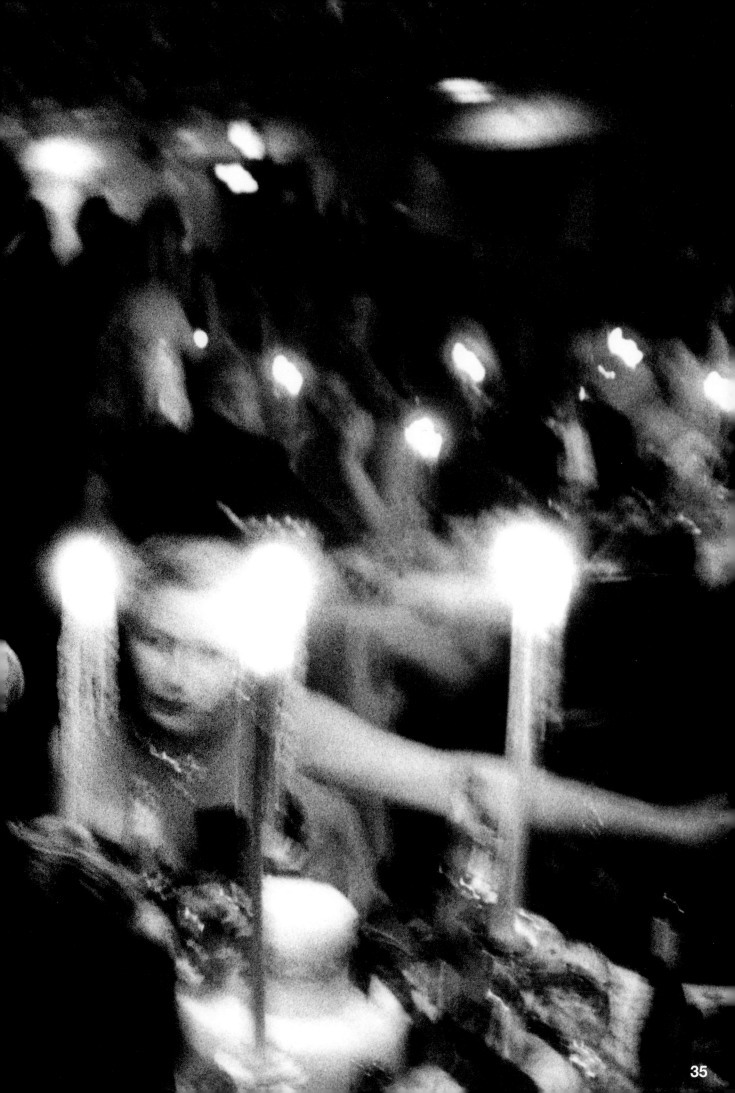

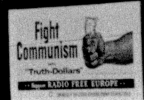

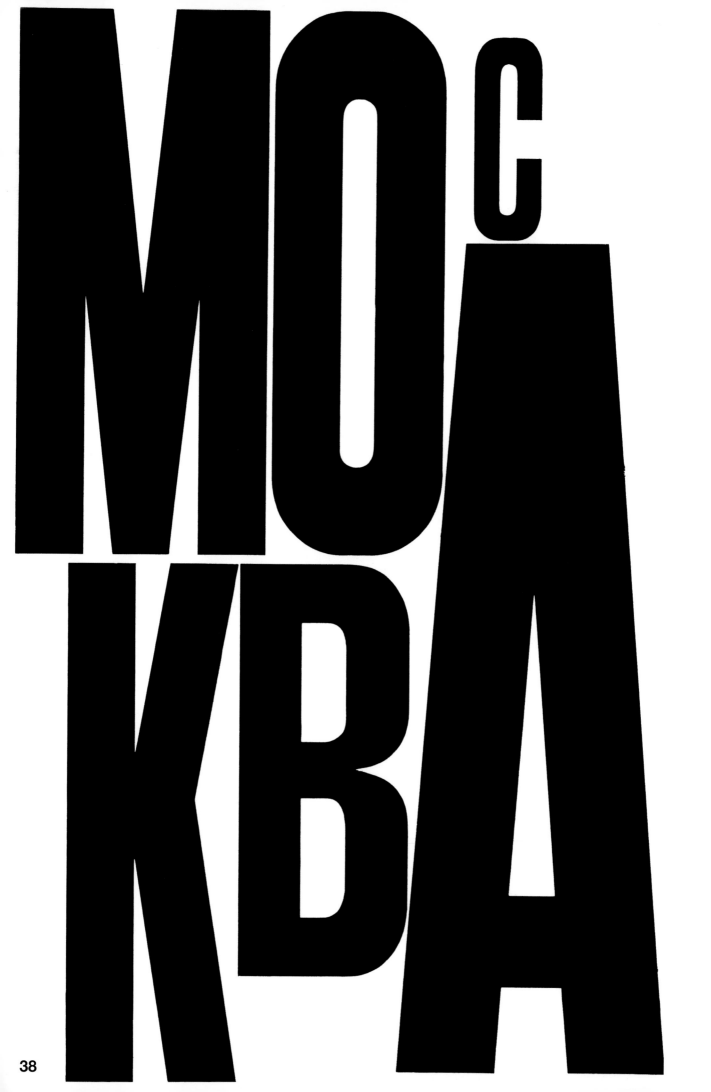

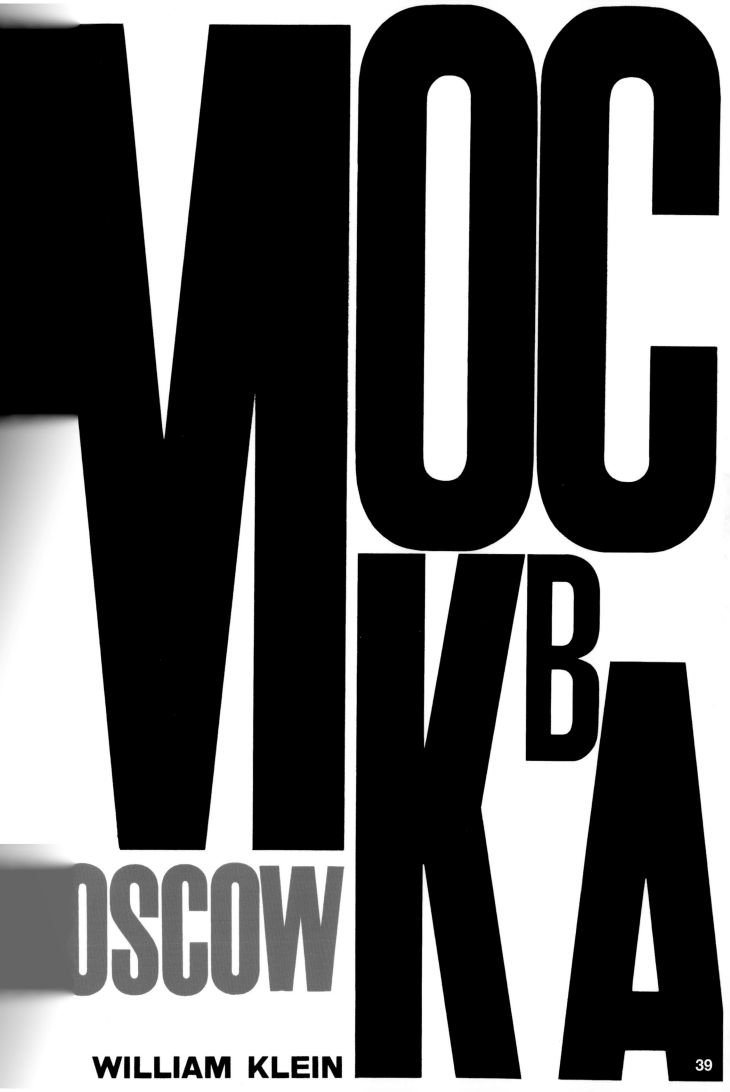

МОСКВА

MOSCOW

WILLIAM KLEIN

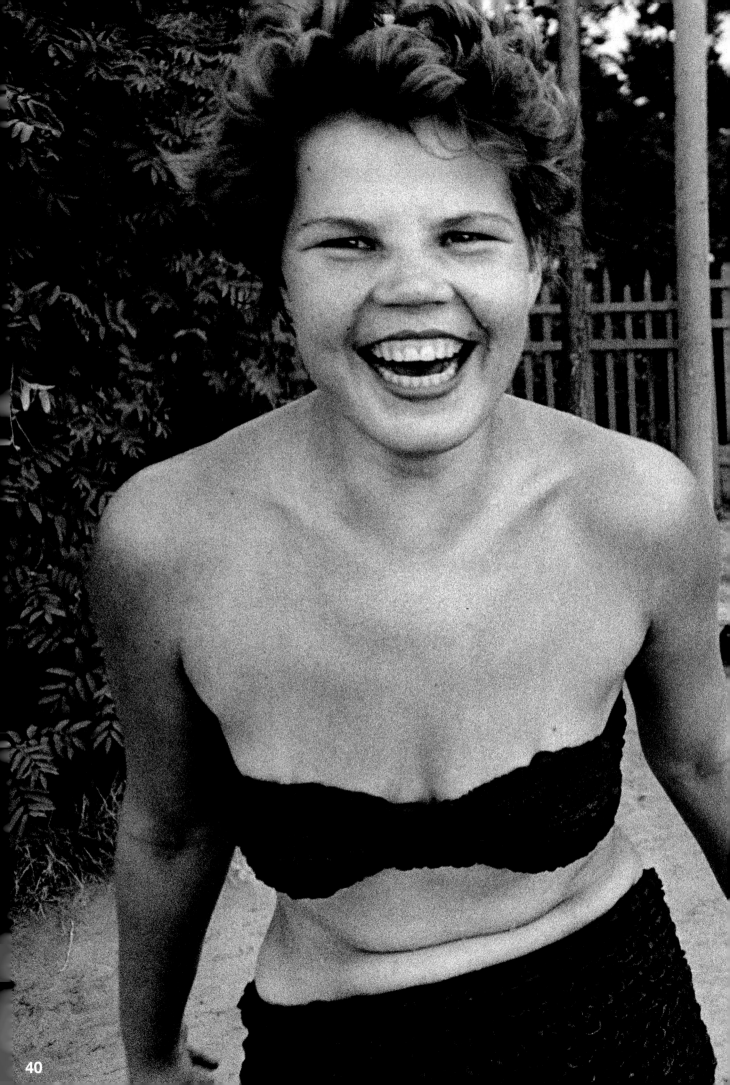

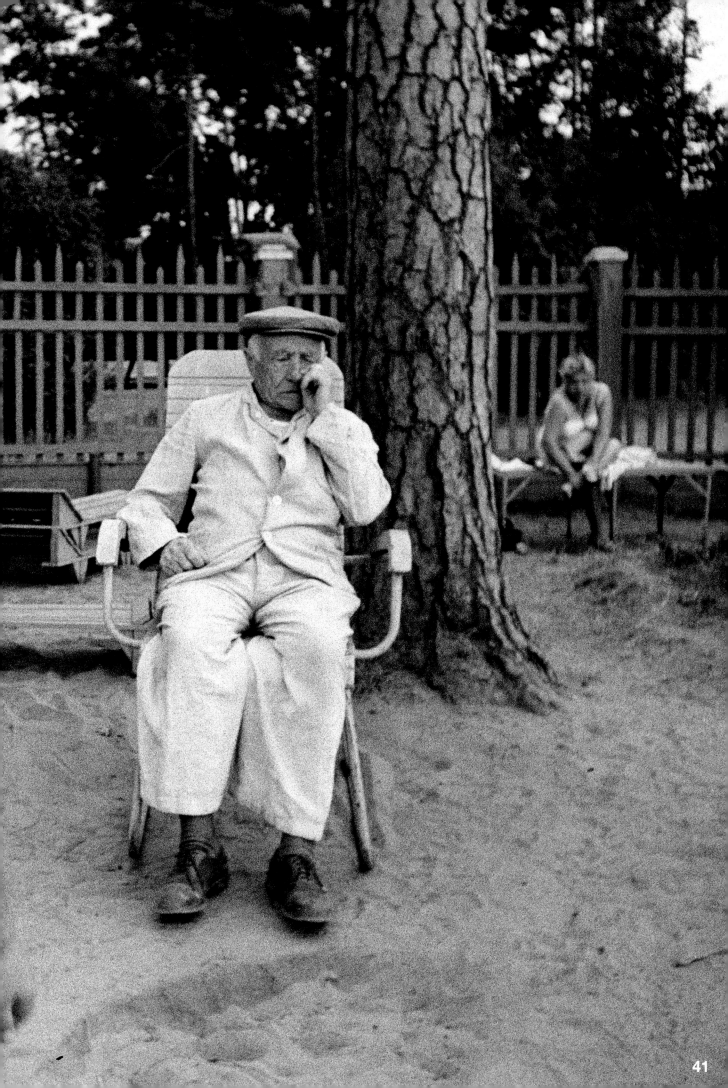

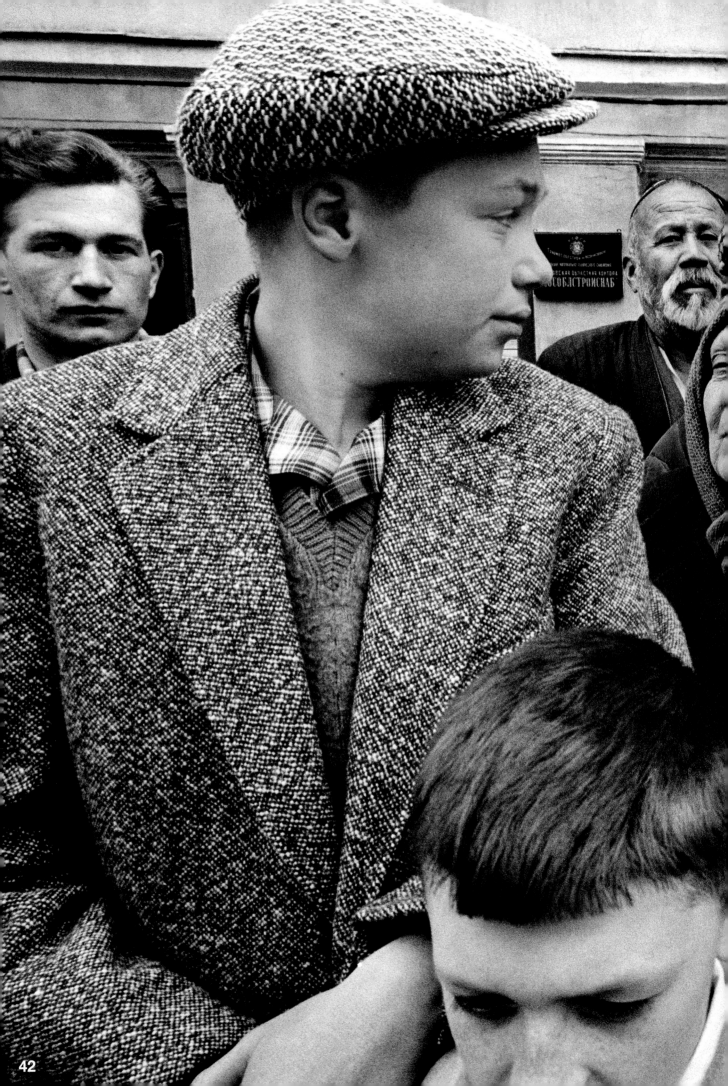

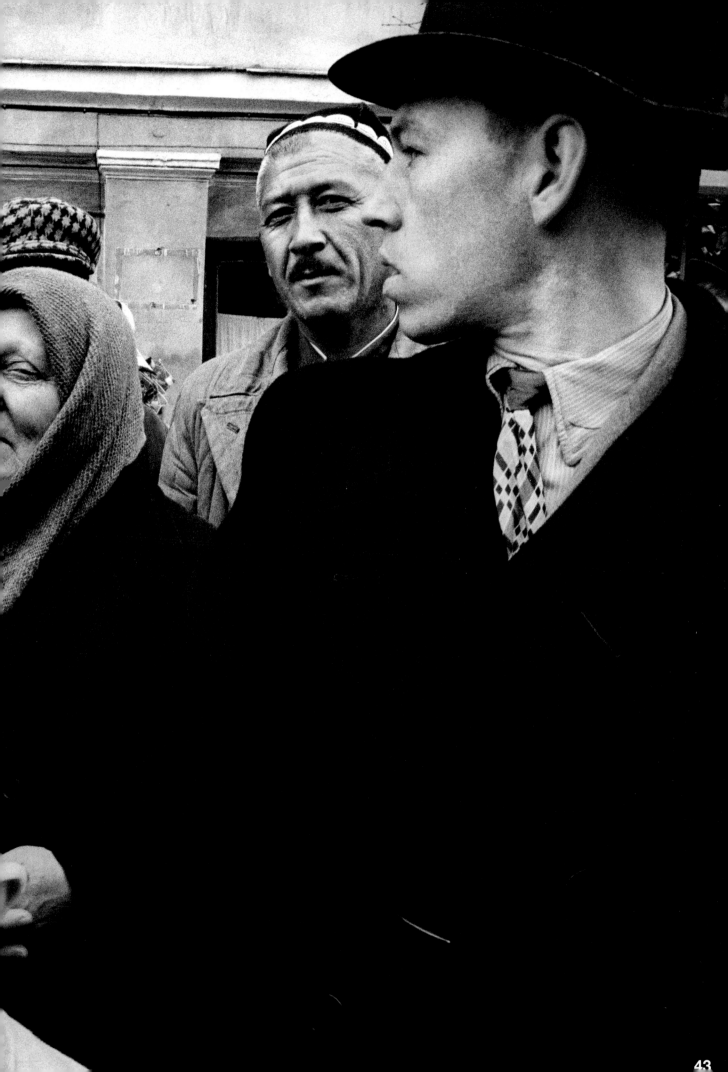

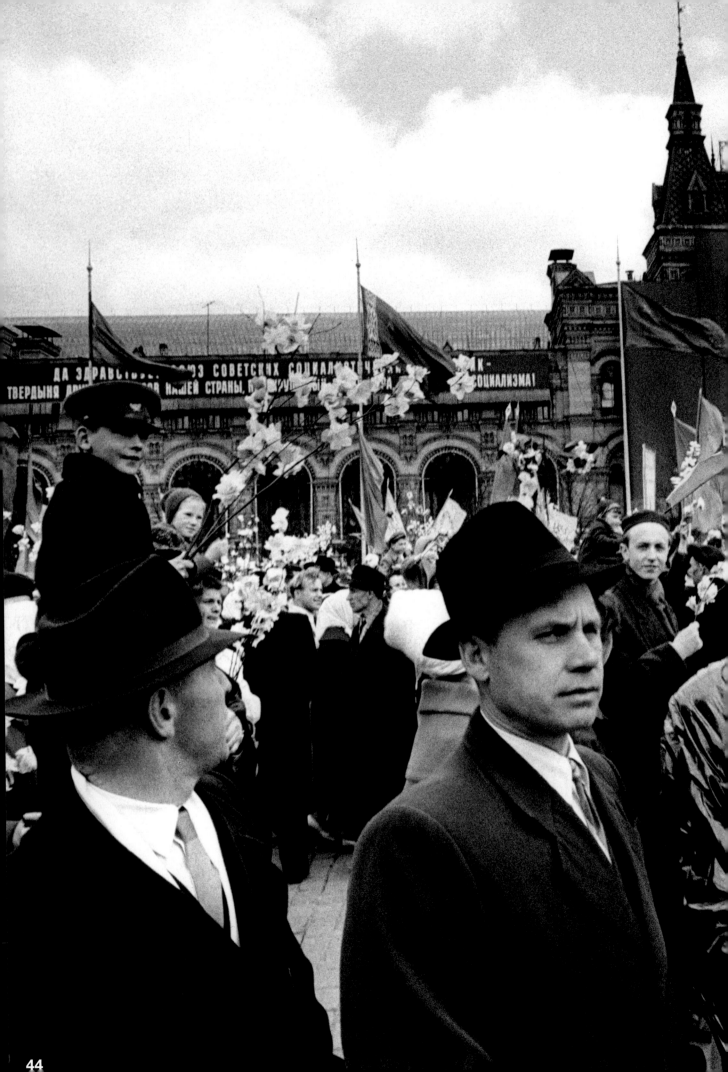

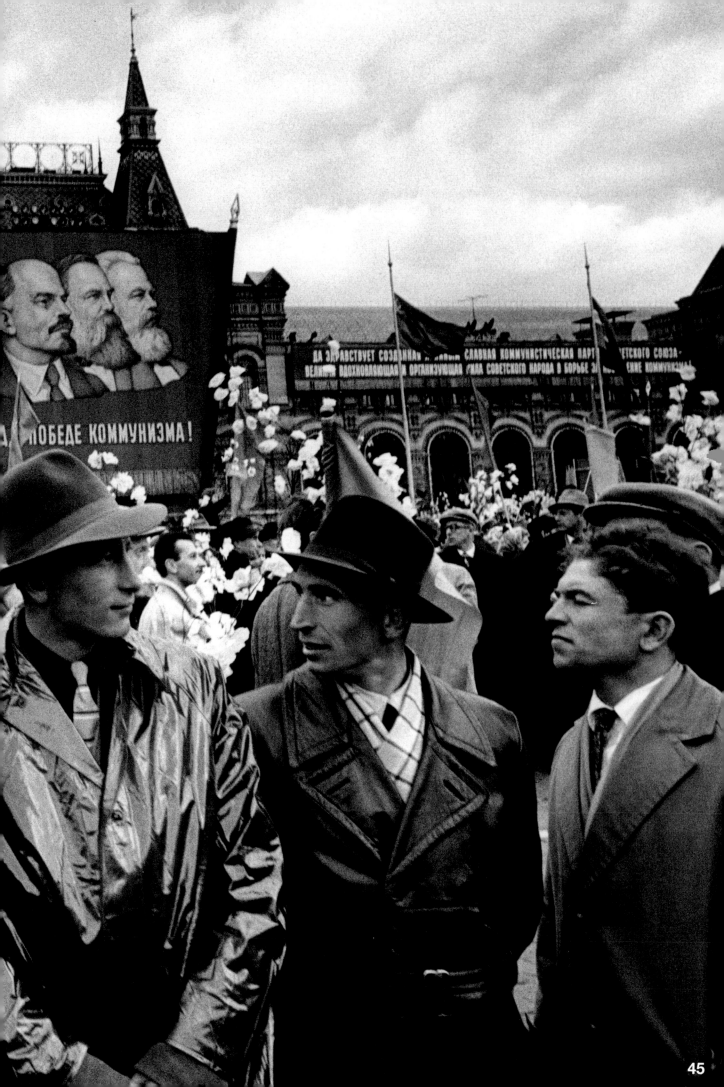

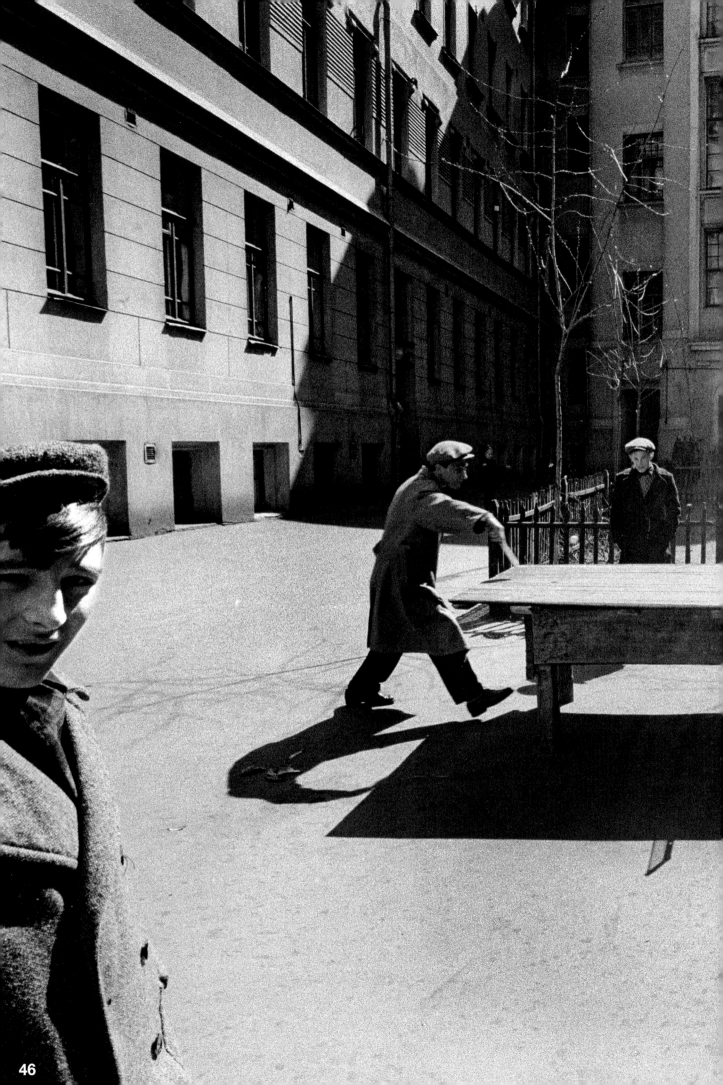

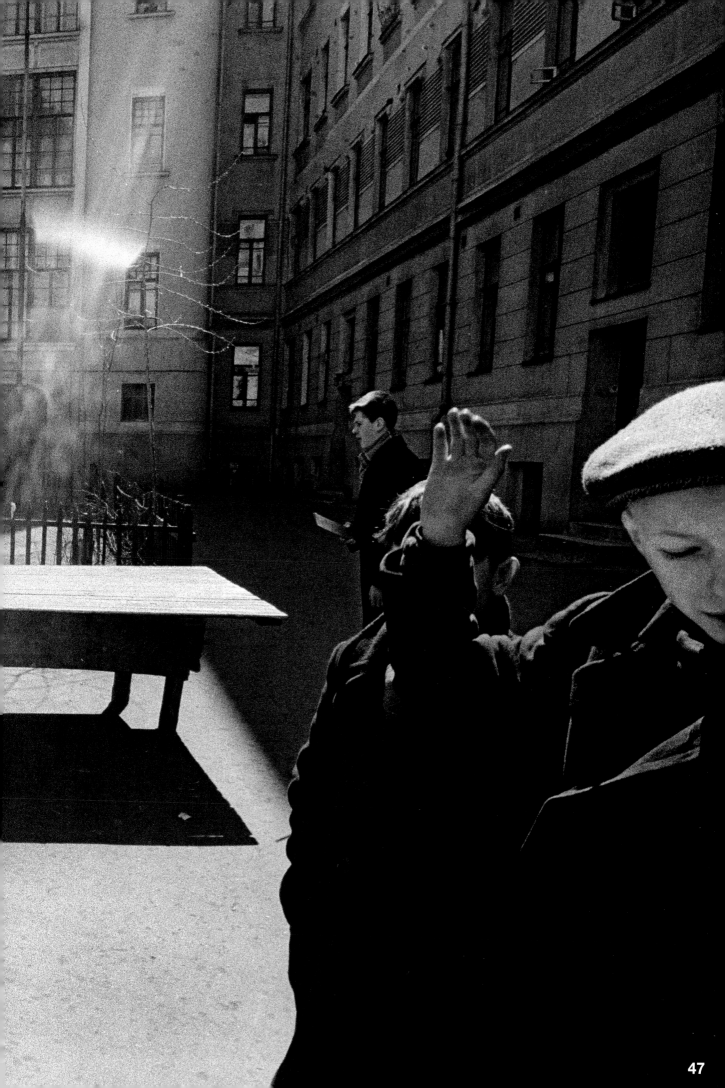

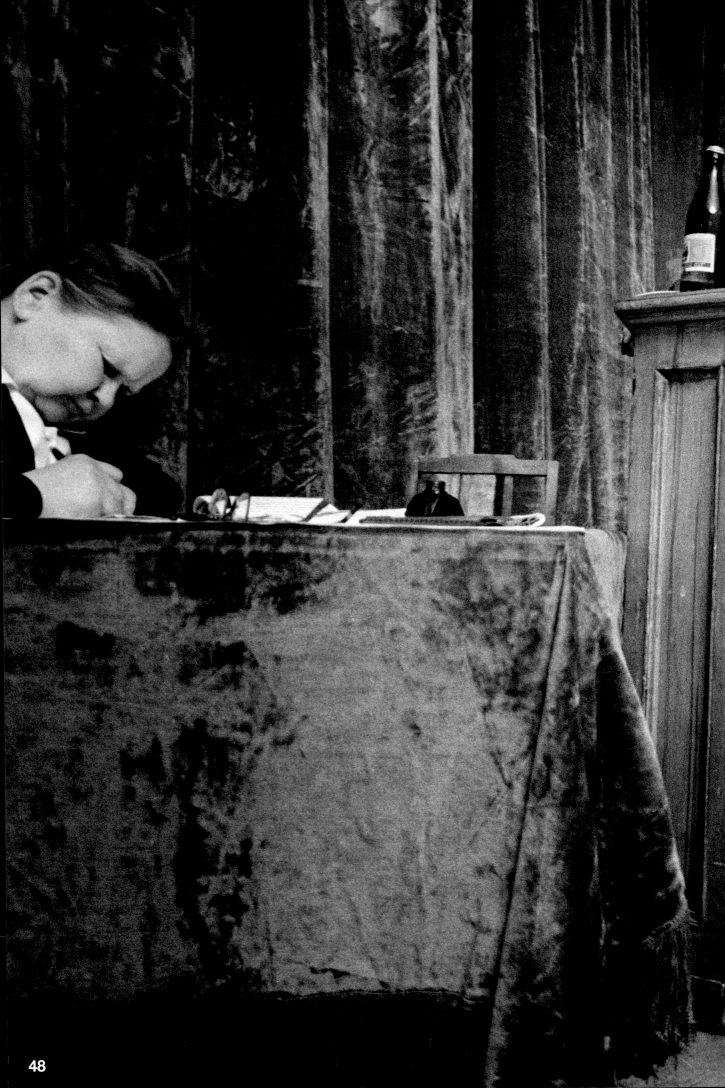

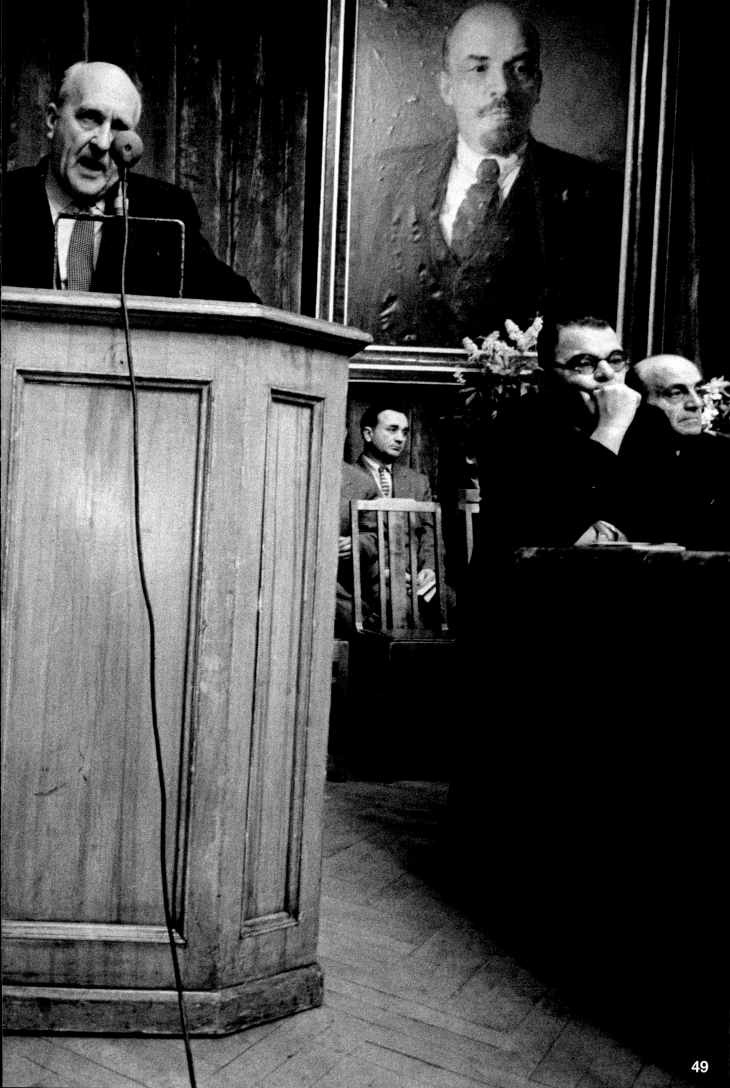

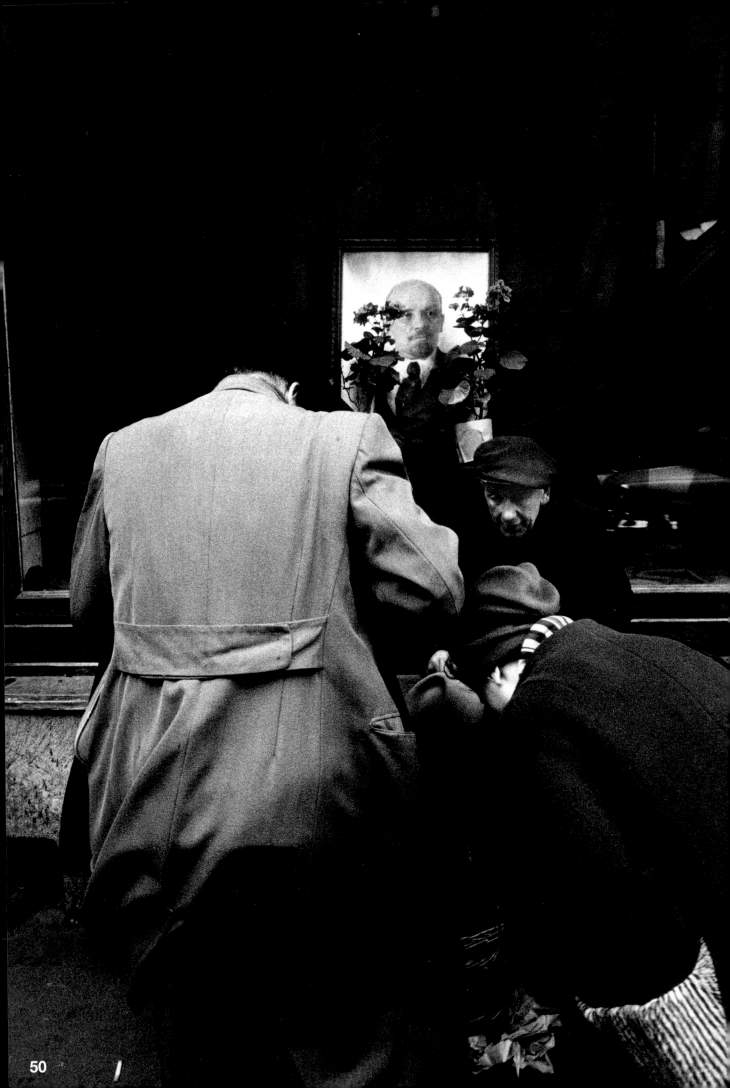

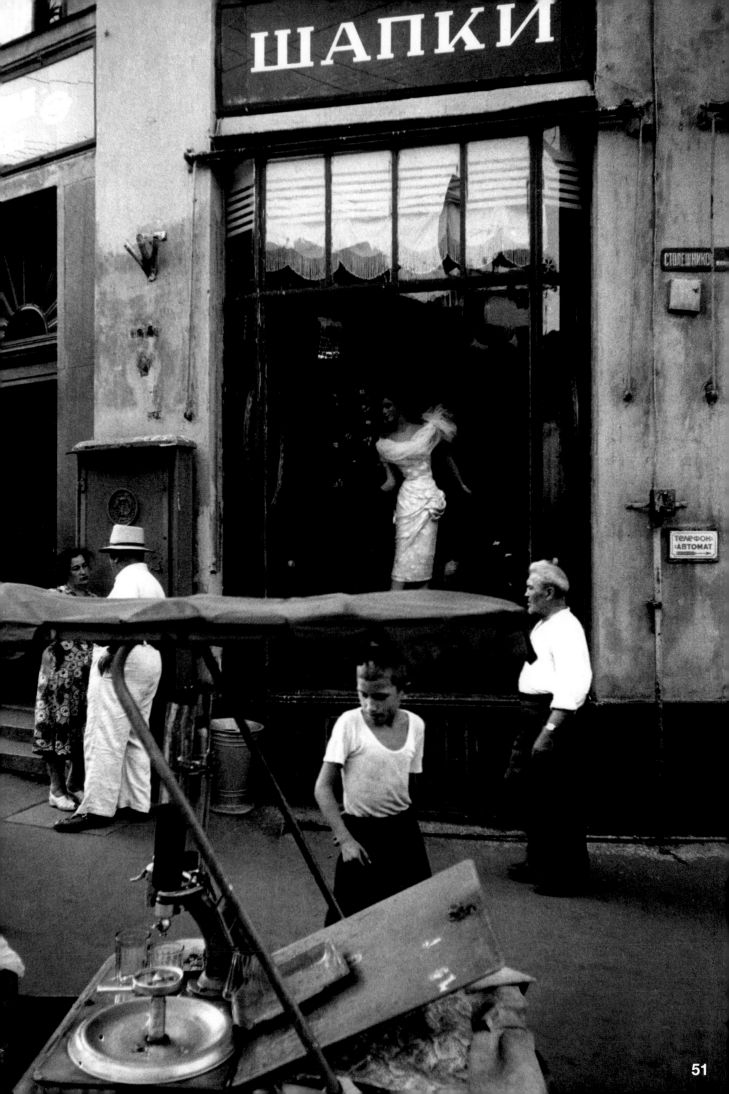

ШАПКИ

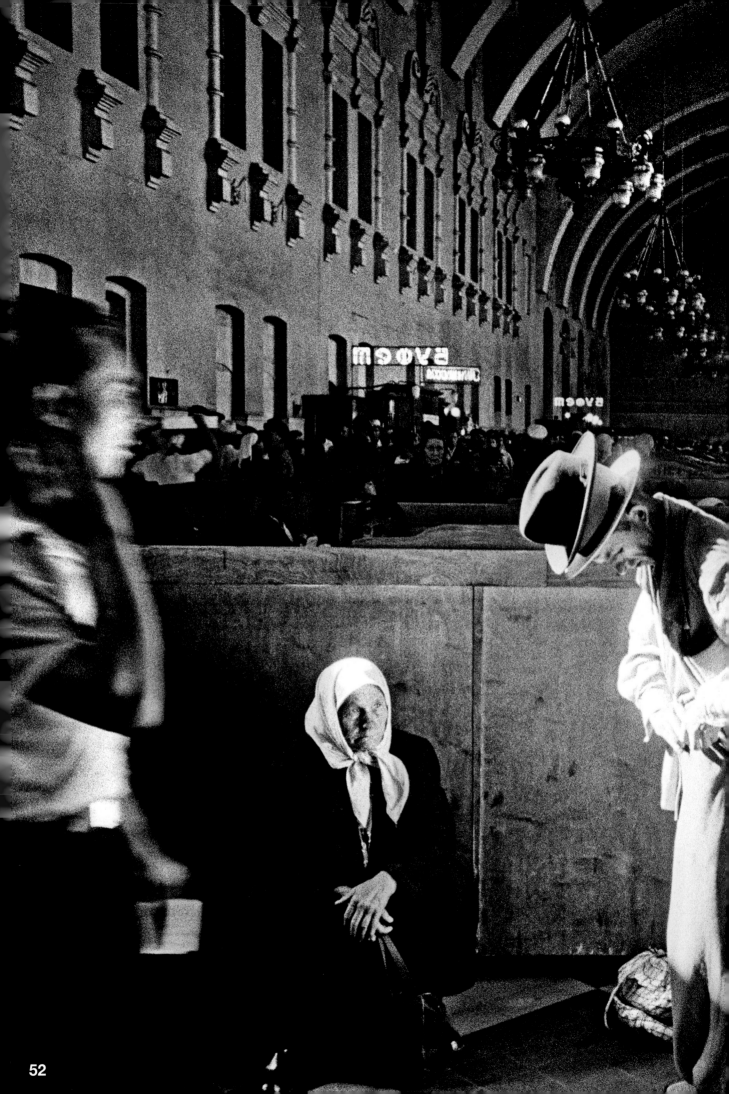

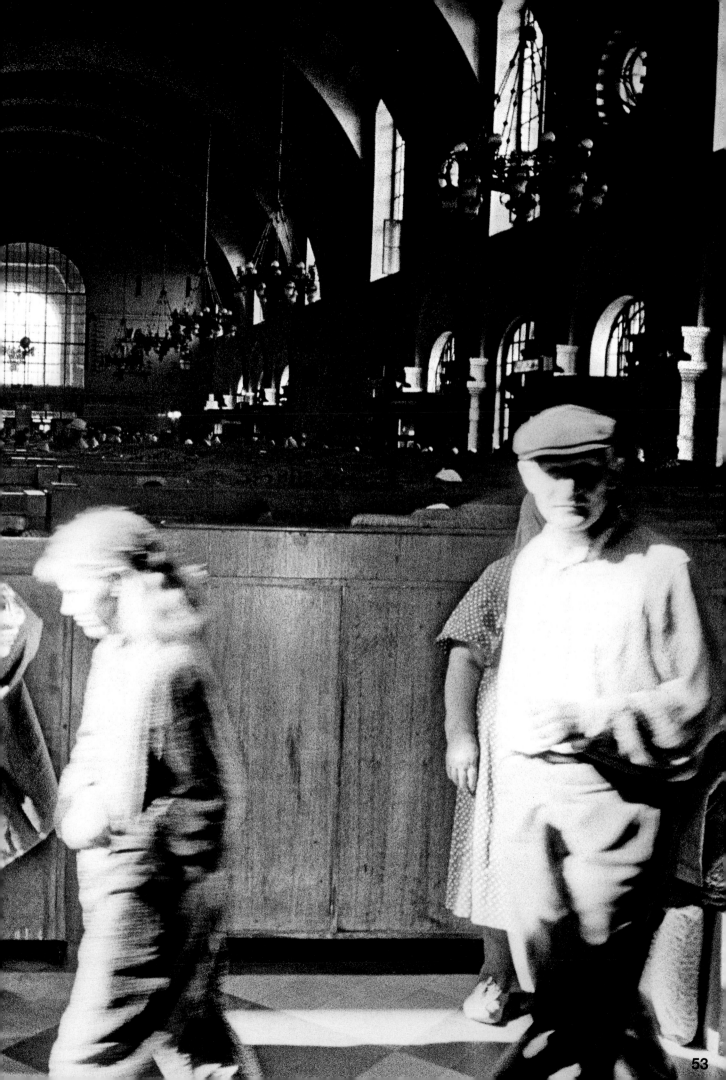

WILLIAM KLEIN **ROME**

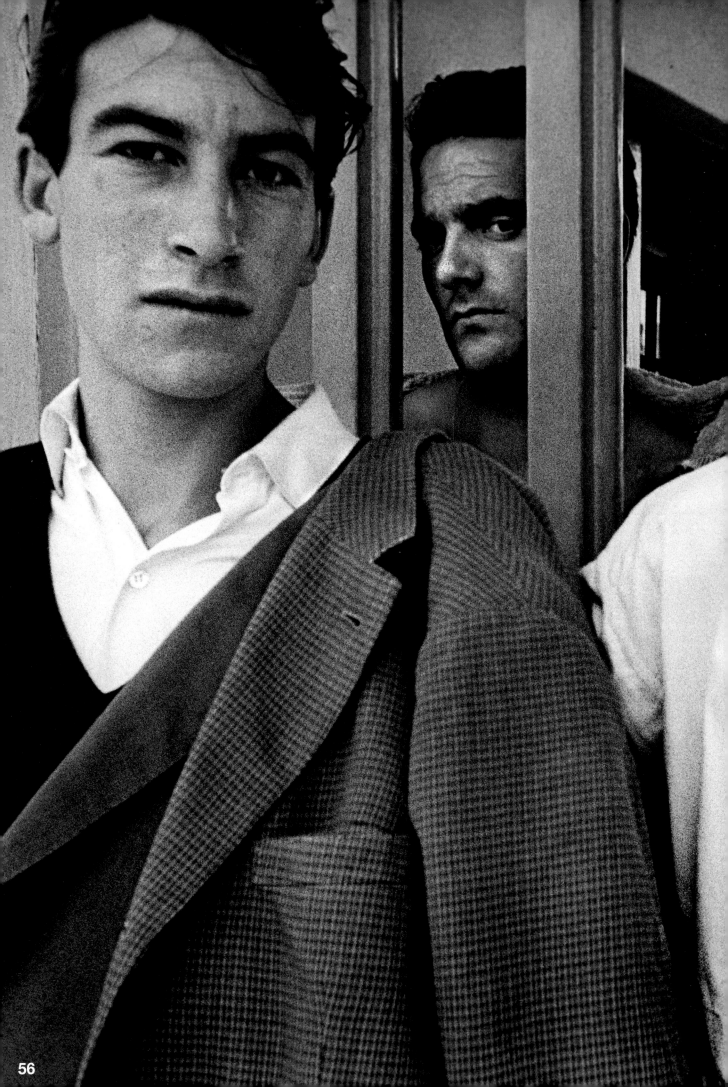

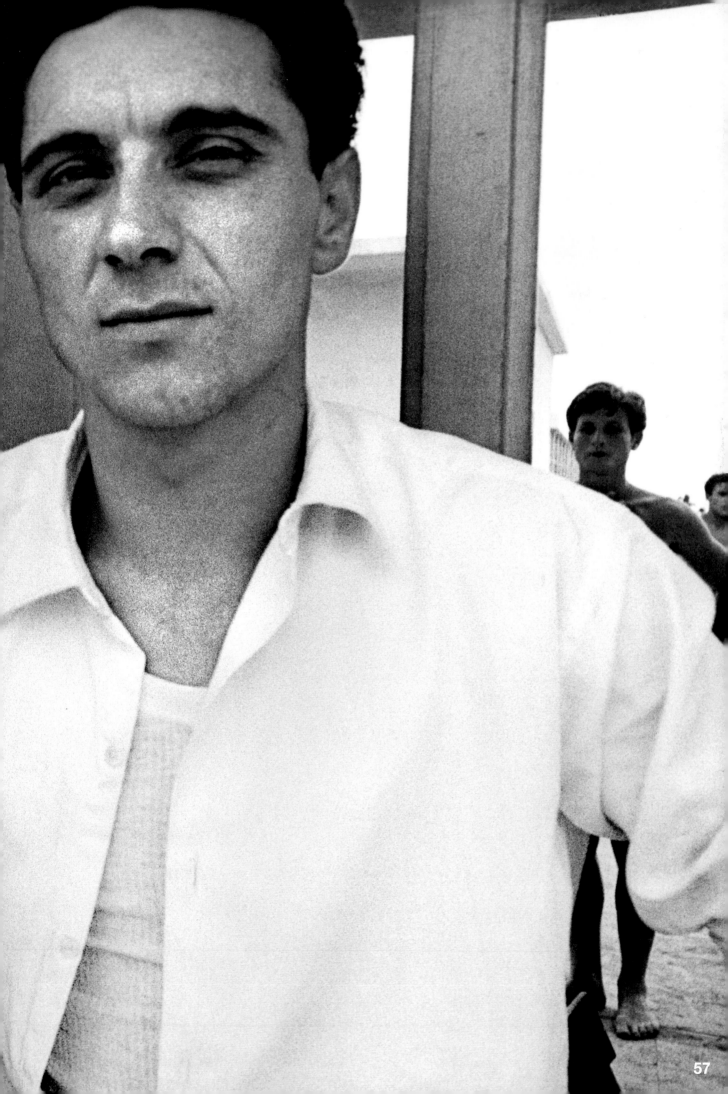

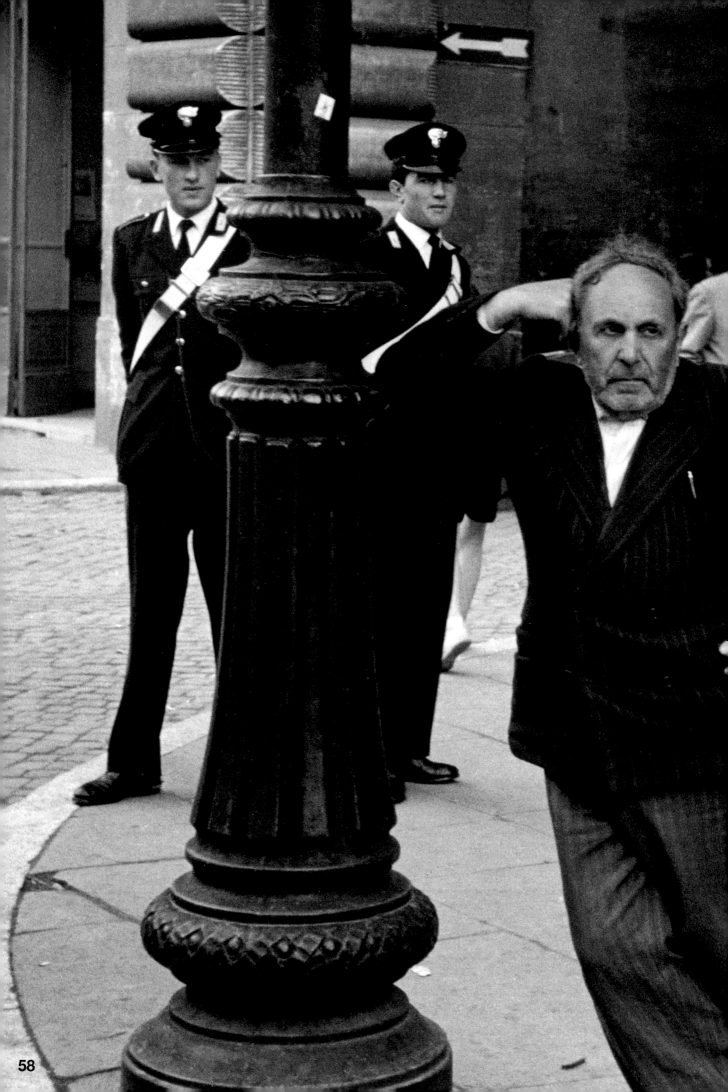

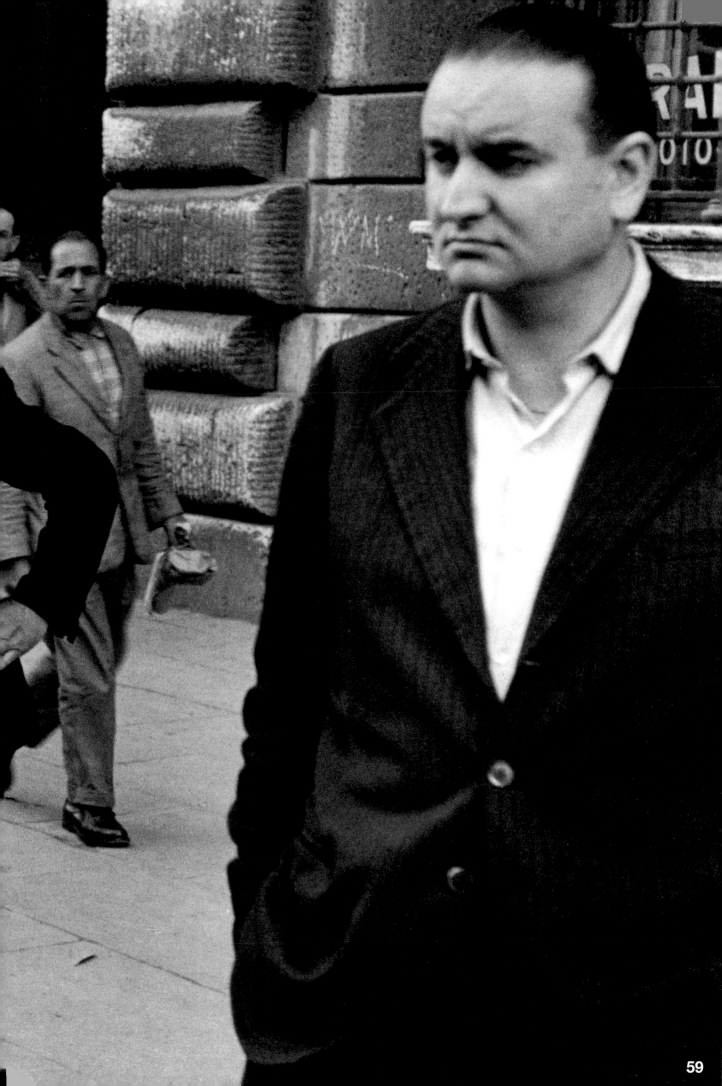

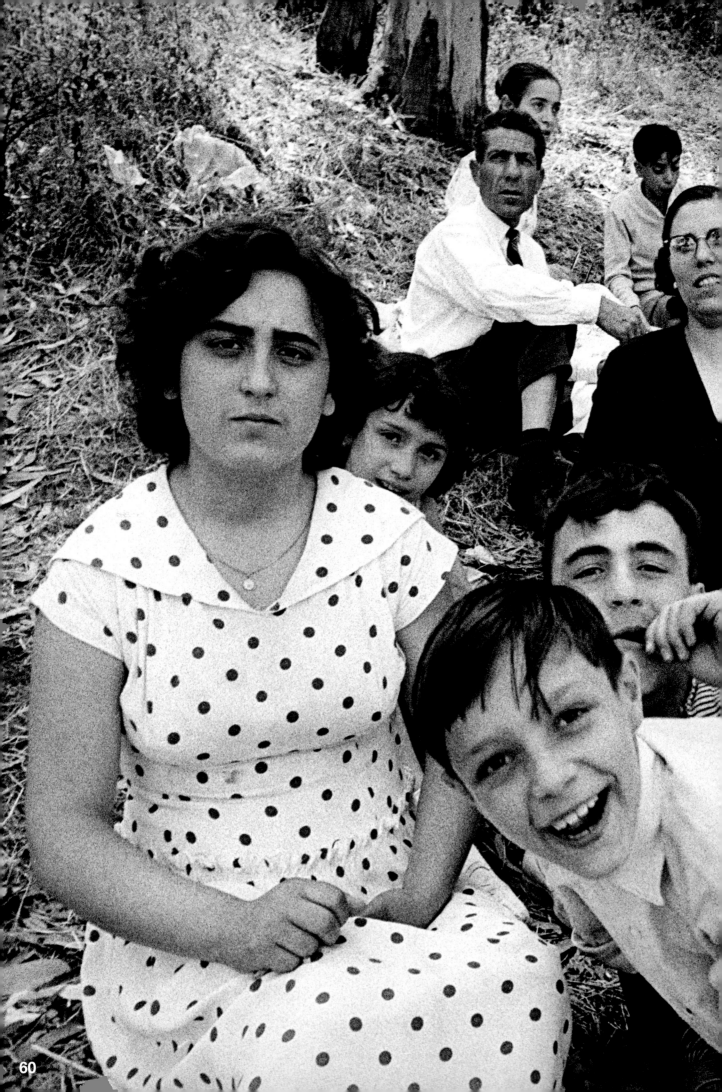

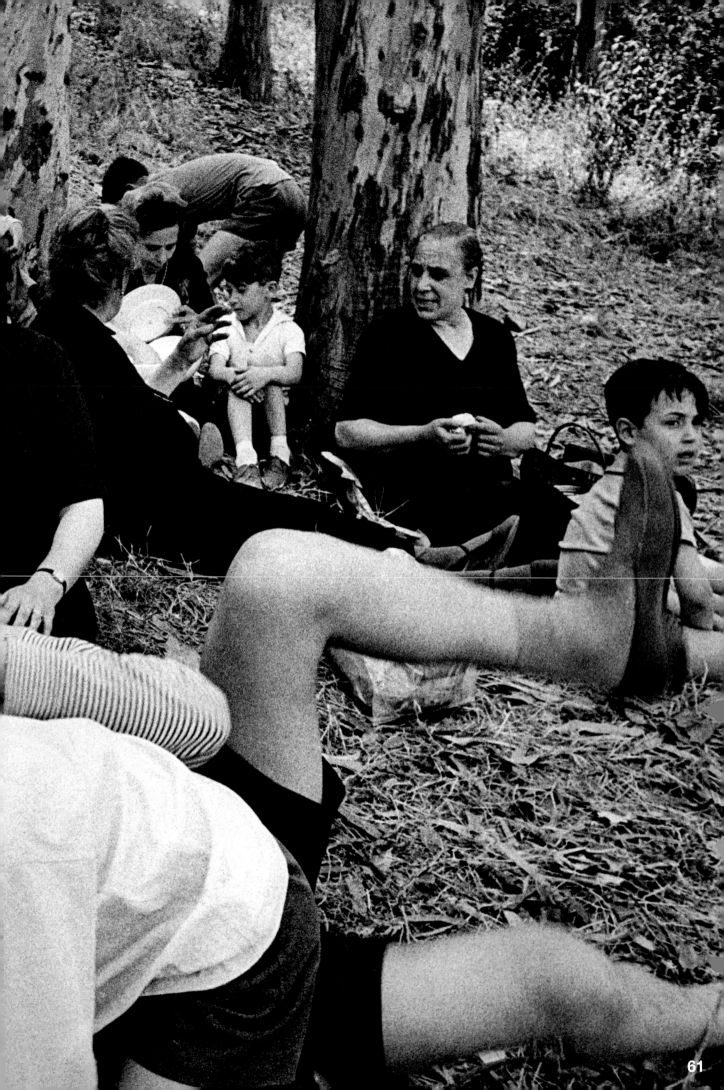

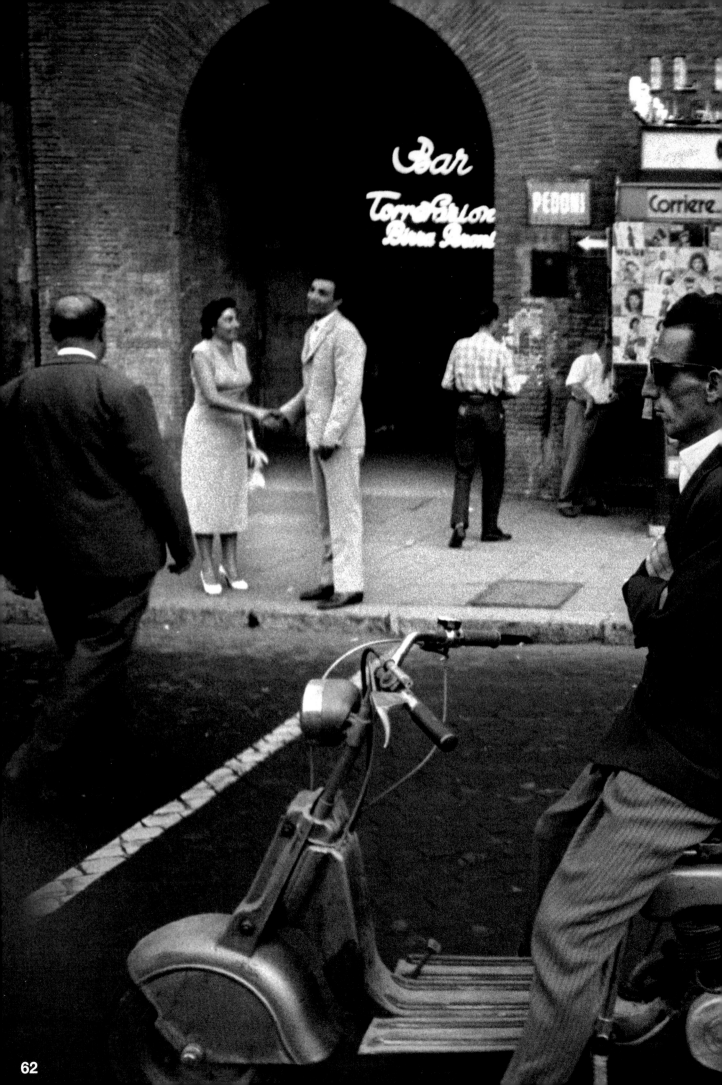

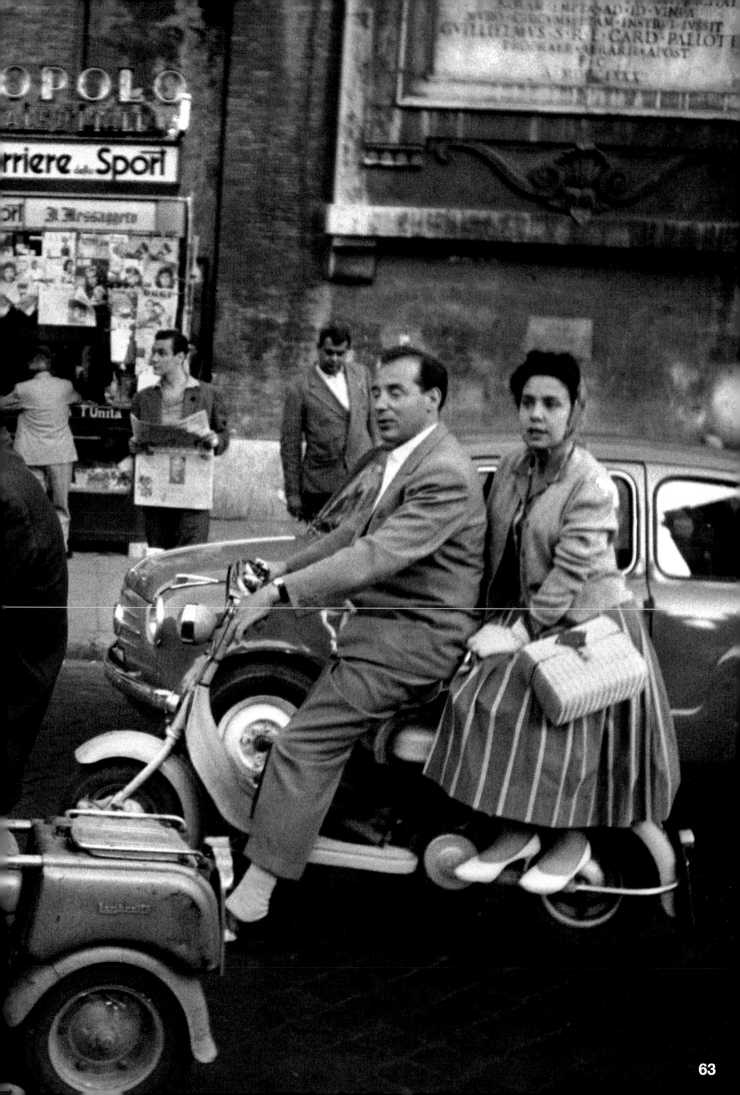

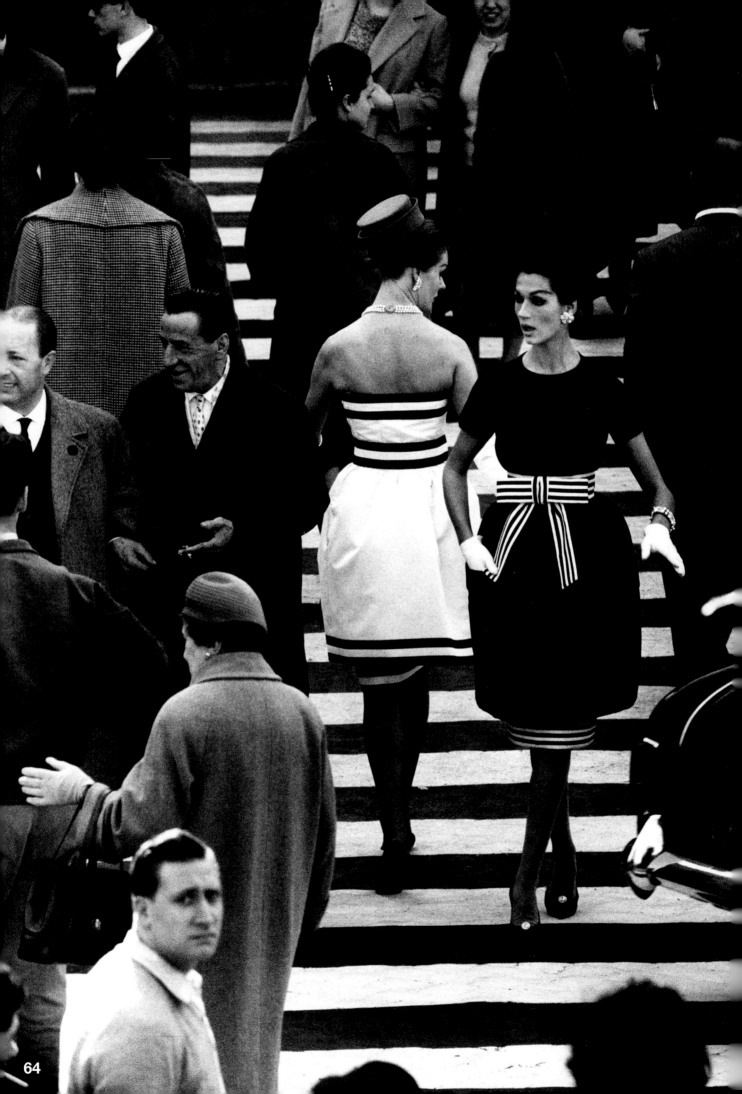

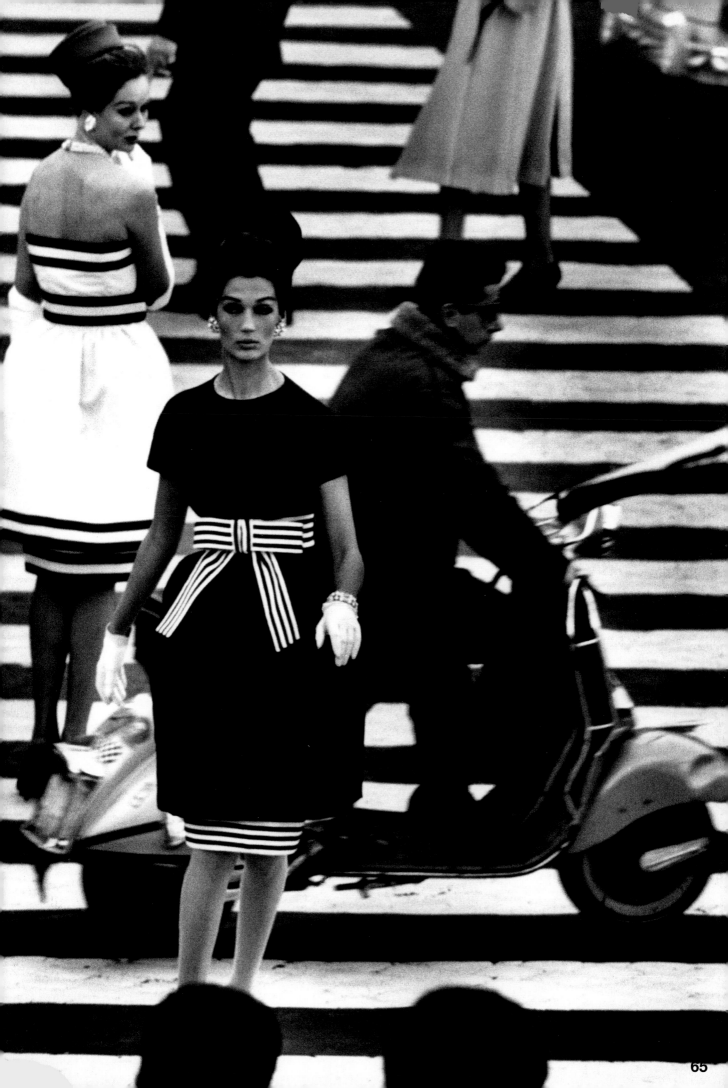

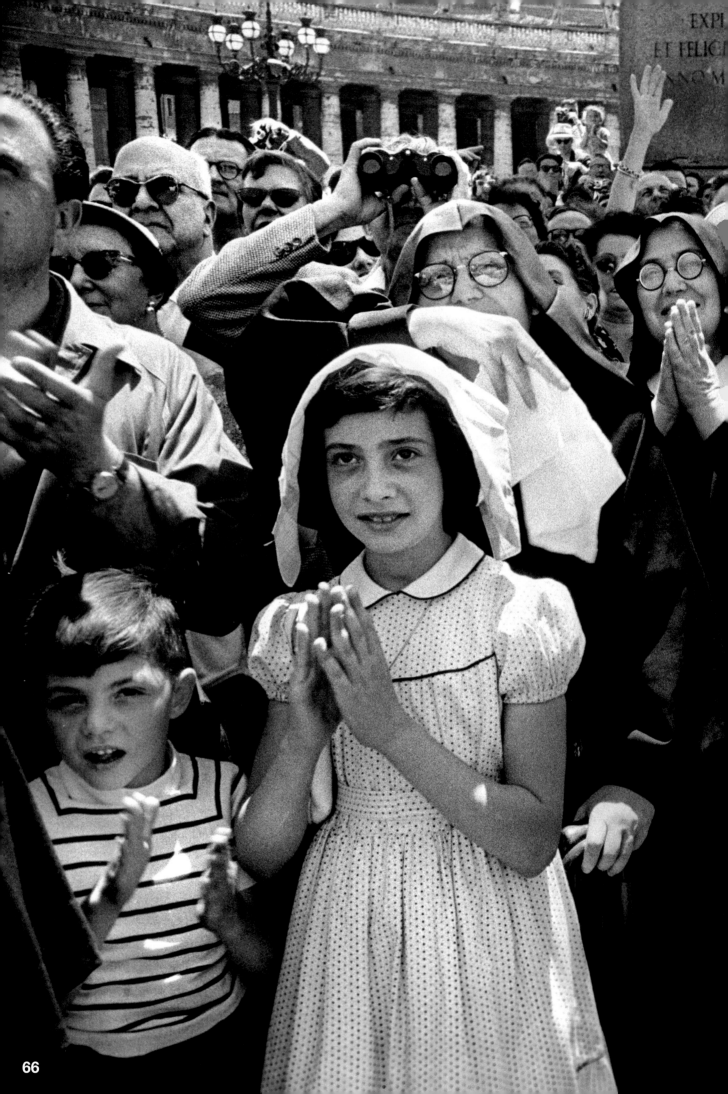

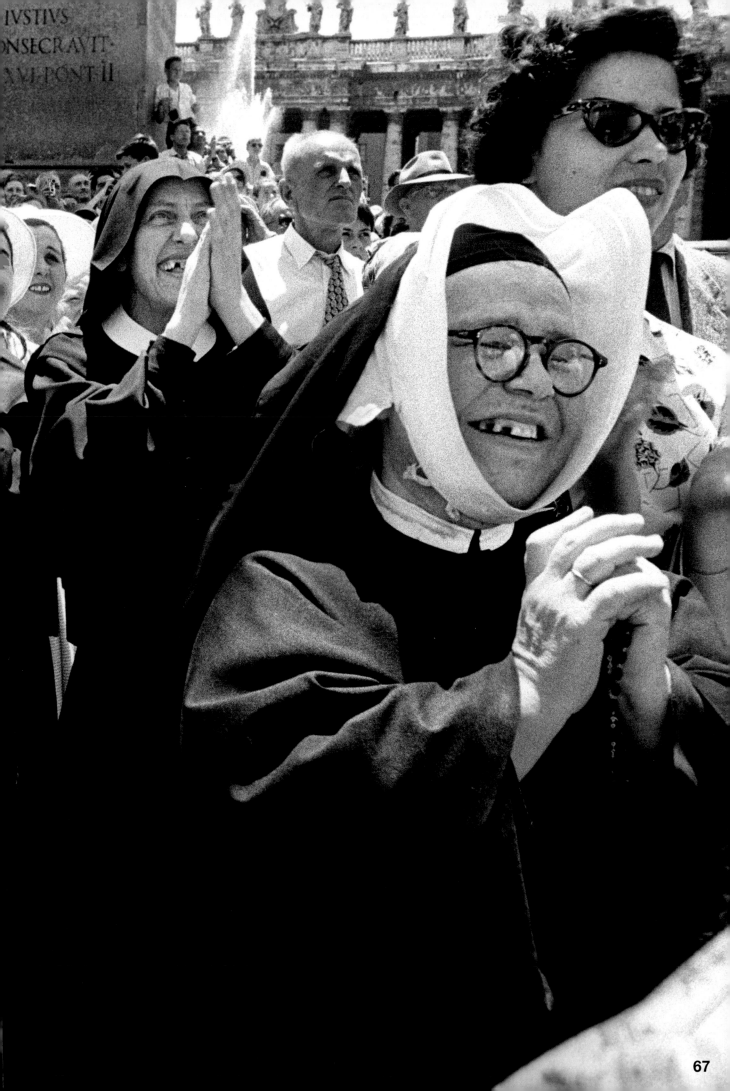

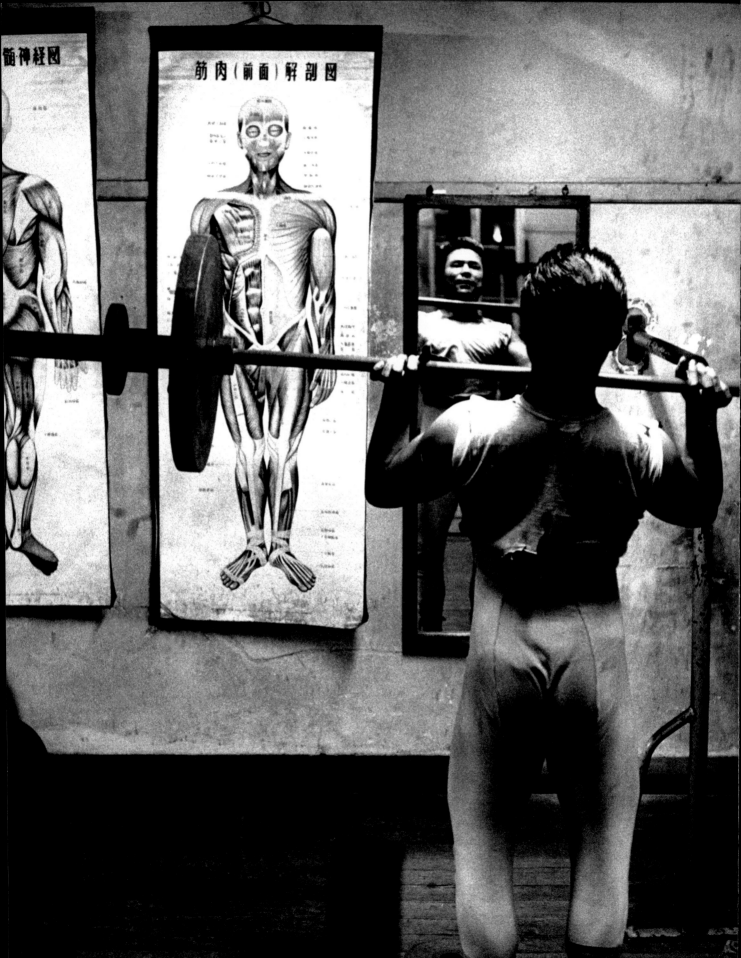

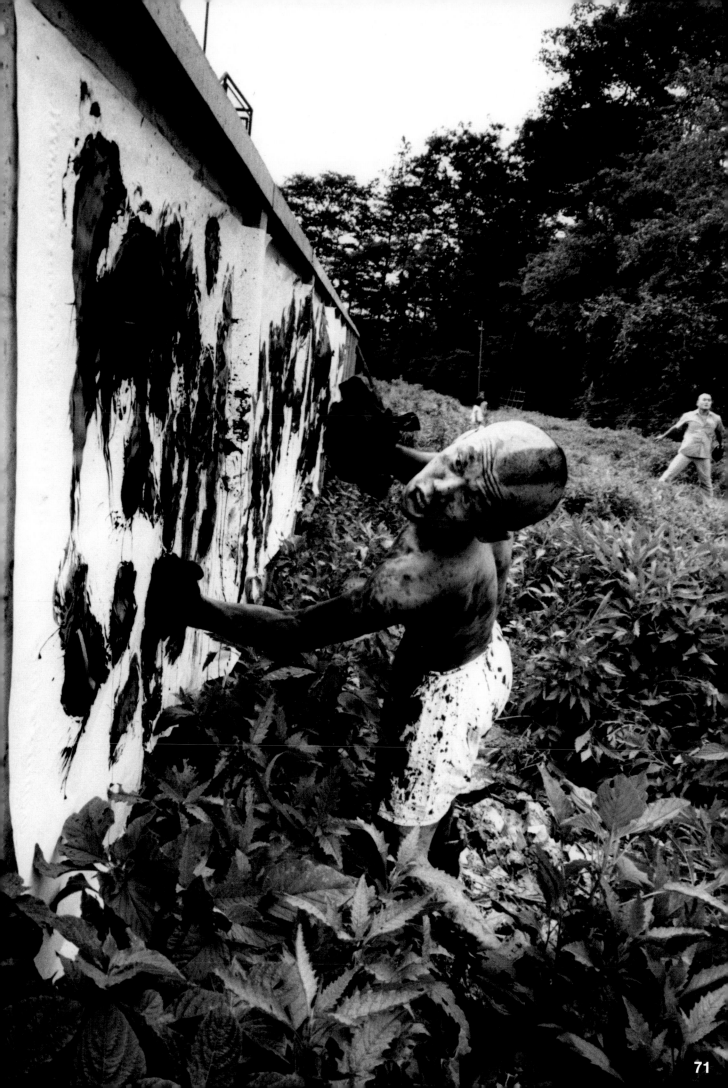

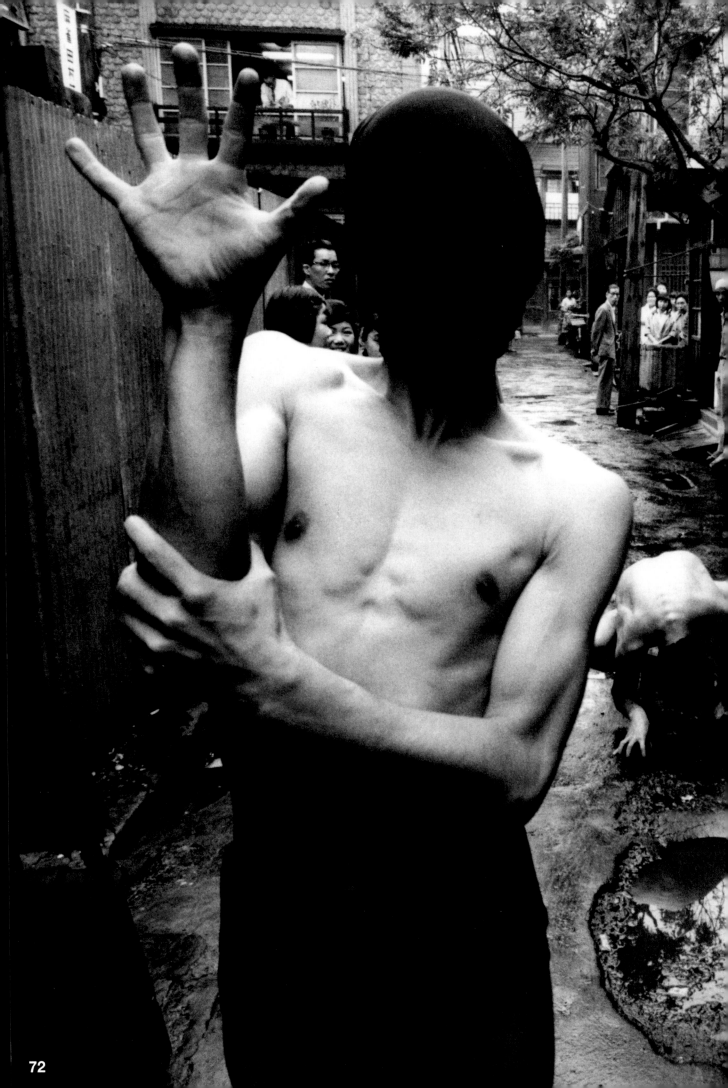

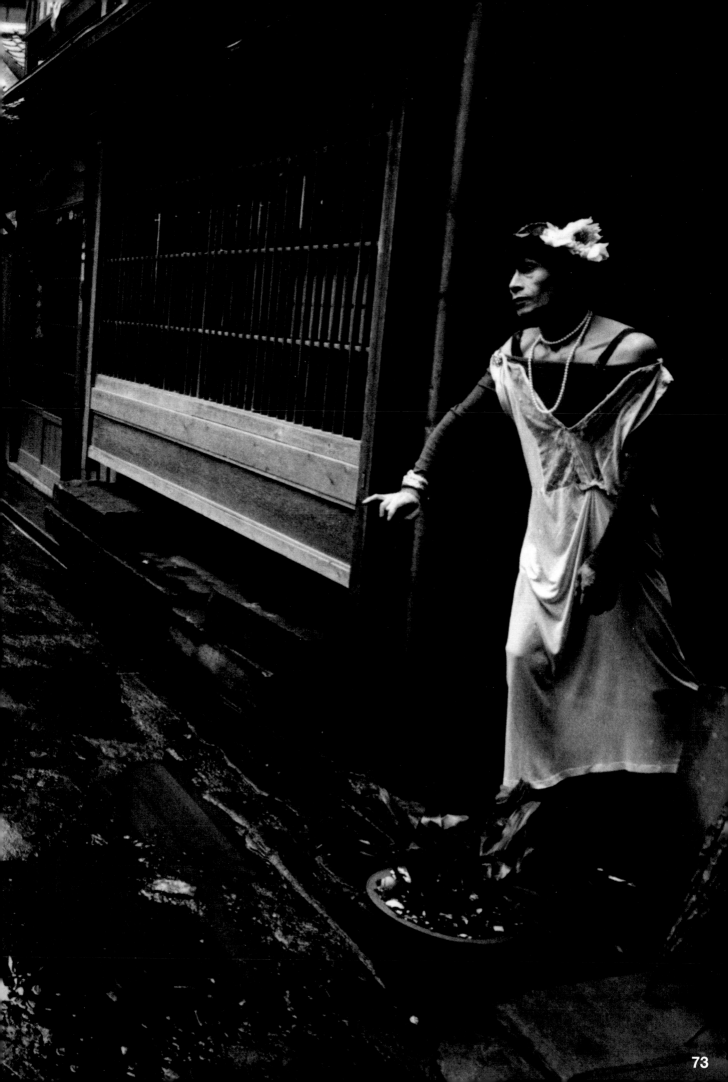

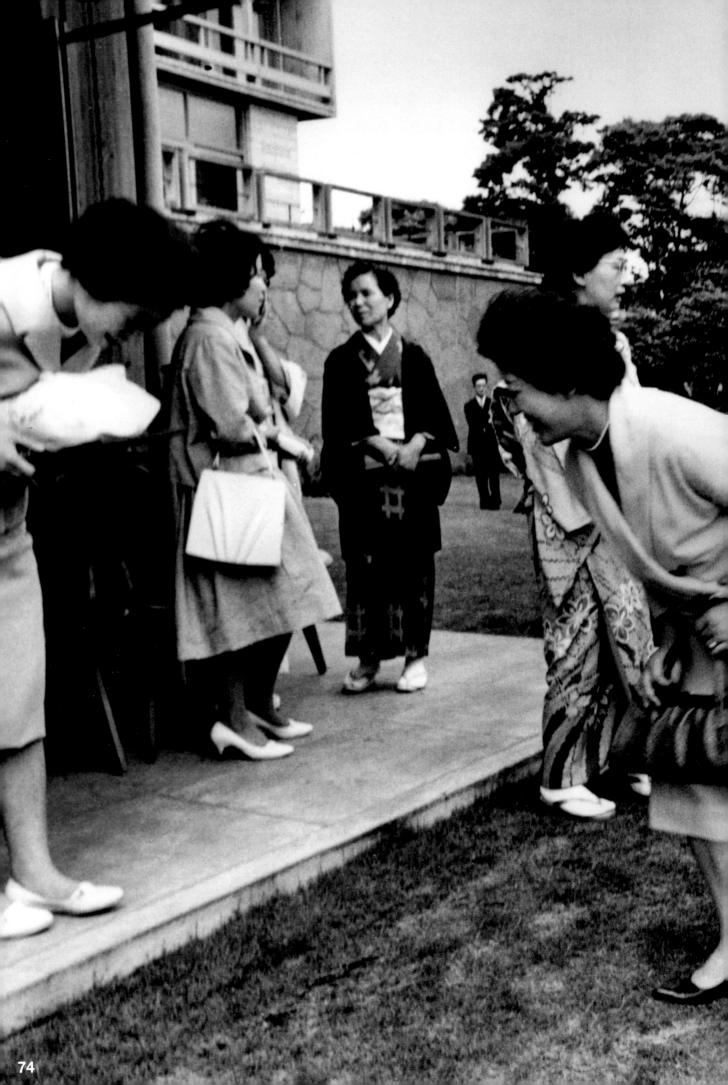

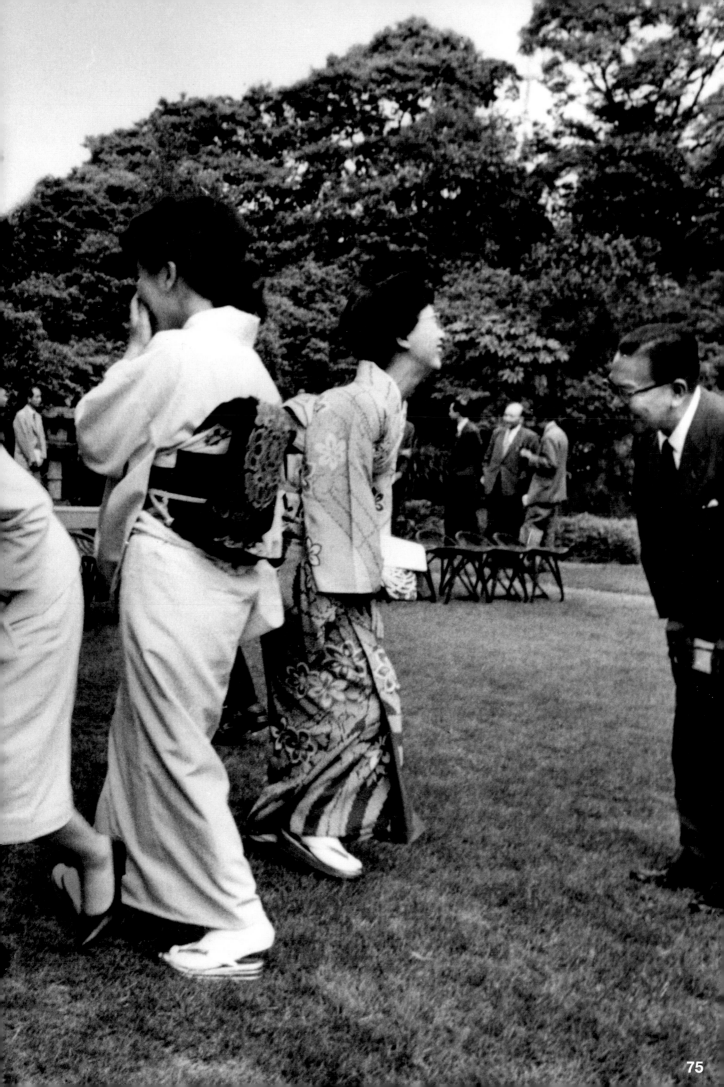

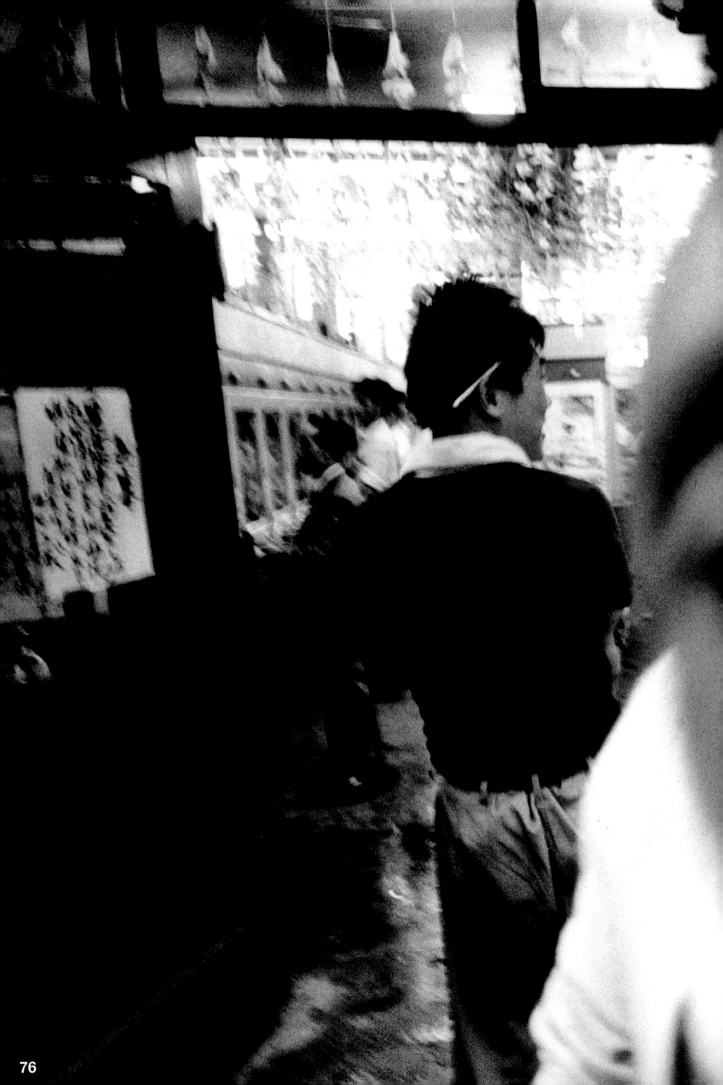

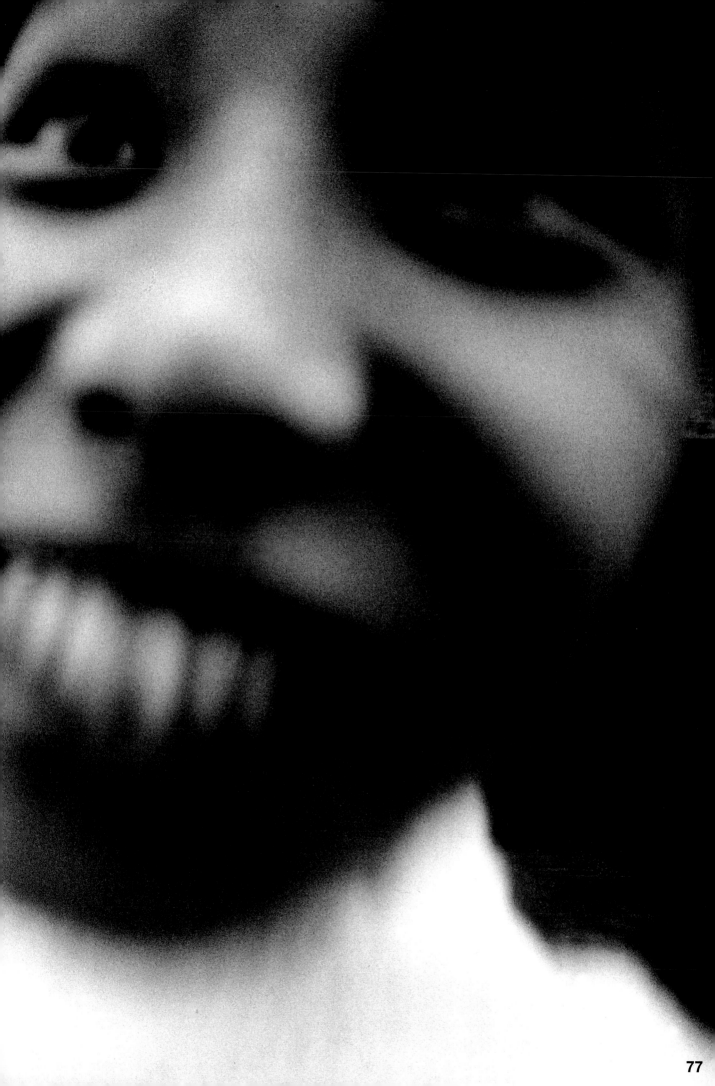

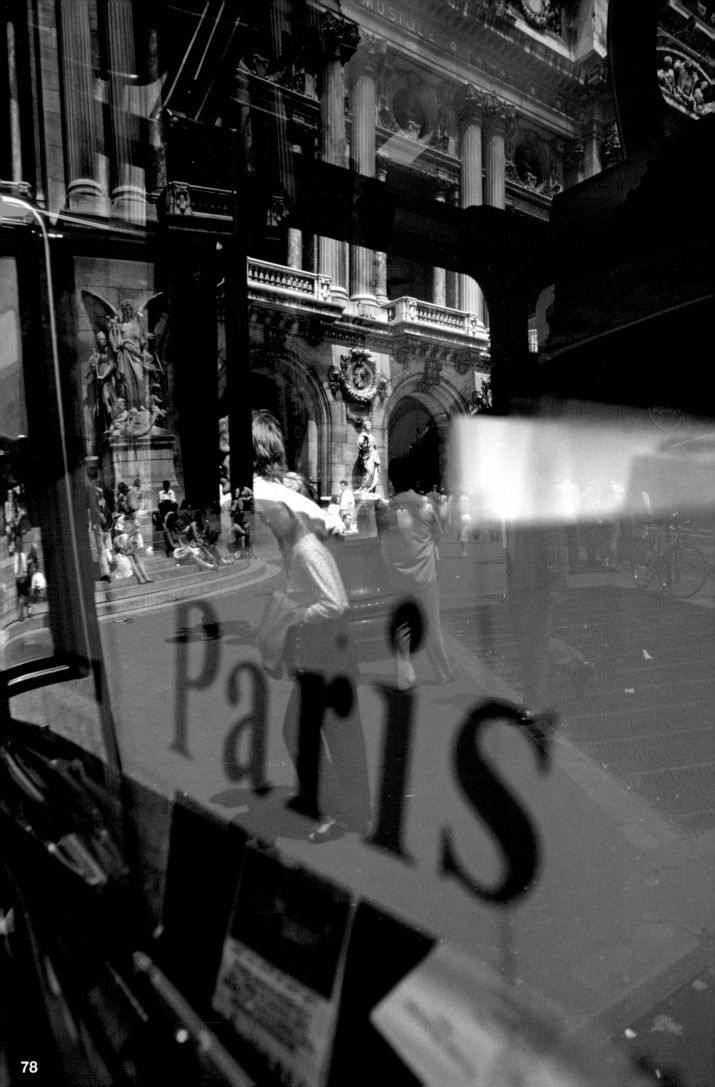

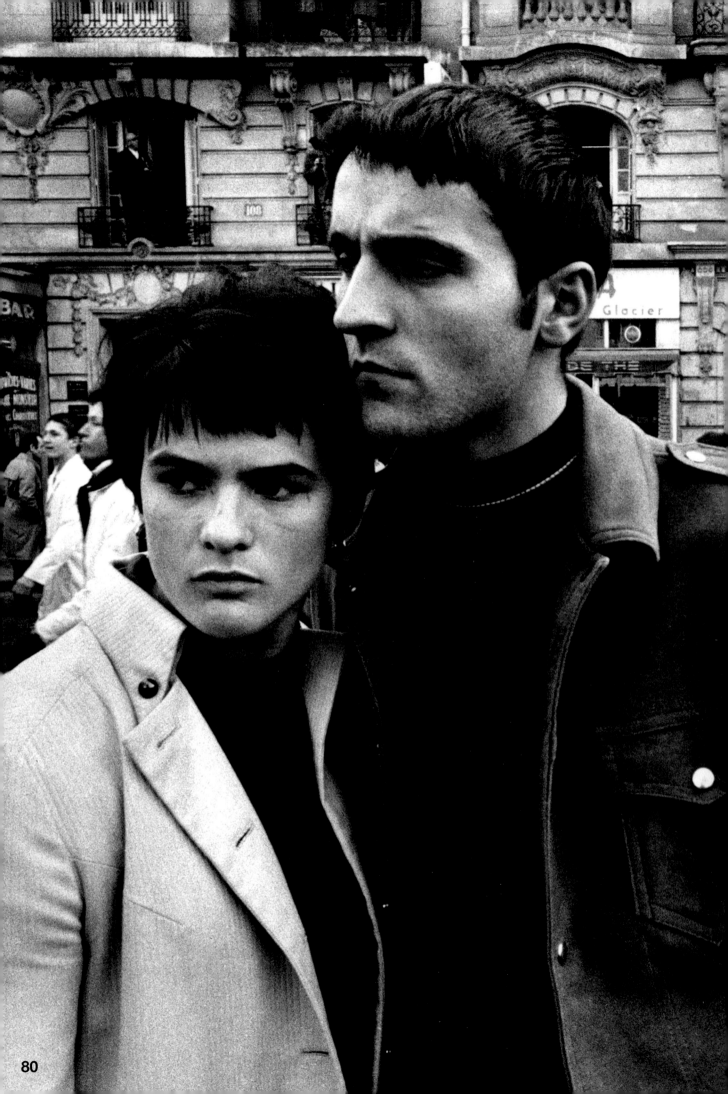

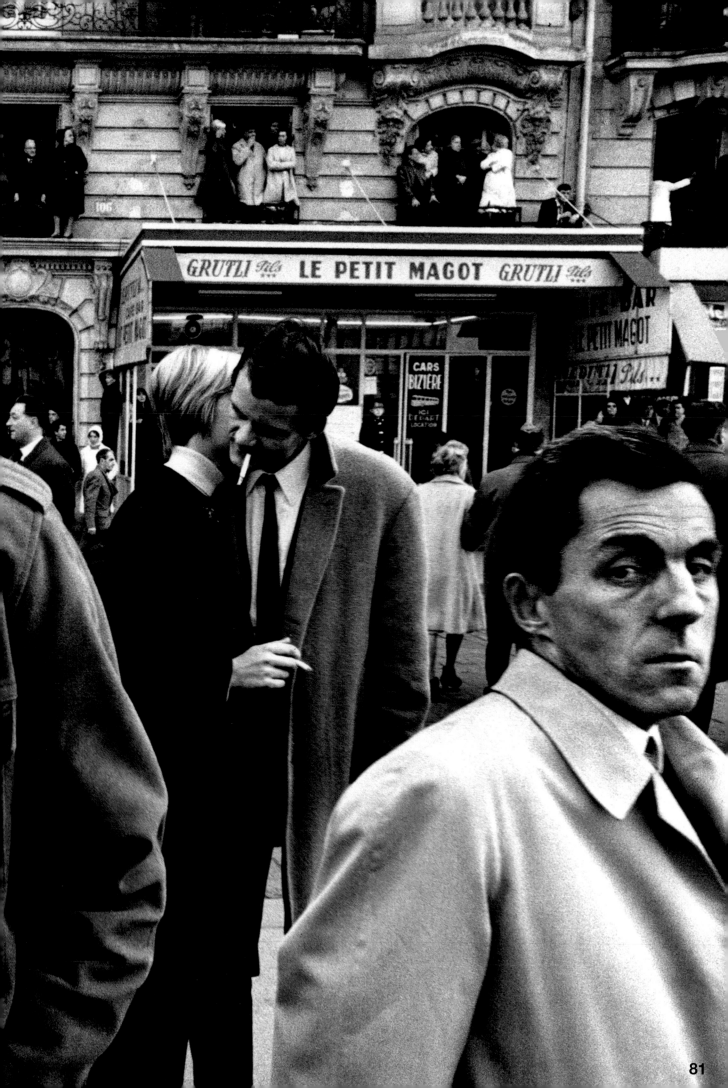

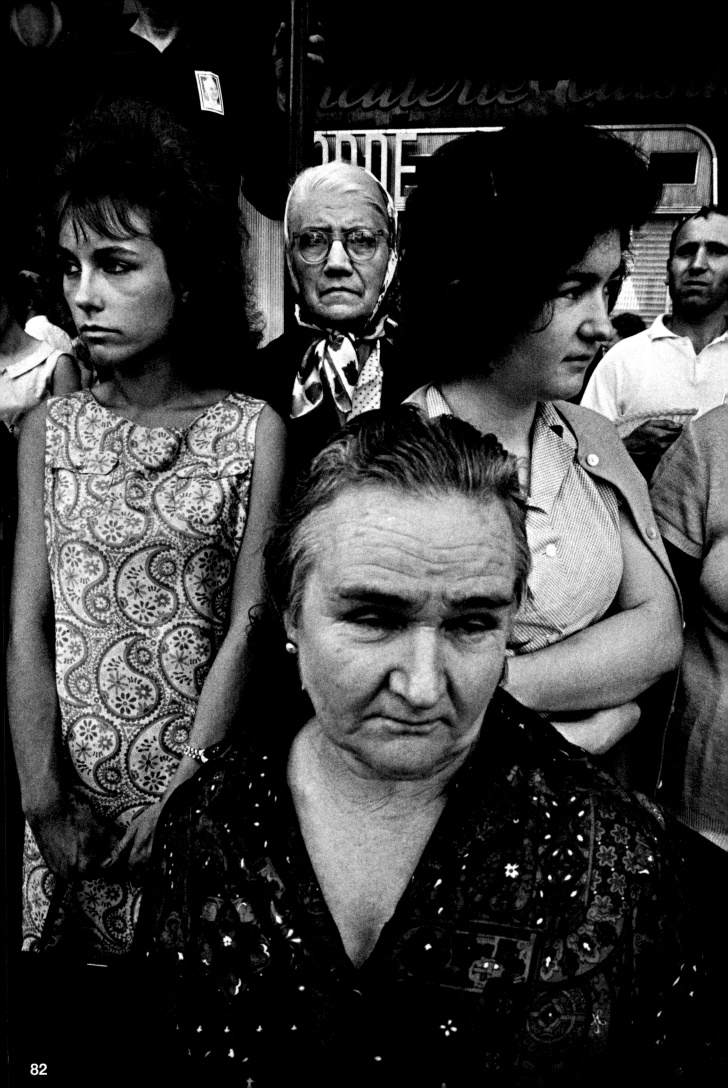

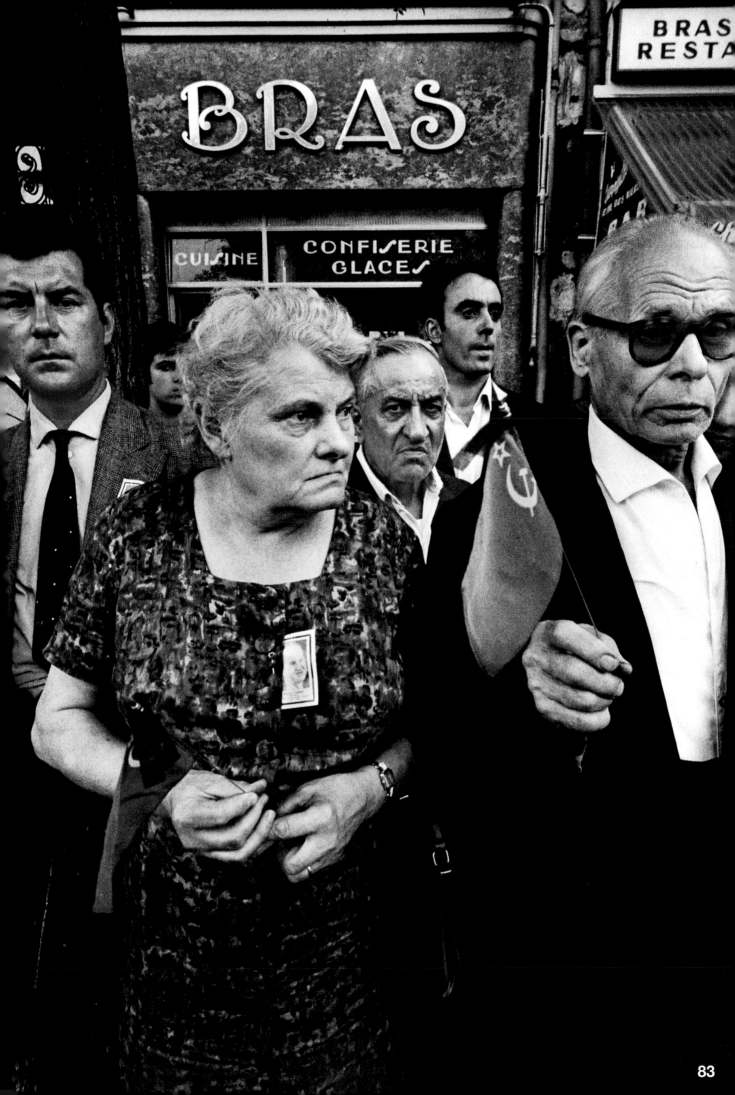

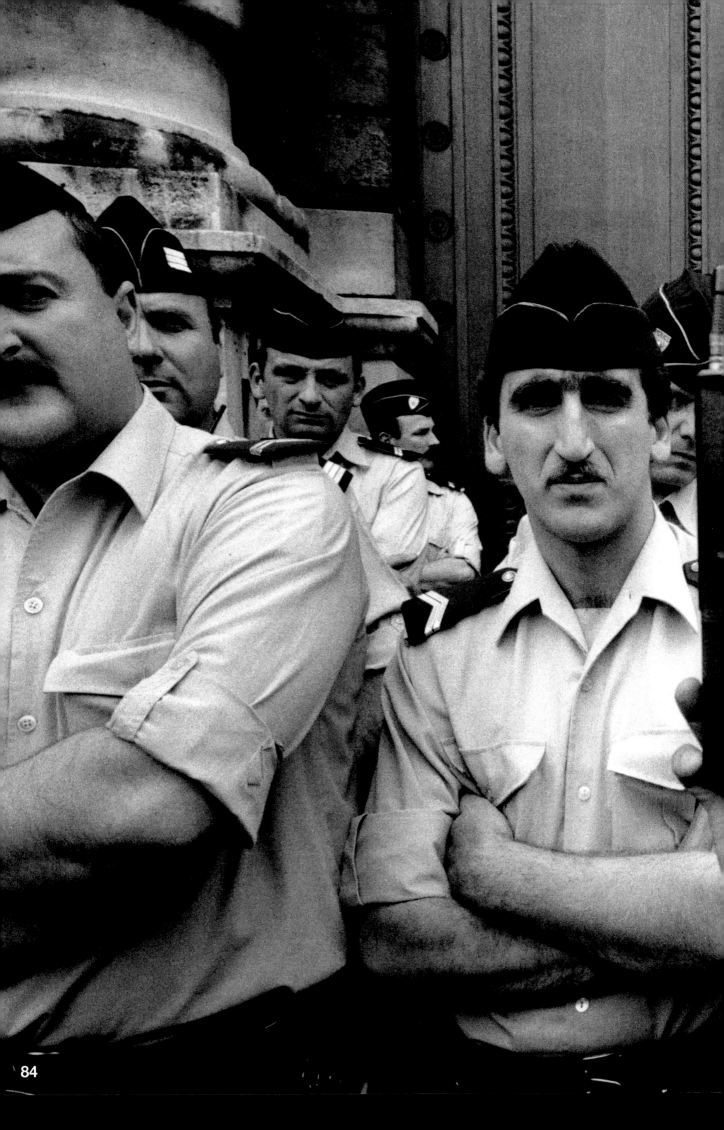

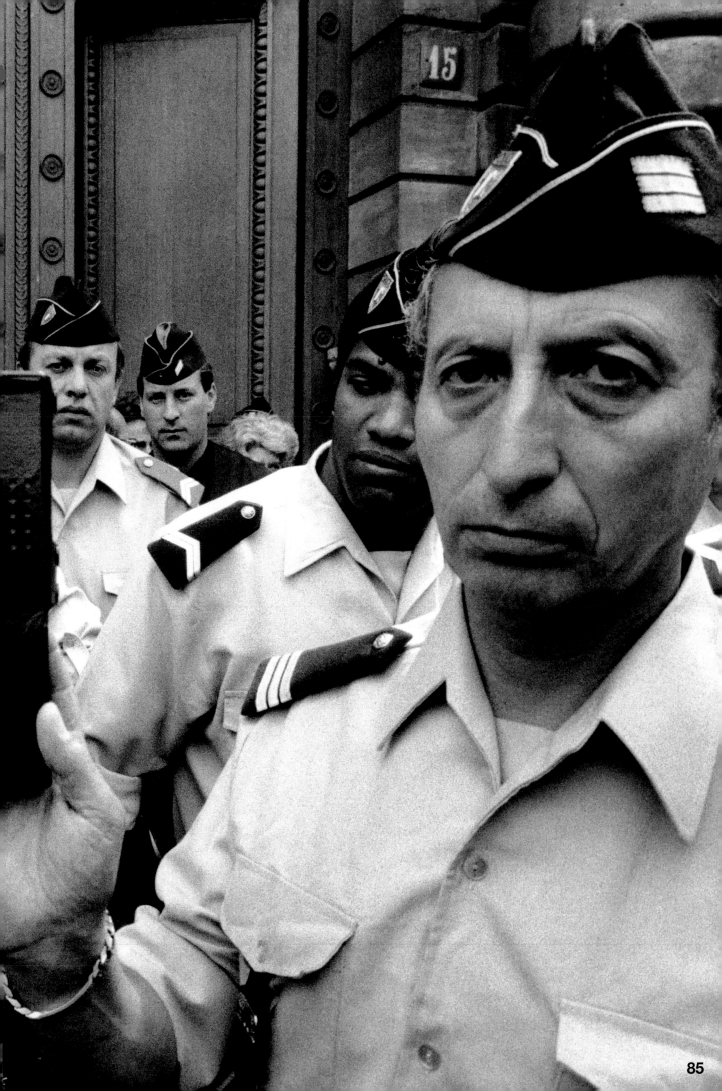

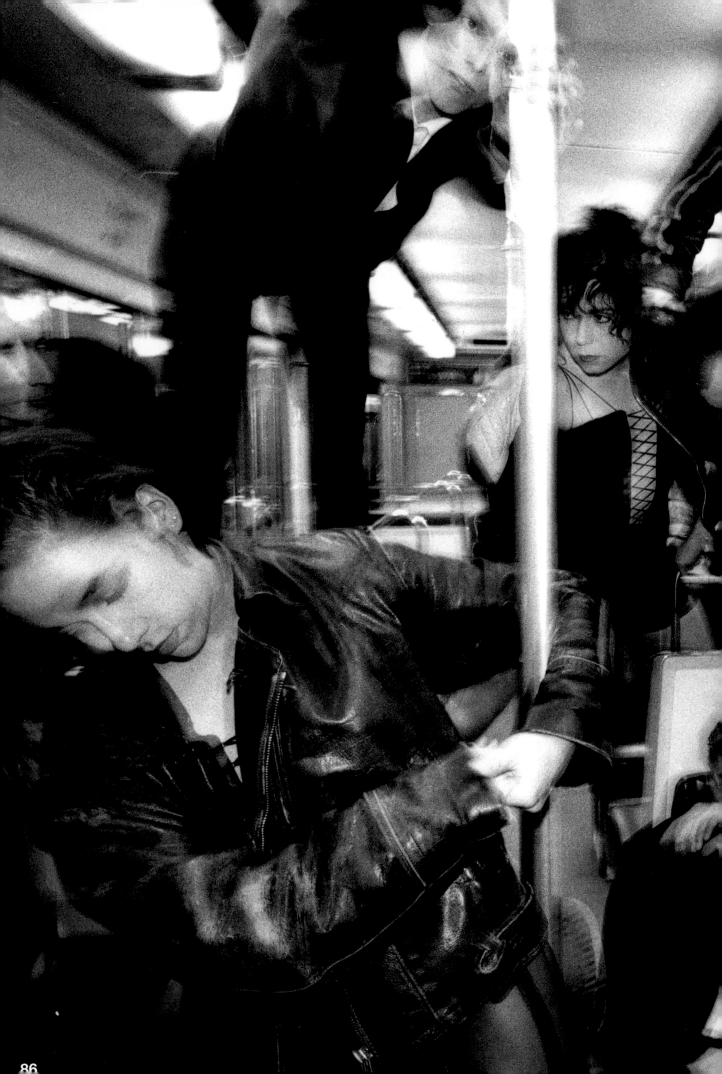

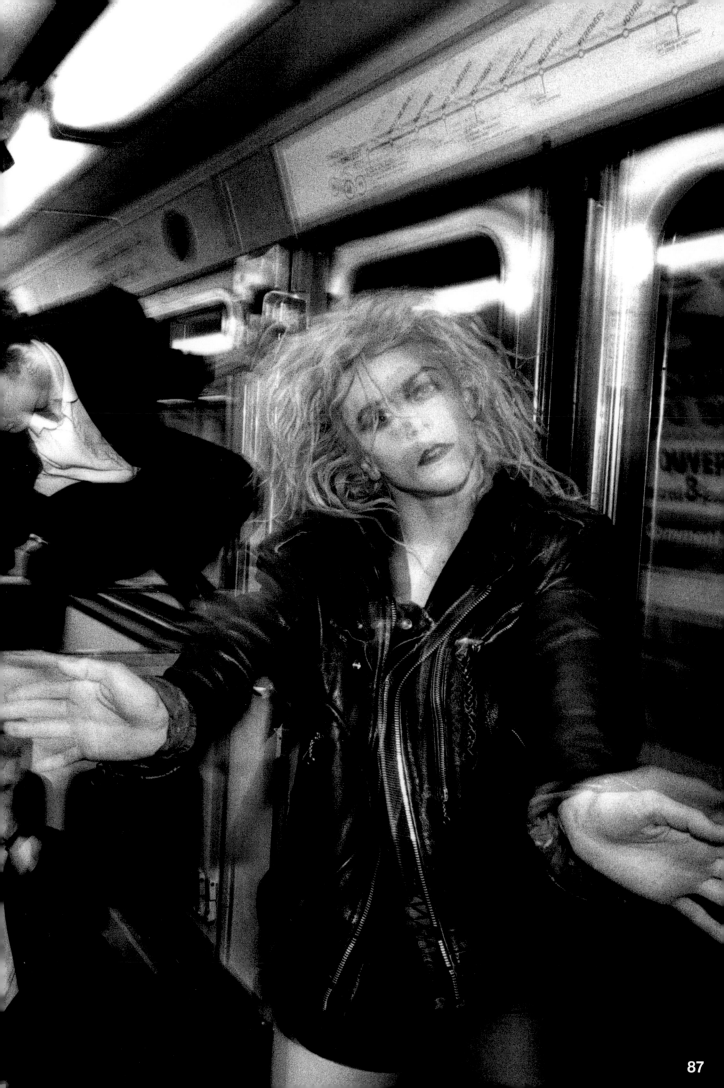

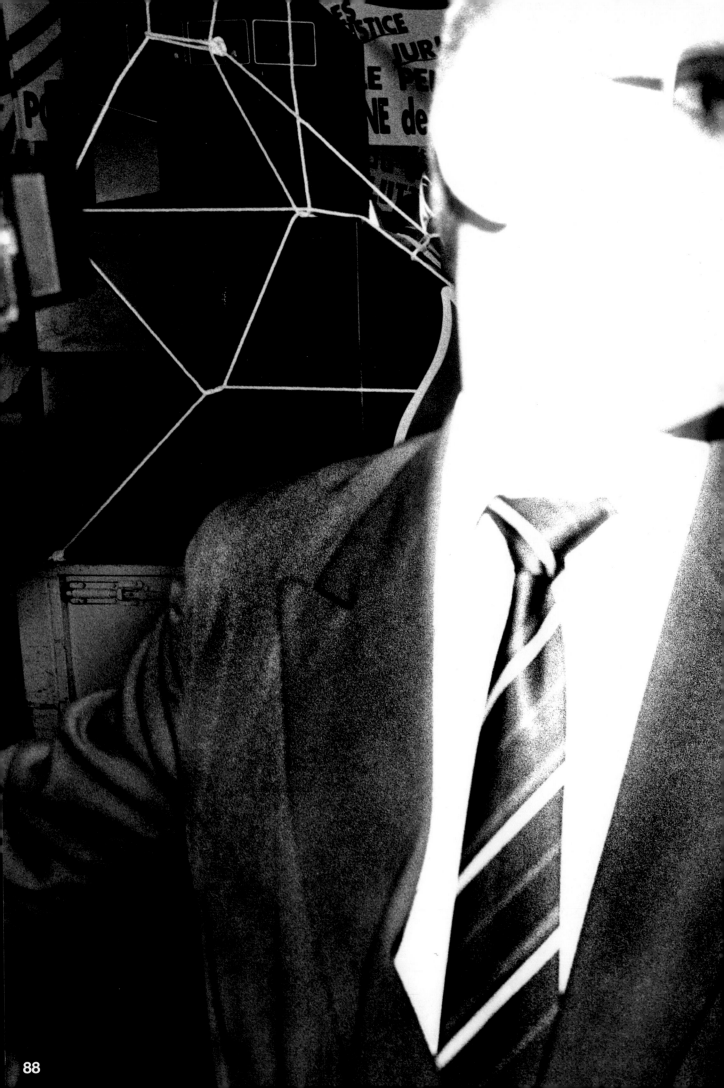

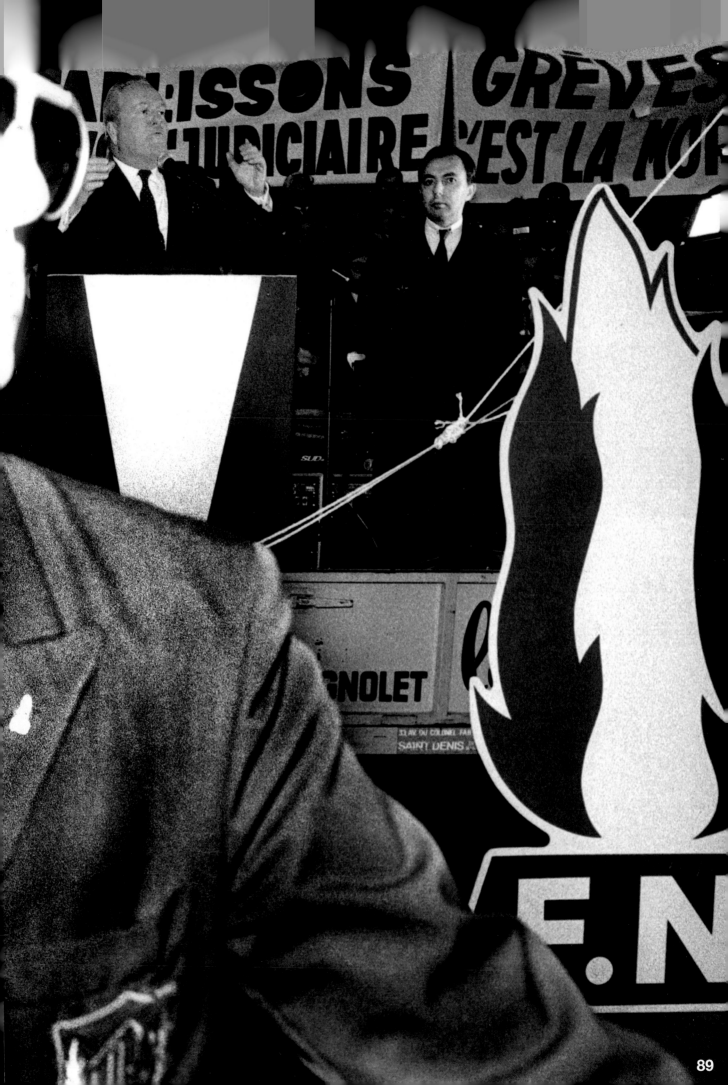

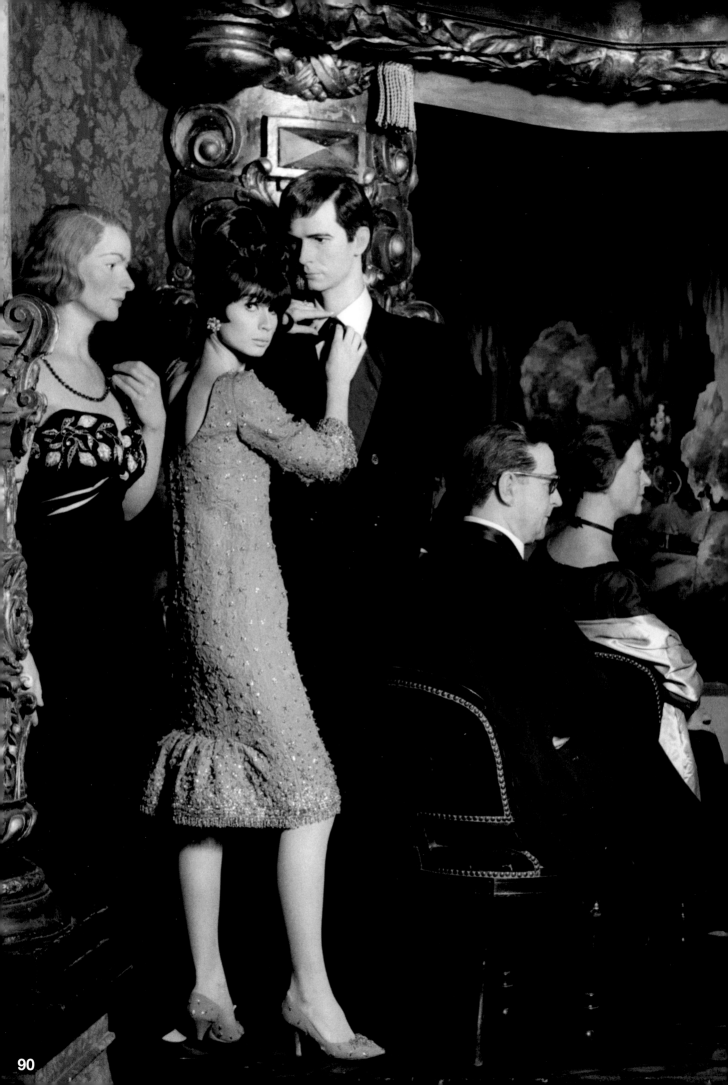

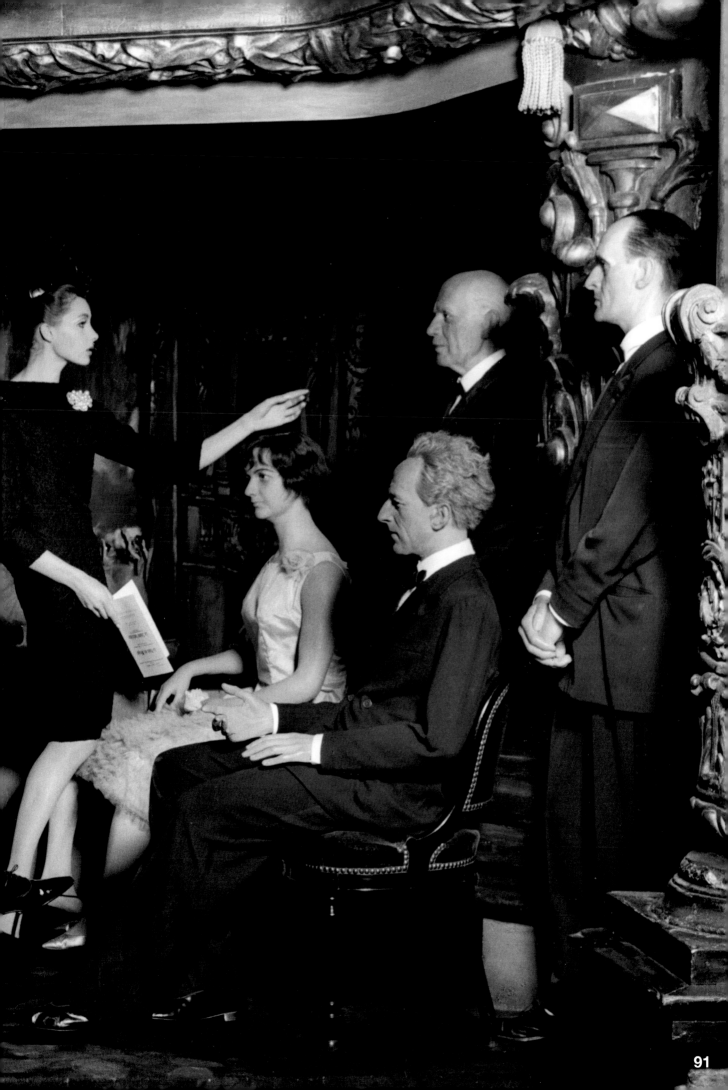

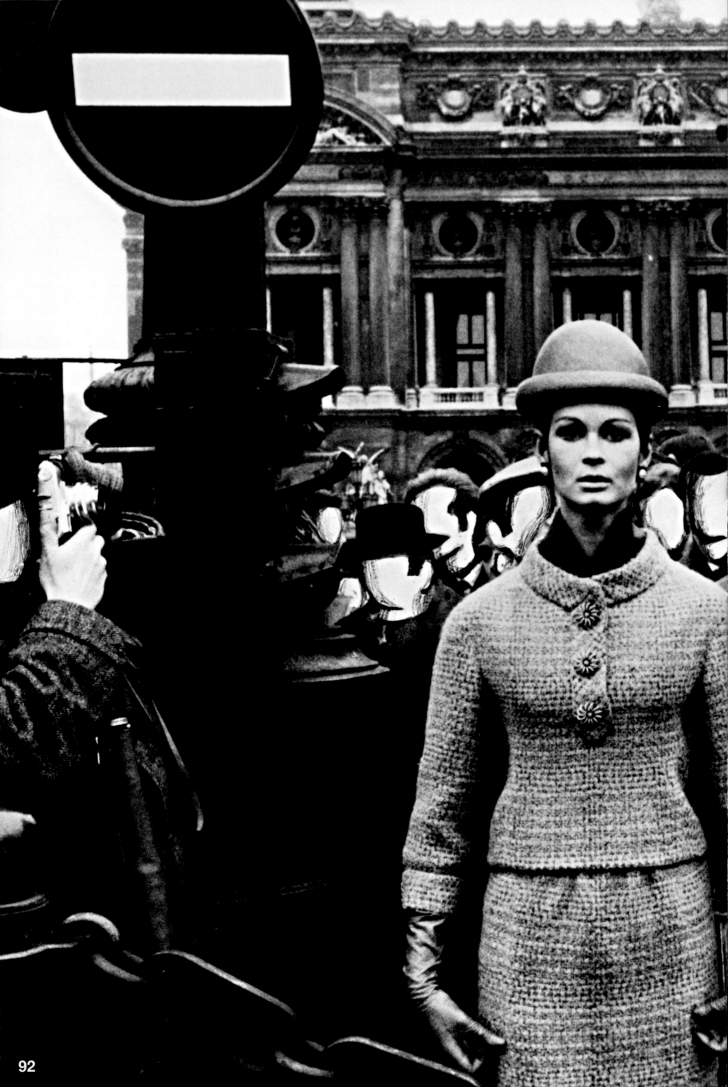

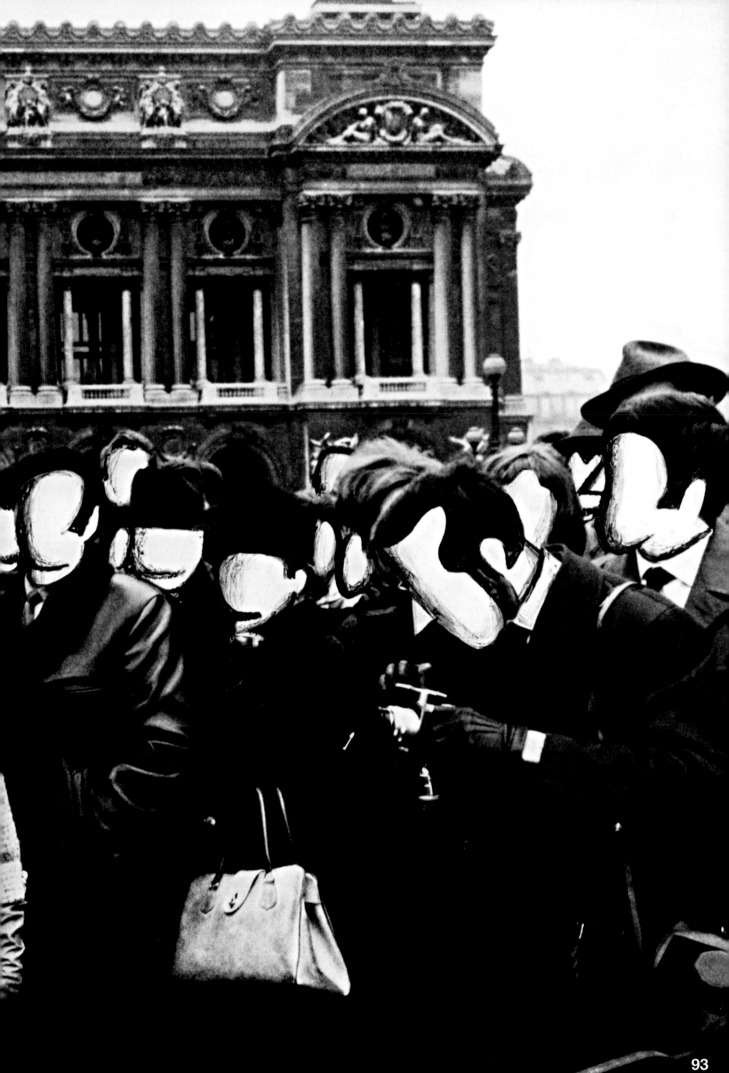

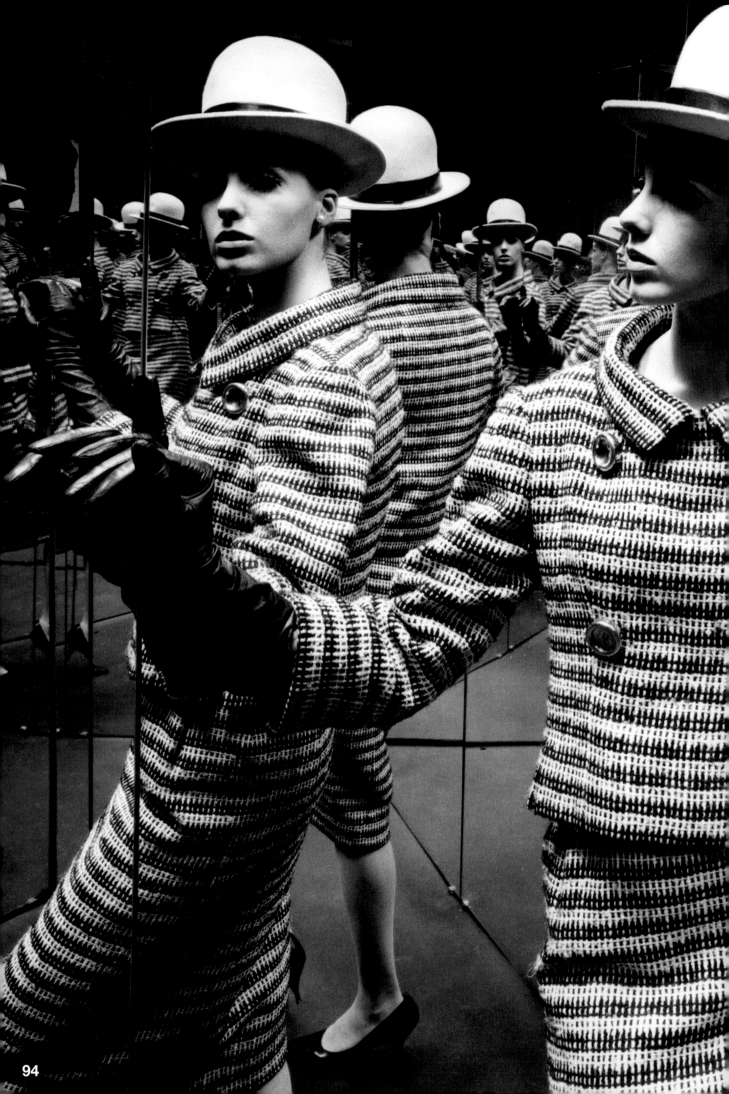

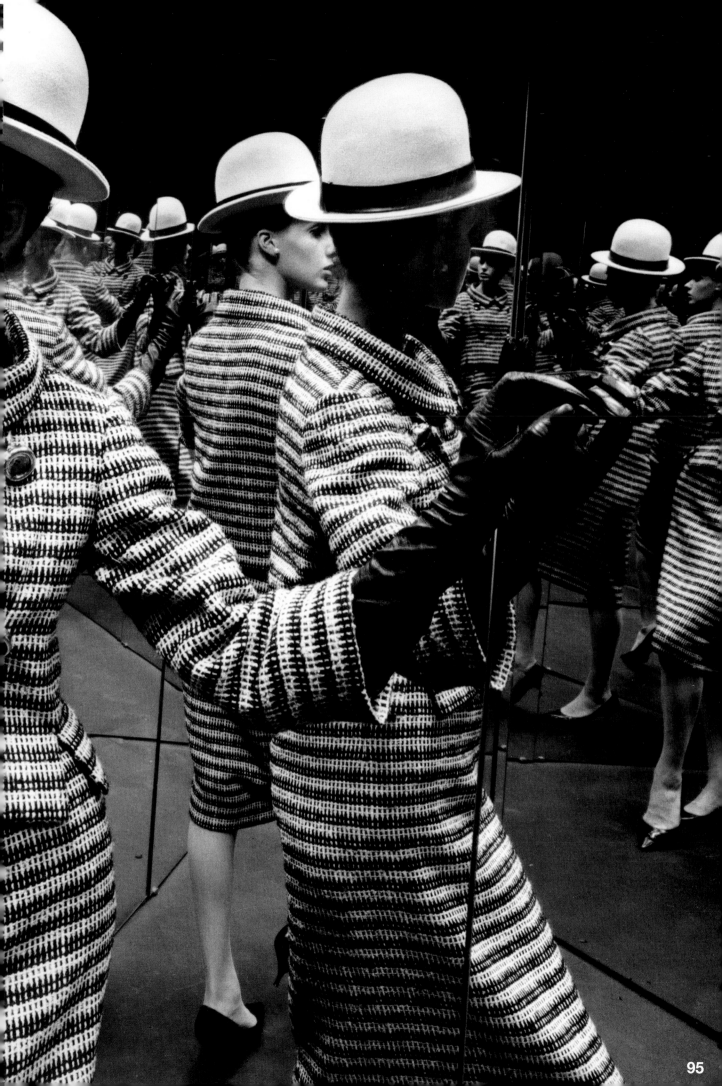

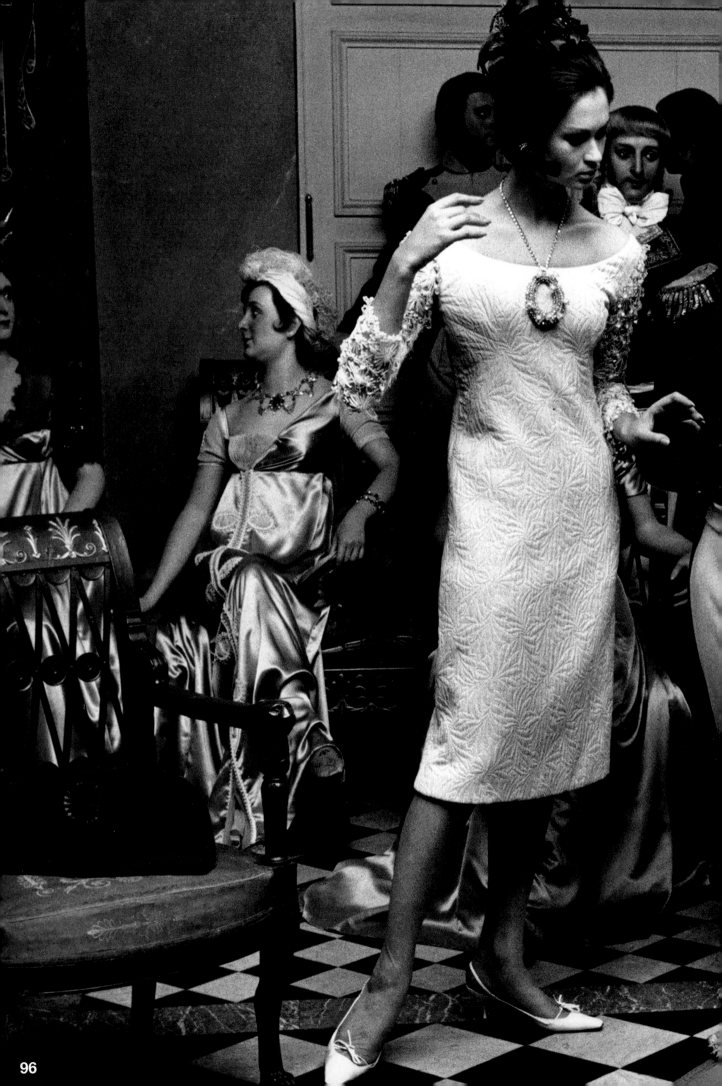

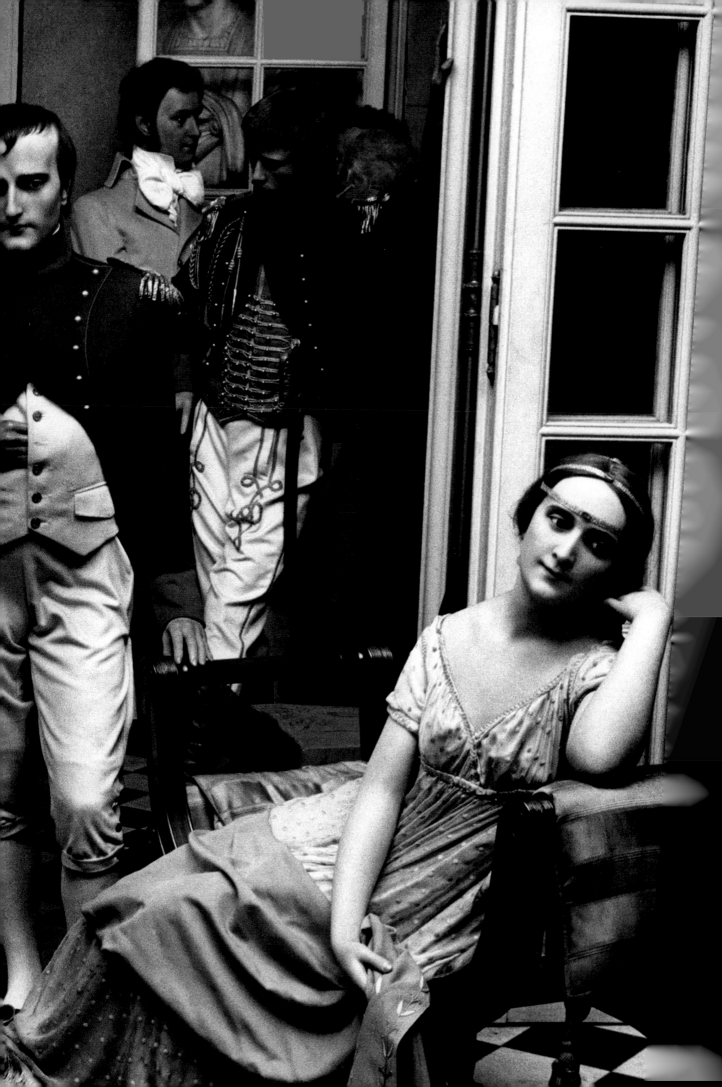

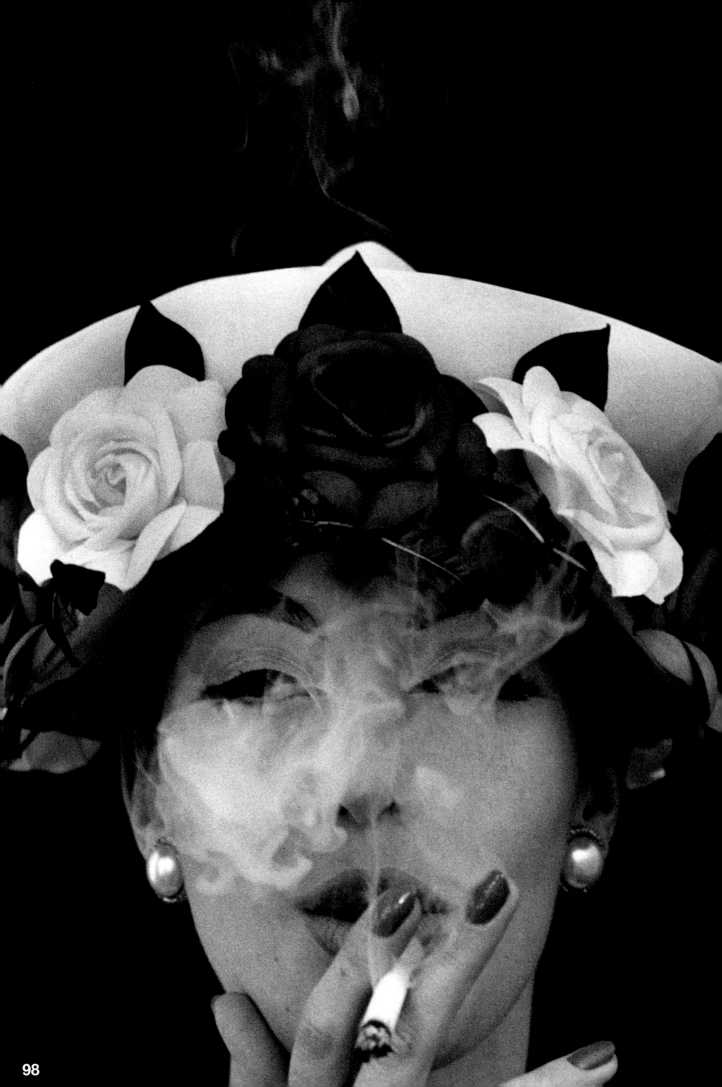

WILLIAM KLEIN

IN AND OUT OF FASHION

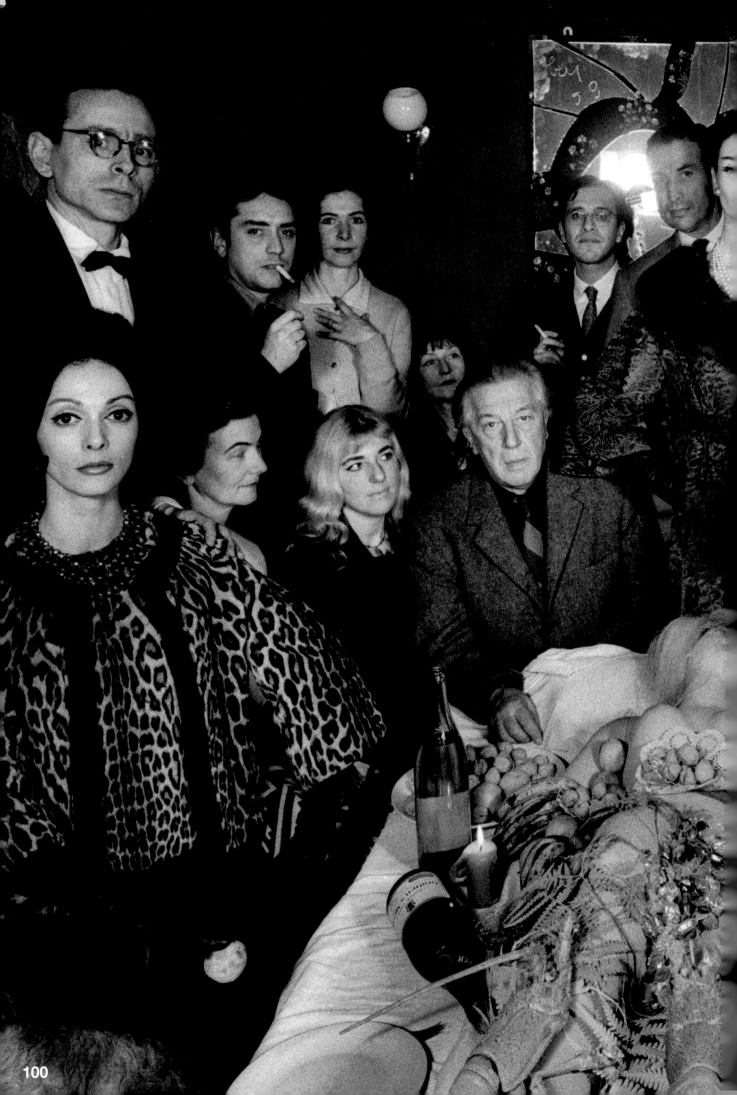

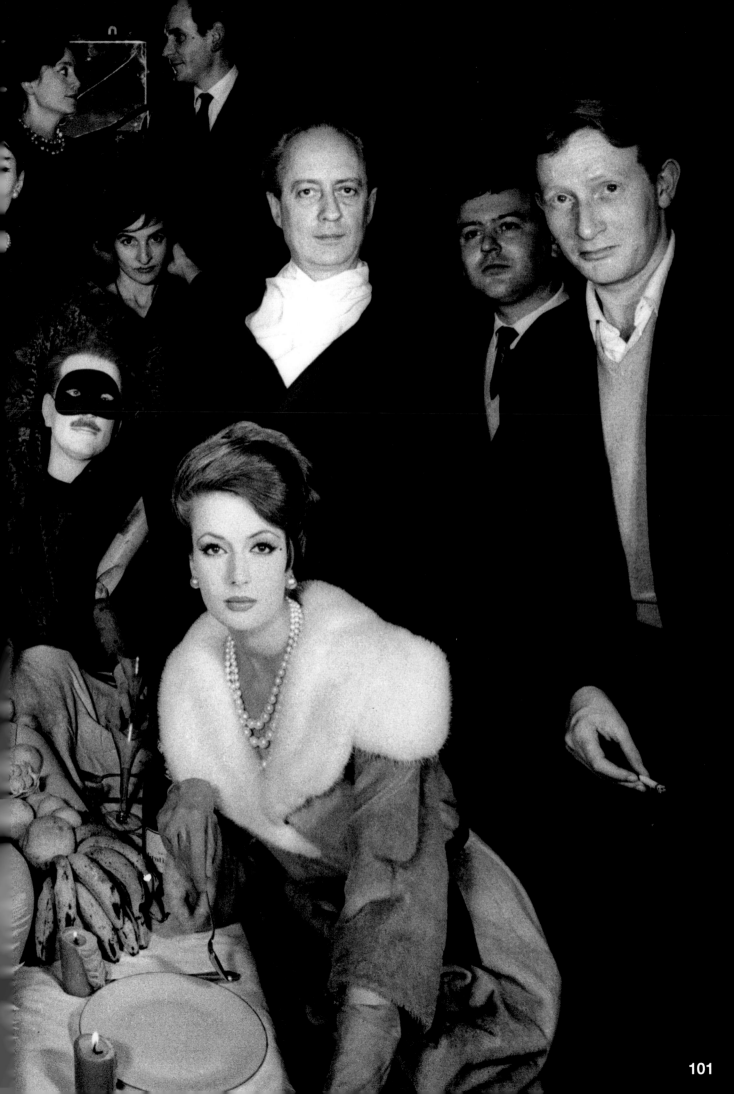

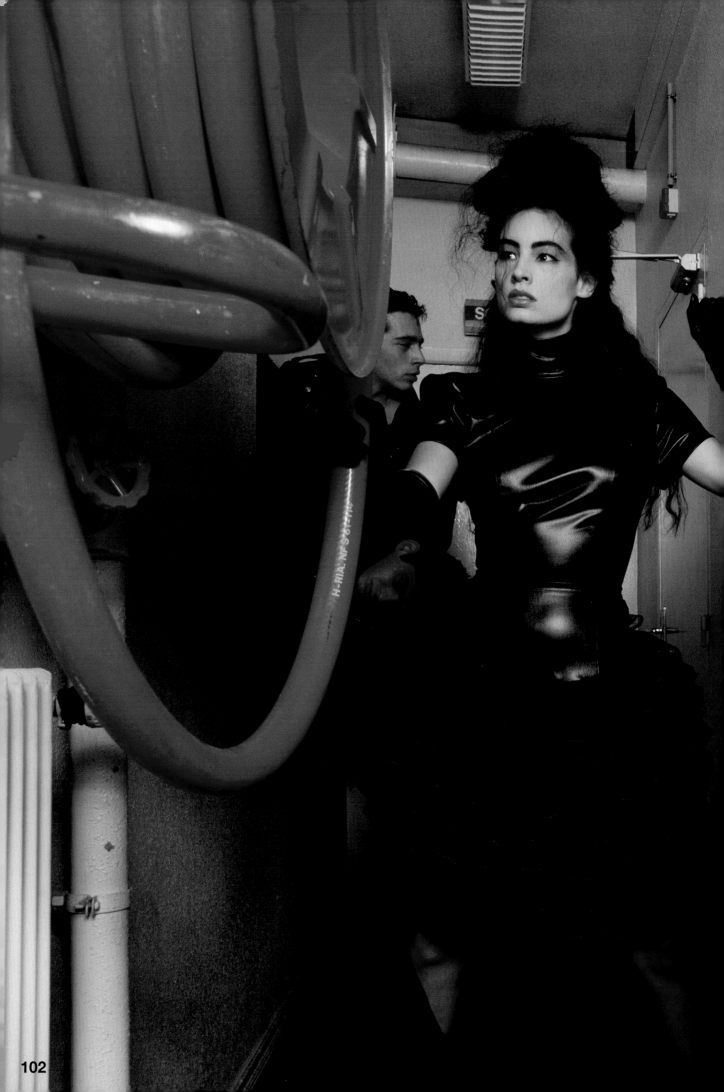

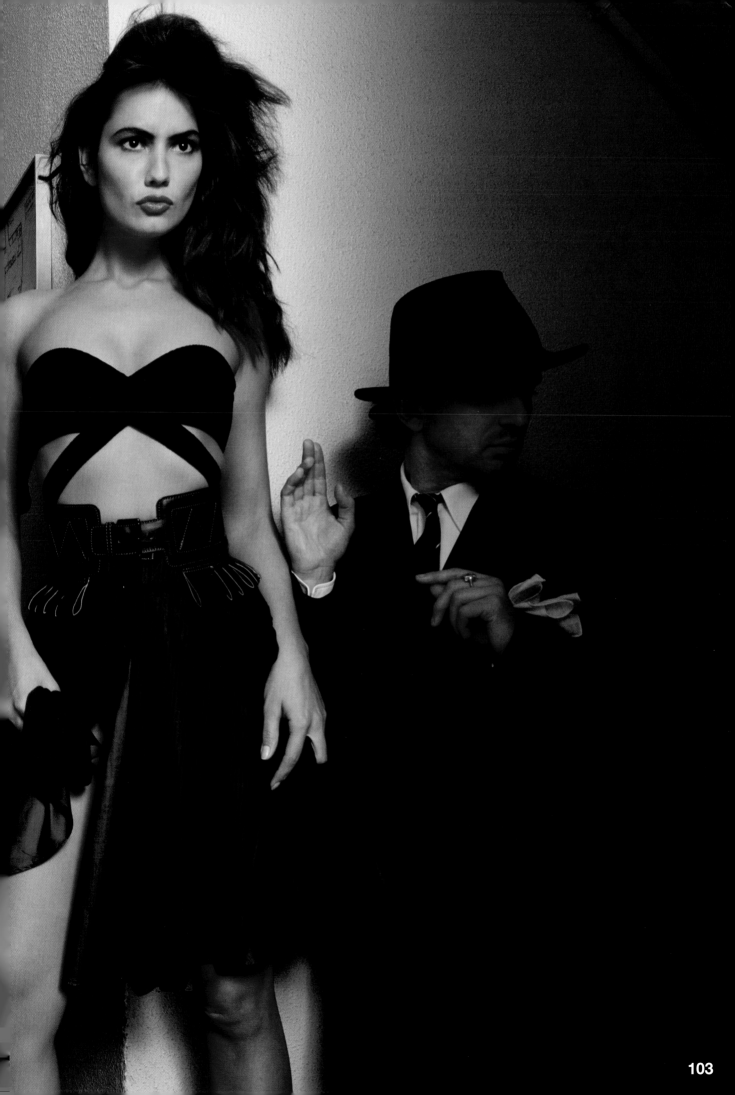

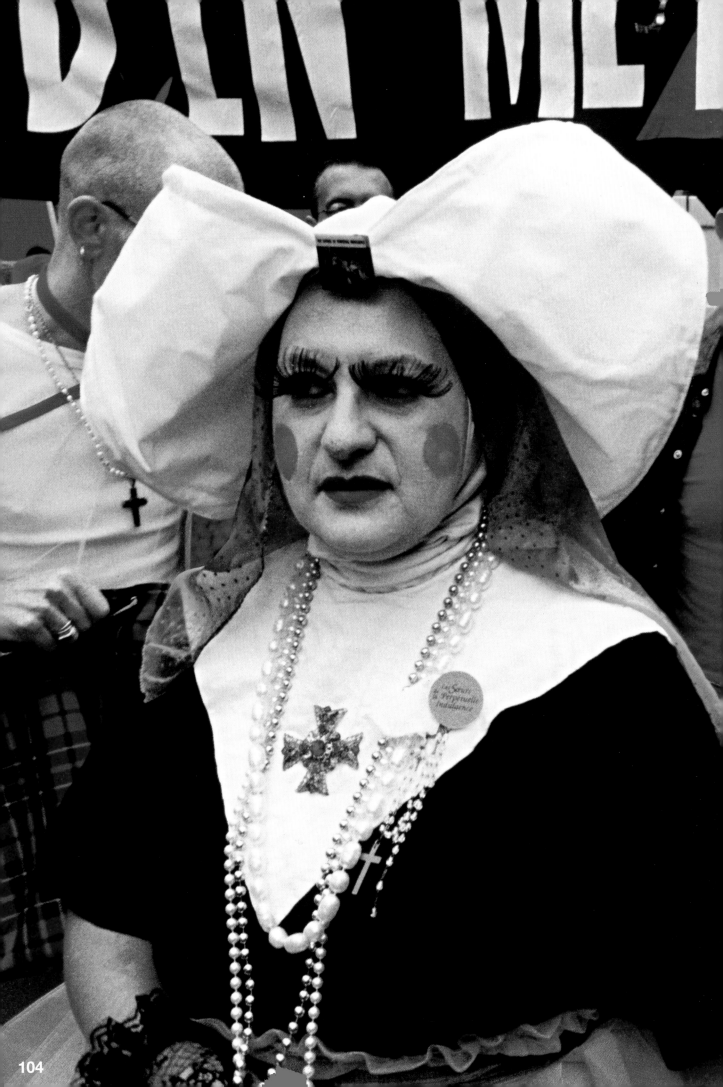

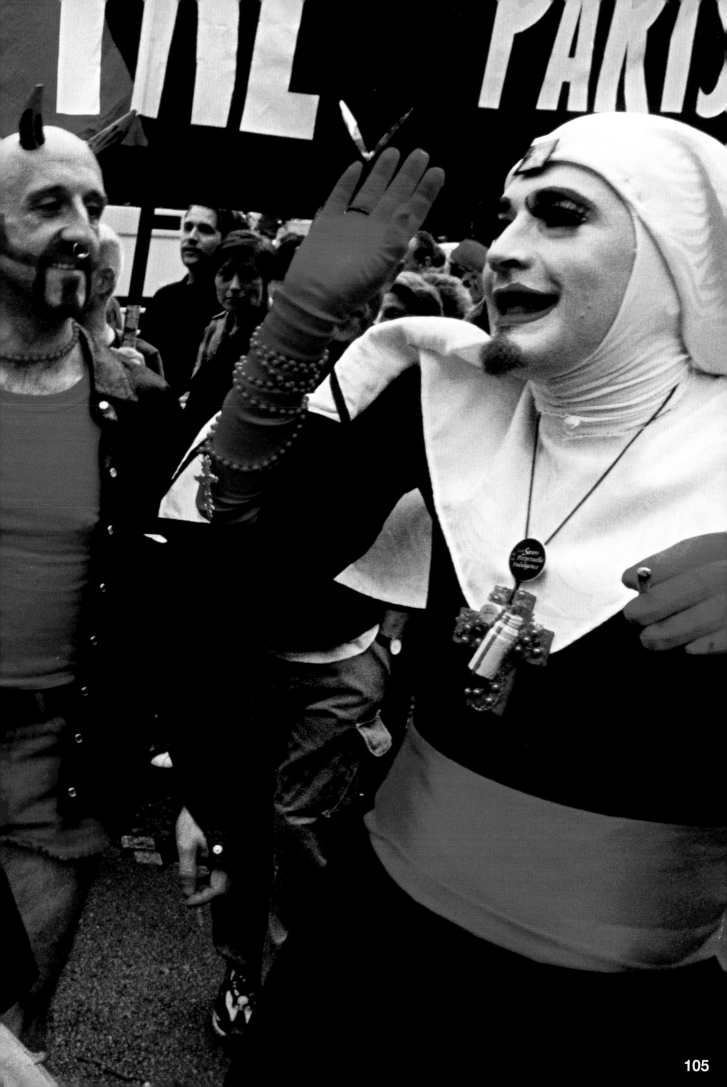

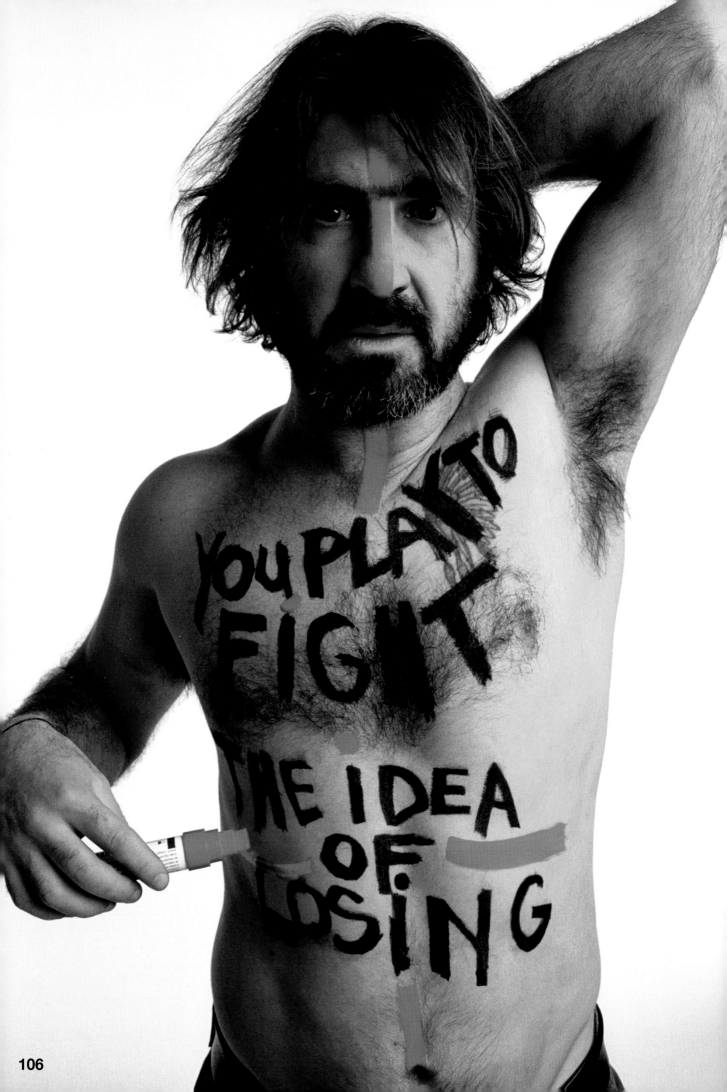

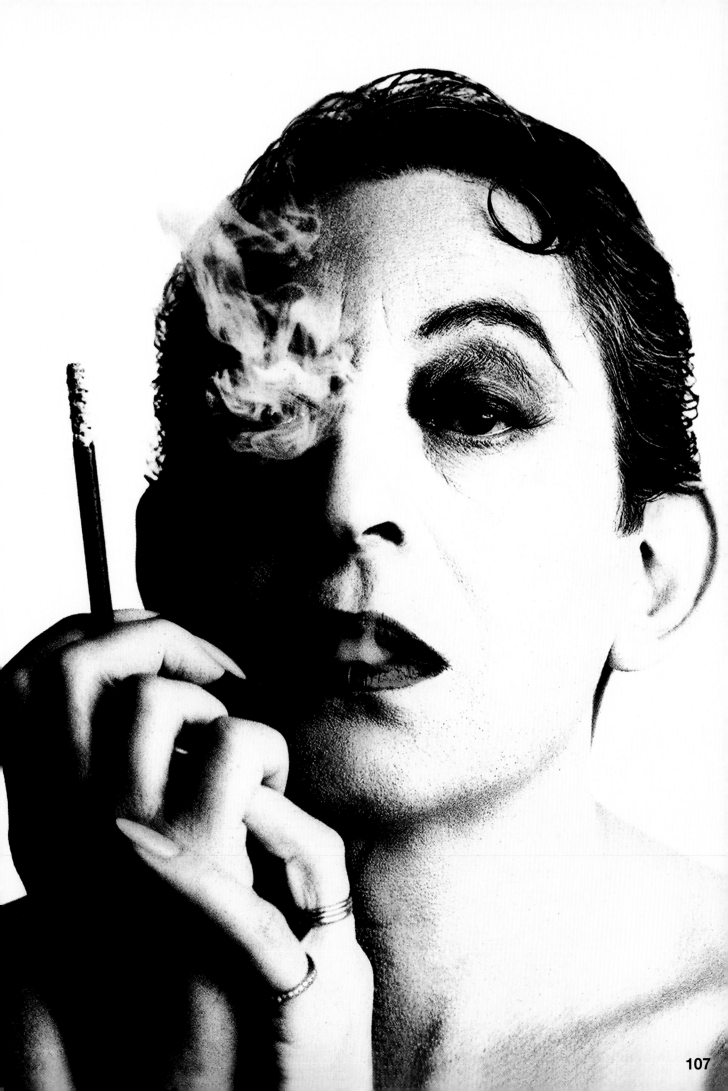

N&OUT OF FASHION
WILLIAM KLEIN

GRANDS SOIRS & PETITS MATINS.
-Mai 68 au Quartier Latin-

Un film de: William KLEIN.

Production: FILMS PARIS NEW YORK et l'INA

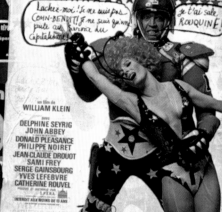

MISTER ★★★★★★
FREEDOM
★★★★★★★★★

un film de
WILLIAM KLEIN

avec
DELPHINE SEYRIG
JOHN ABBEY
DONALD PLEASANCE
PHILIPPE NOIRET
JEAN-CLAUDE DROUOT
SAMI FREY
SERGE GAINSBOURG
YVES LEFEBVRE
CATHERINE ROUVEL

INTERDIT AUX MOINS DE 13 ANS

The French
Les coups droits et les coulisses de Roland-Garros

un film de William Klein

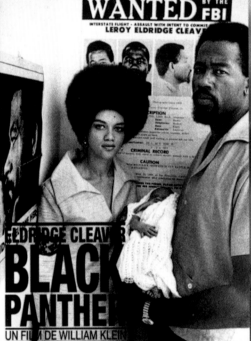

WANTED BY THE FBI
INTERSTATE FLIGHT - ASSAULT WITH INTENT TO COMMIT
LEROY ELDRIDGE CLEAVER

ELDRIDGE CLEAVER
BLACK PANTHER
UN FILM DE WILLIAM KLEIN

MUHAMMAD
ALI
THE GREATEST
1964.74

un film de WILLIAM KLEIN

Le Couple Témoin
un film de
William Klein

L'ONCIC PRESENTE
FES
TI
VAL
PANAFRICAIN
D'ALGER

un film de
WILLIAM
KLEIN

URSULINES DISTRIBUTION

Qui êtes-vous Polly Maggoo ?

UN FILM DE WILLIAM KLEIN
AVEC
DOROTHY MAC GOWAN
JEAN ROCHEFORT SAMI FREY
GRAYSON HALL
AVEC LA PARTICIPATION DE
PHILIPPE NOIRET ET
ALICE SAPRITCH
MUSIQUE DE MICHEL LEGRAND
DELPIRE PRODUCTIONS

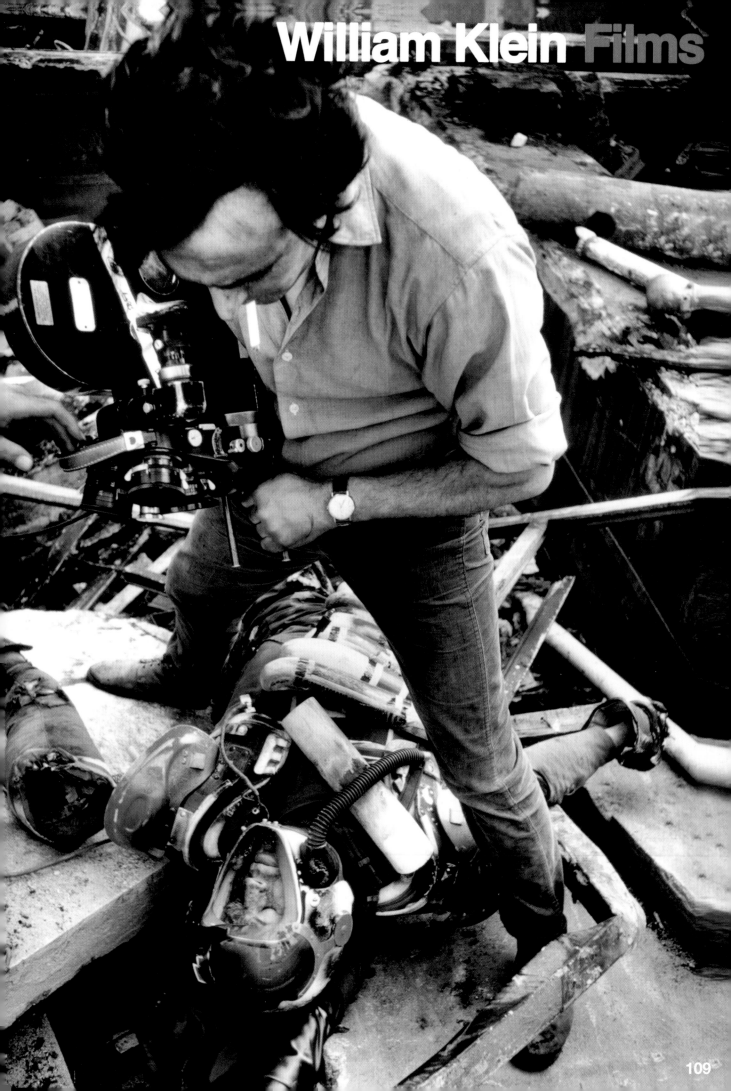

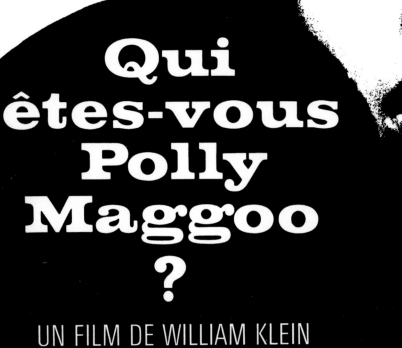

Qui êtes-vous Polly Maggoo ?

UN FILM DE WILLIAM KLEIN
AVEC
DOROTHY MAC GOWAN
JEAN ROCHEFORT SAMI FREY
GRAYSON HALL
AVEC LA PARTICIPATION DE
PHILIPPE NOIRET ET
ALICE SAPRITCH
MUSIQUE DE MICHEL LEGRAND
DELPIRE PRODUCTIONS

Who Are You, Polly Maggoo ?
written and directed by William Klein
produced by Robert Delpire

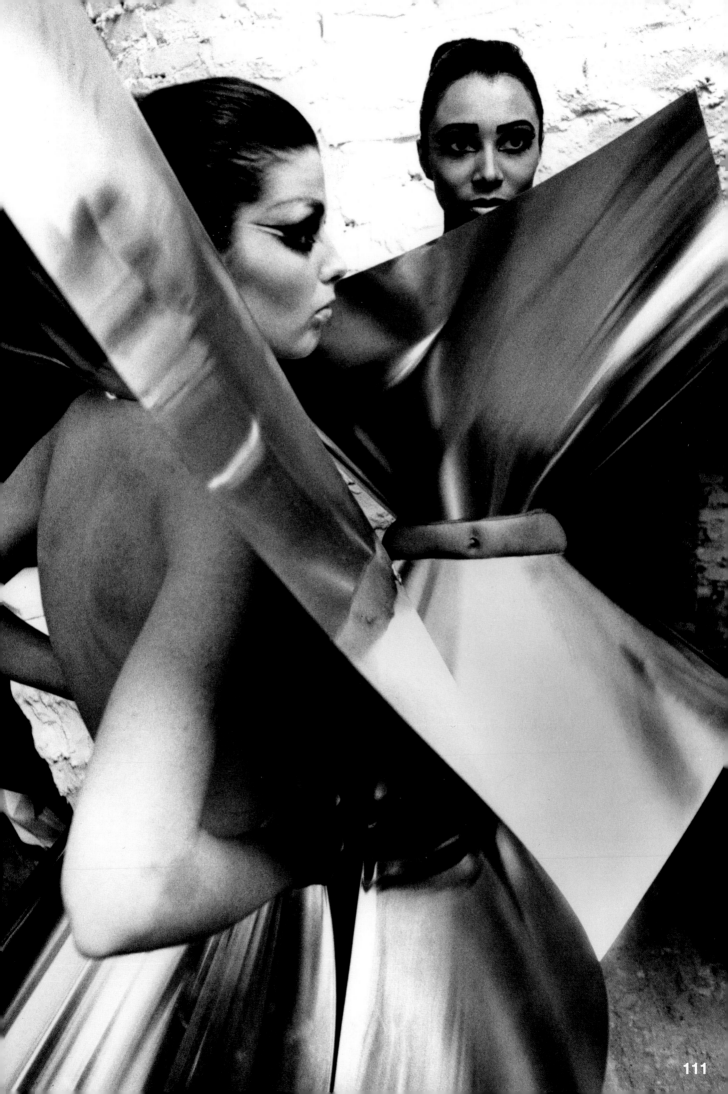

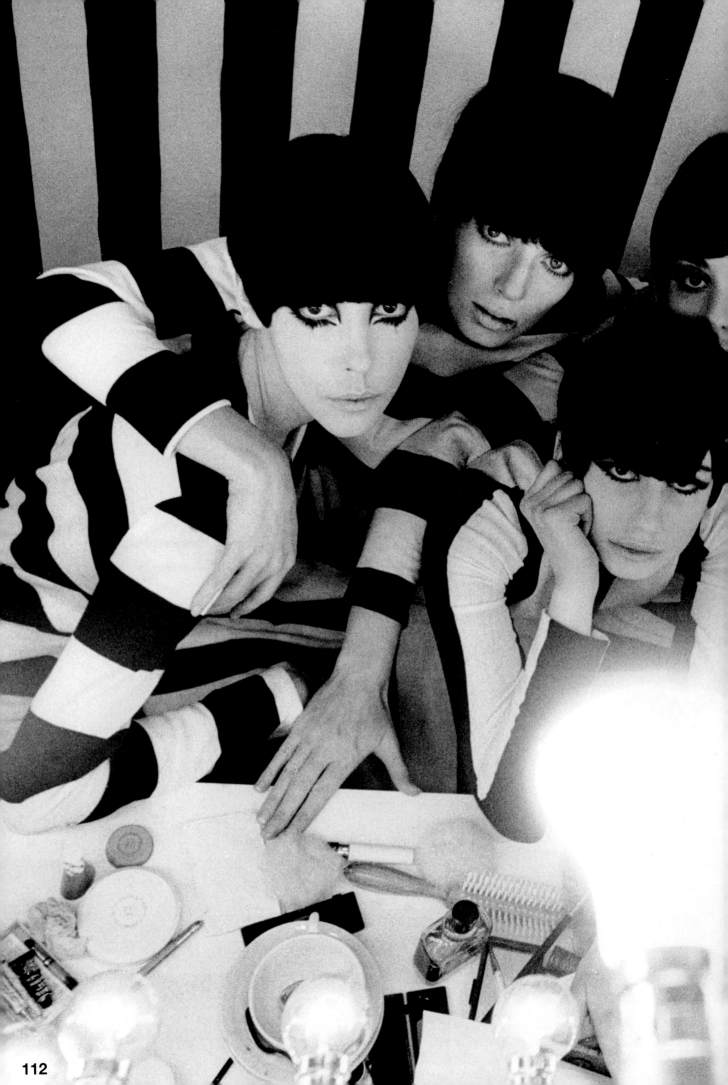

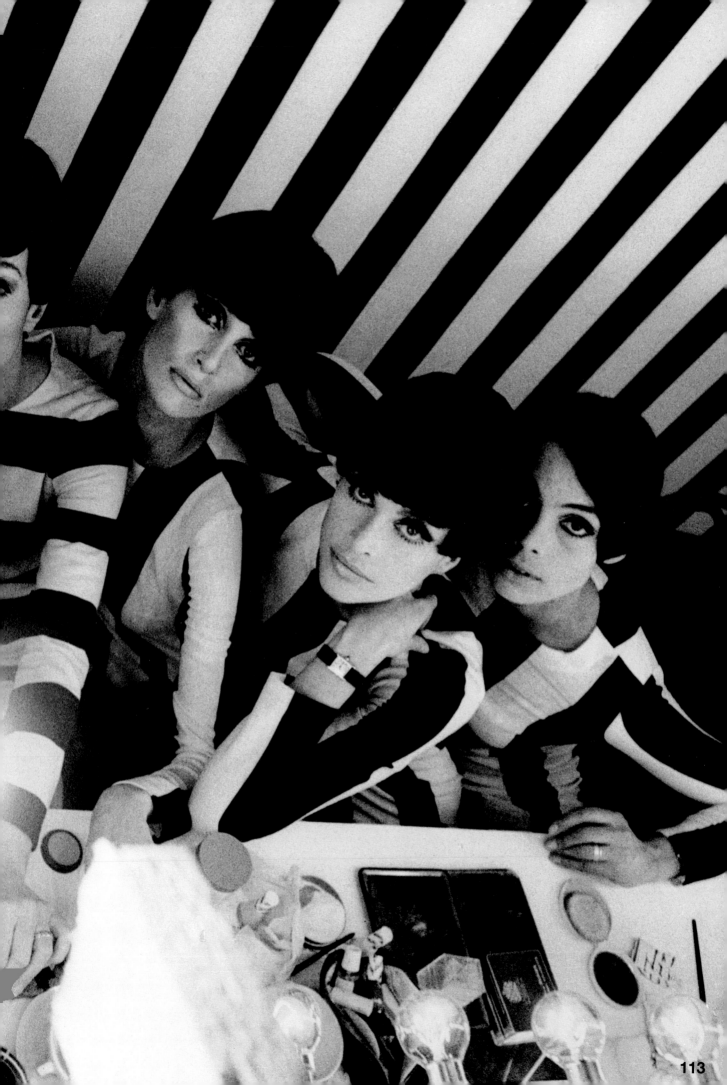

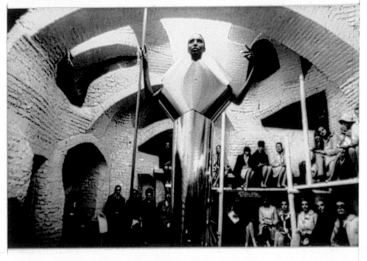

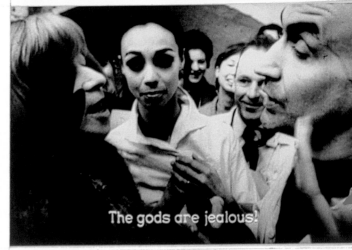

The gods are jealous!

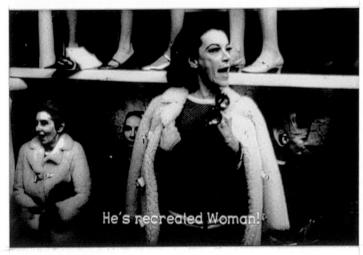

He's recreated Woman!

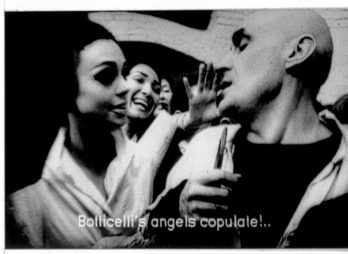

Botticelli's angels copulate!..

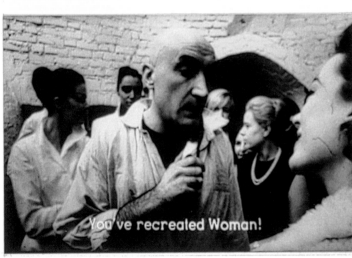

You've recreated Woman!

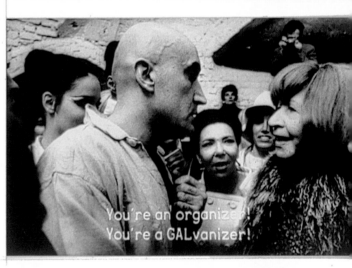

You're an organizer!
You're a GALvanizer!

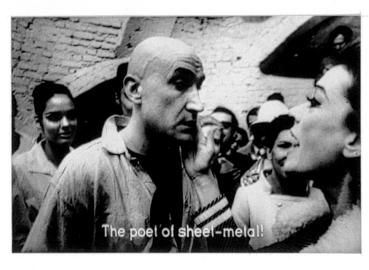

The poet of sheet-metal!

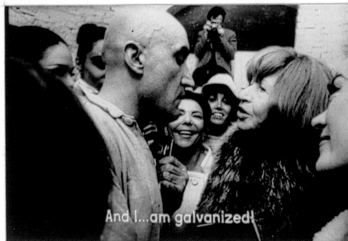

And I...am galvanized!

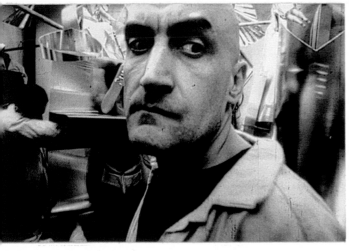

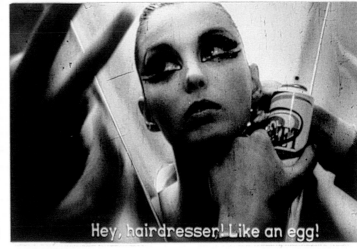
Hey, hairdresser! Like an egg!

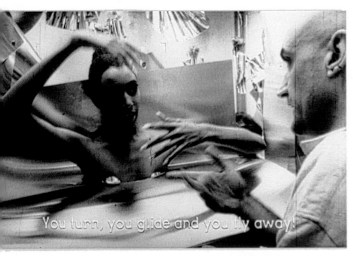
You turn, you glide and you fly away!

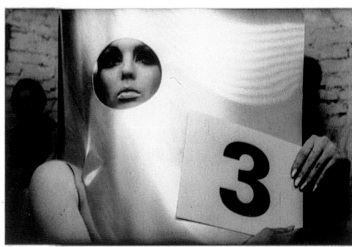

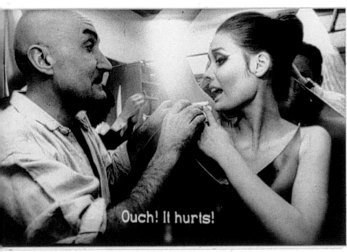
Ouch! It hurts!

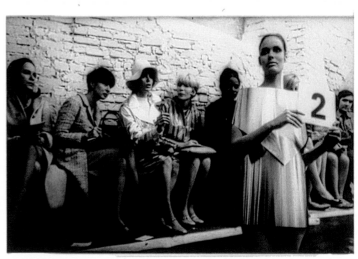

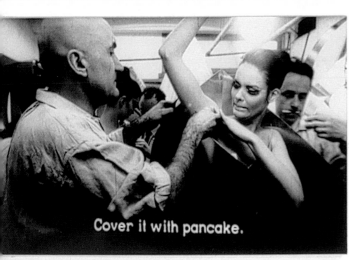
Cover it with pancake.

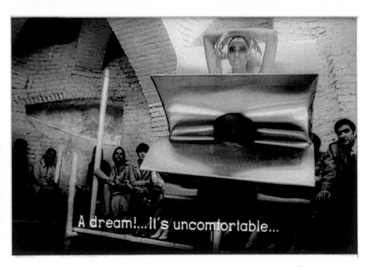
A dream!...It's uncomfortable...

115

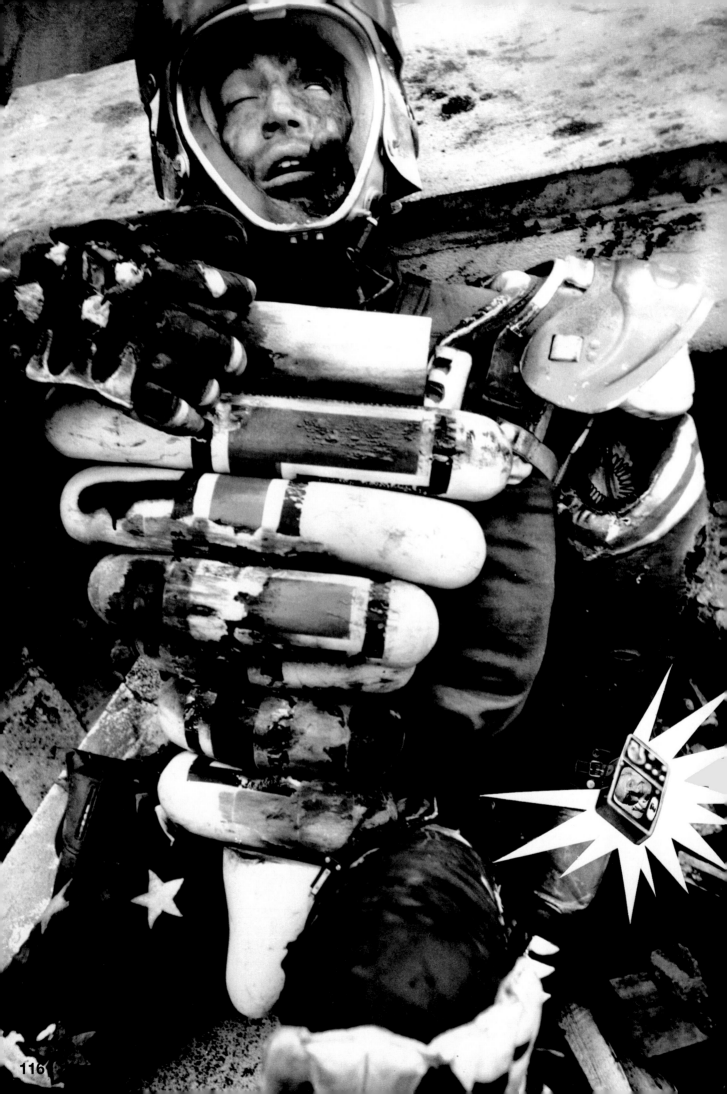

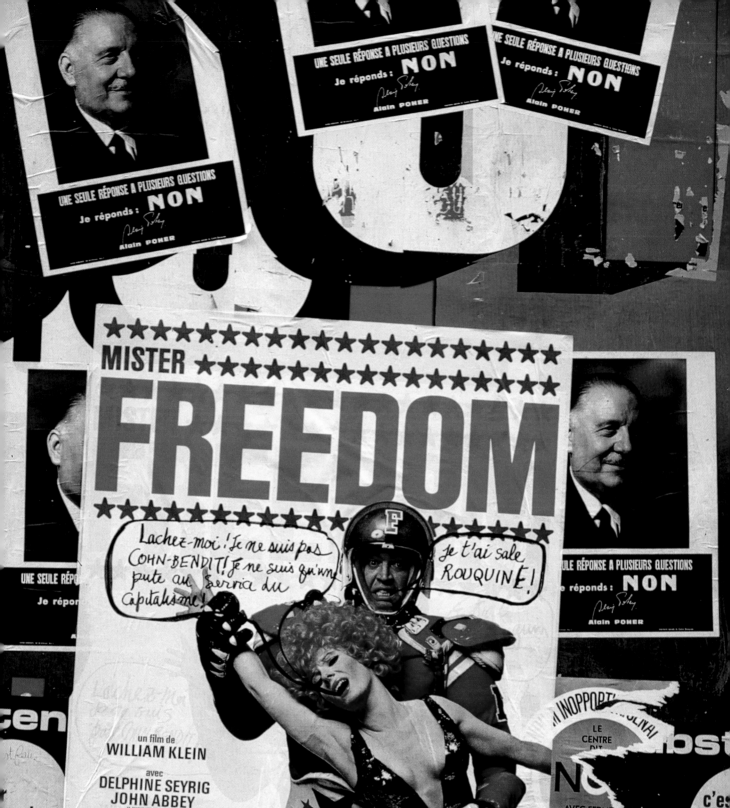

philippe NOIRET

sami FREY

catherine ROUVEL

delphine SEYRIG

john ABBEY

donald PLEASANCE

jean-claude DROUOT
serge GAINSBOURG
yves LEFEVRE
RUFUS

119

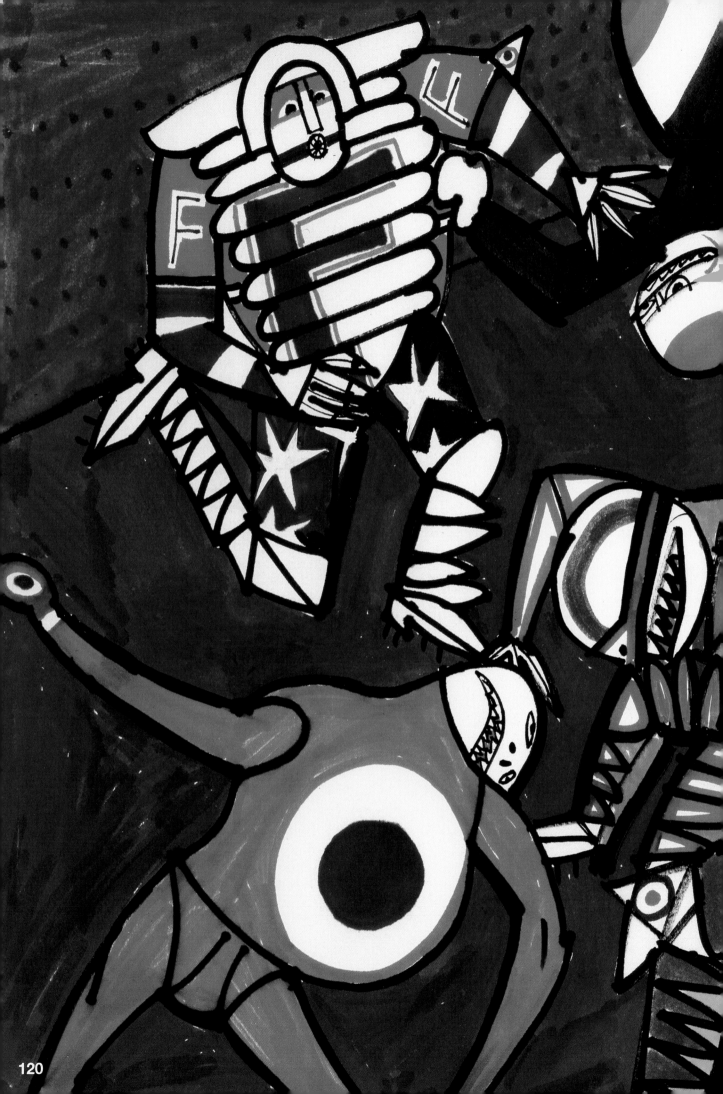

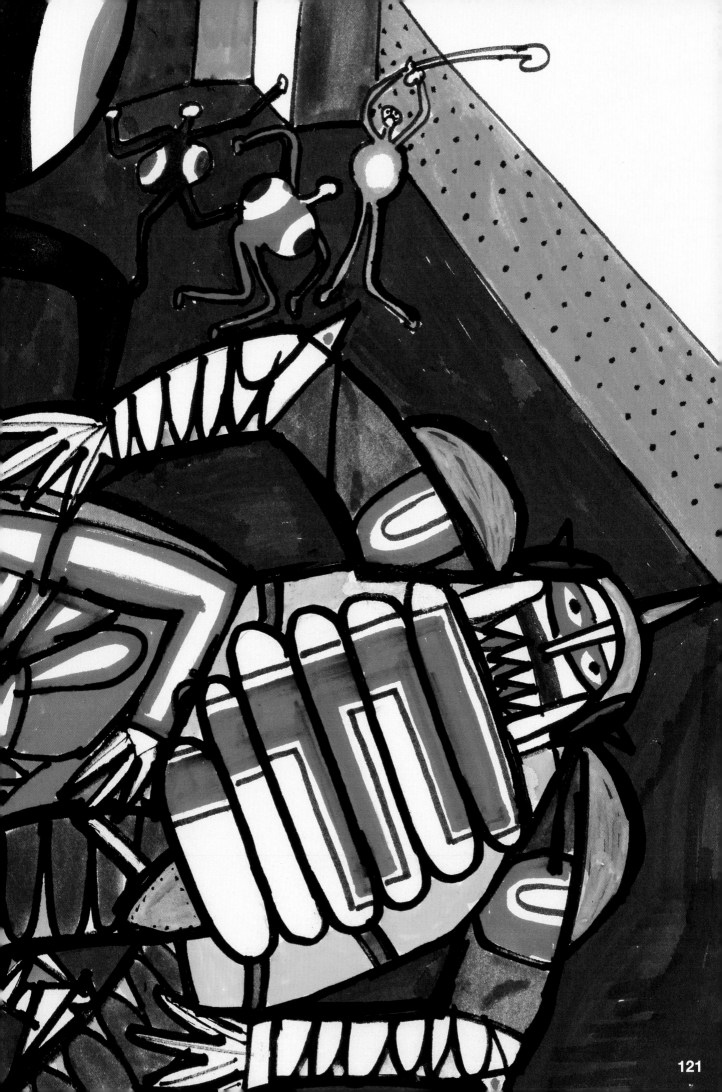

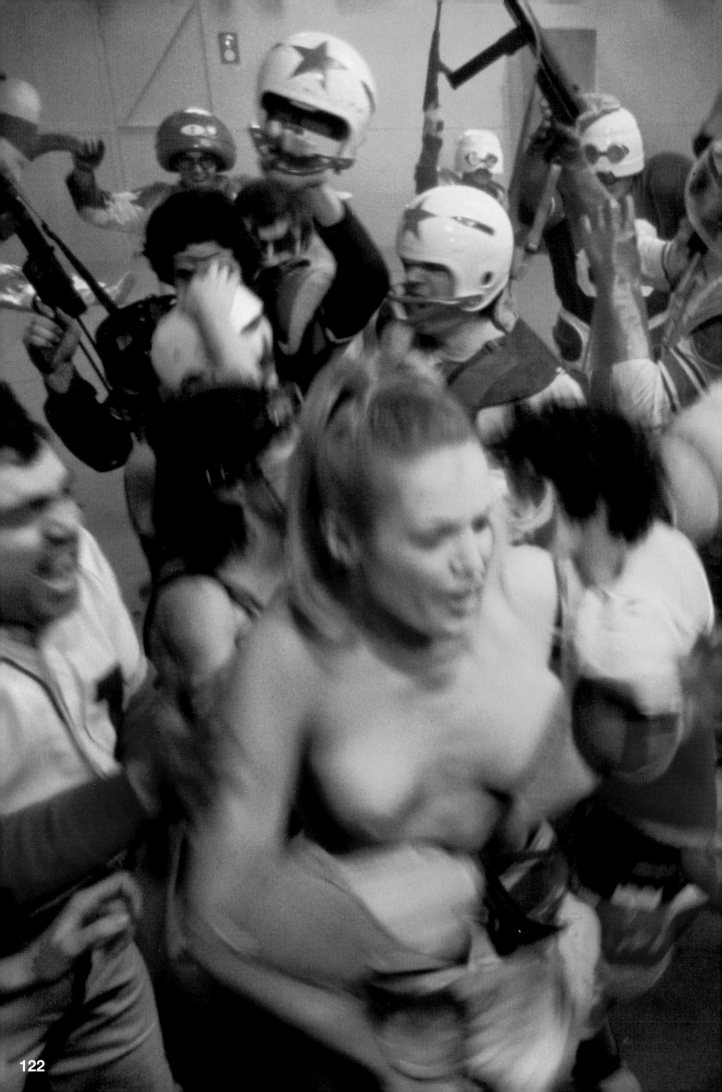

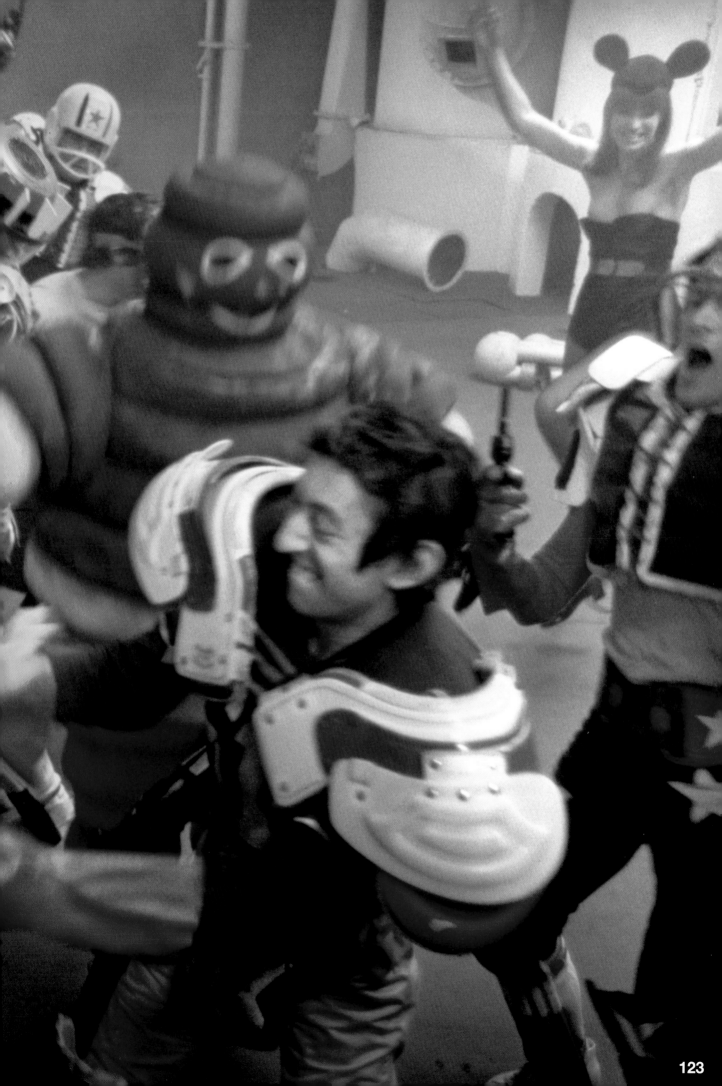

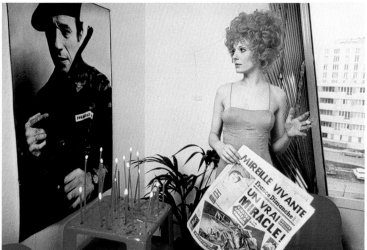

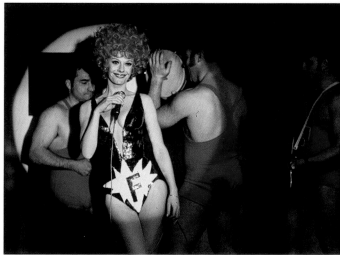

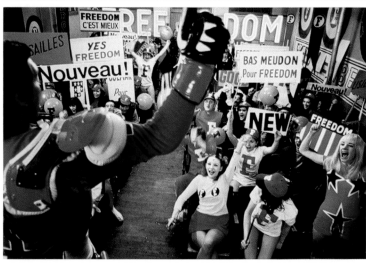

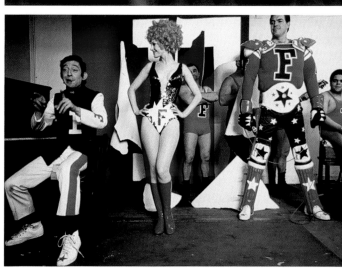

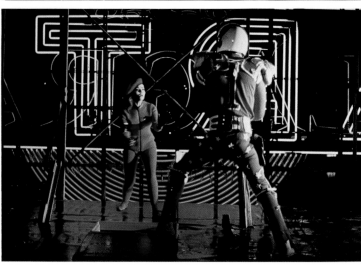

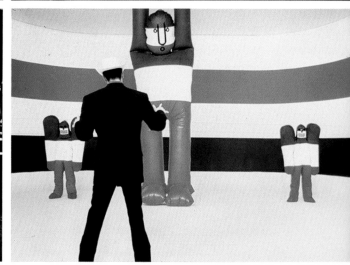

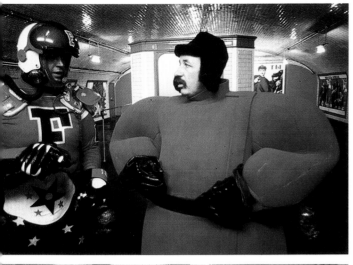
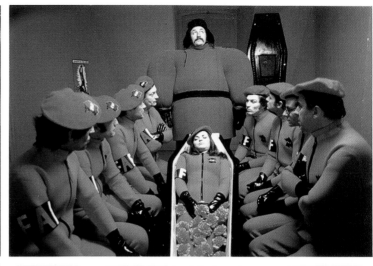
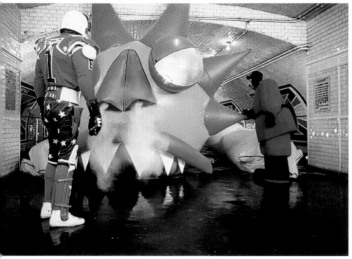
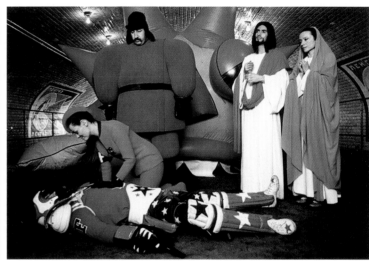
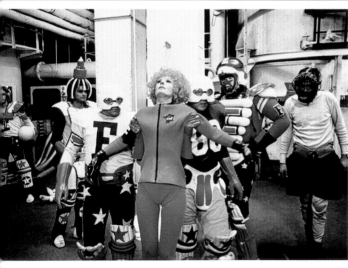
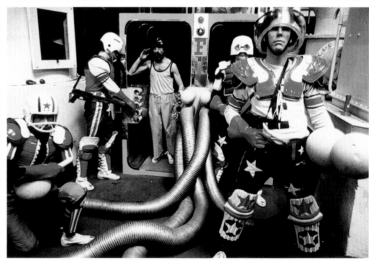
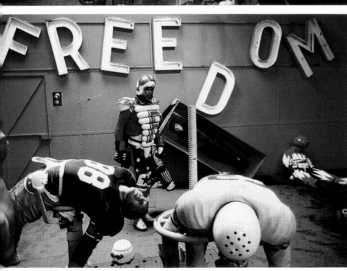
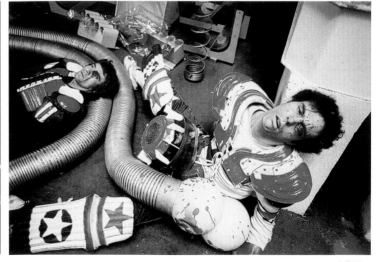

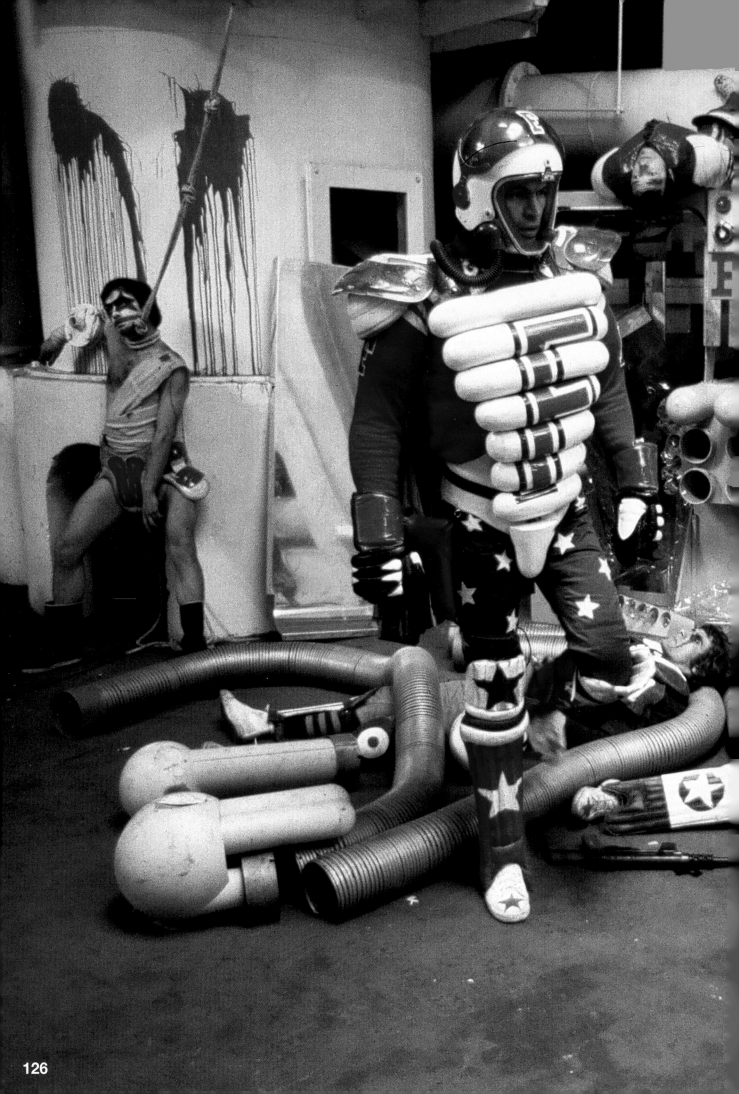

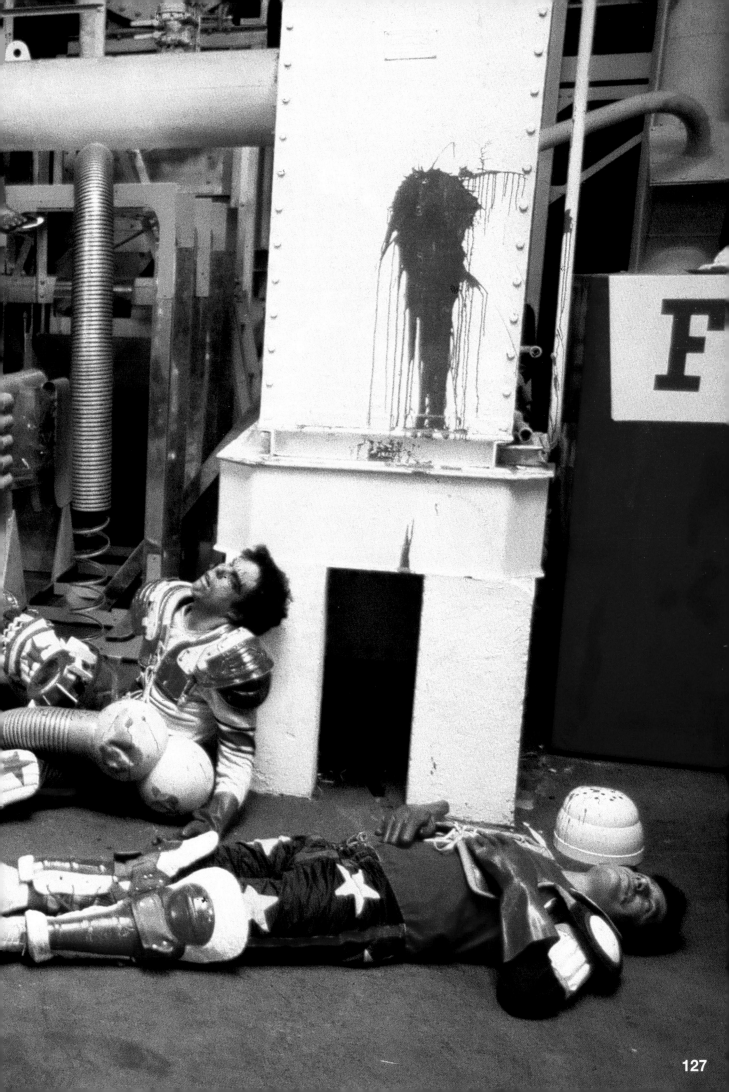

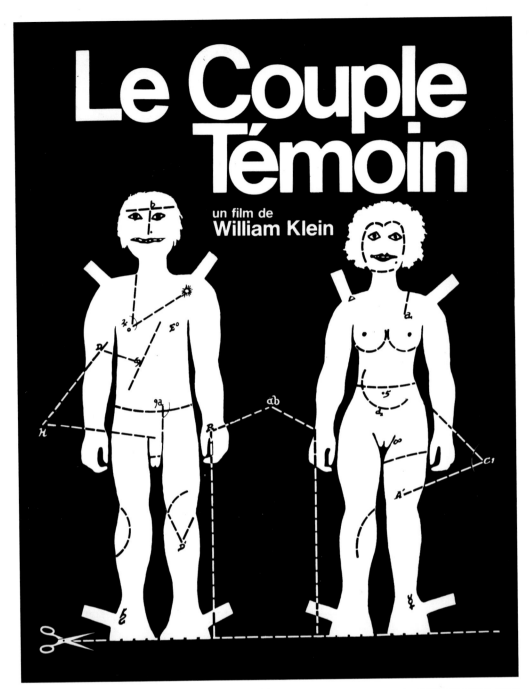

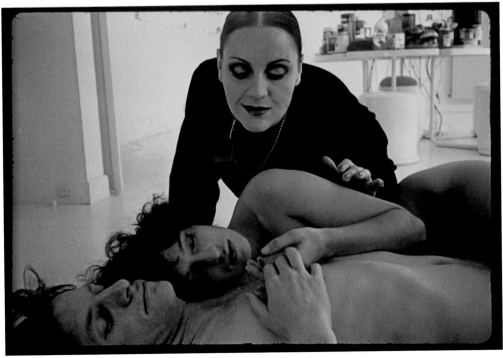

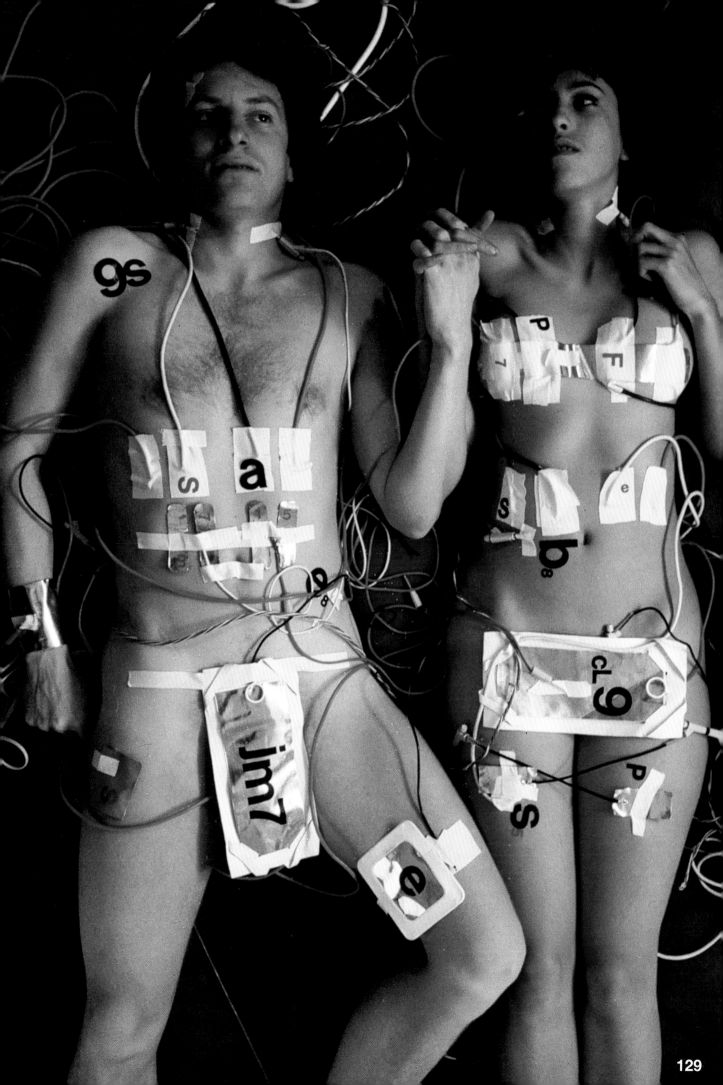

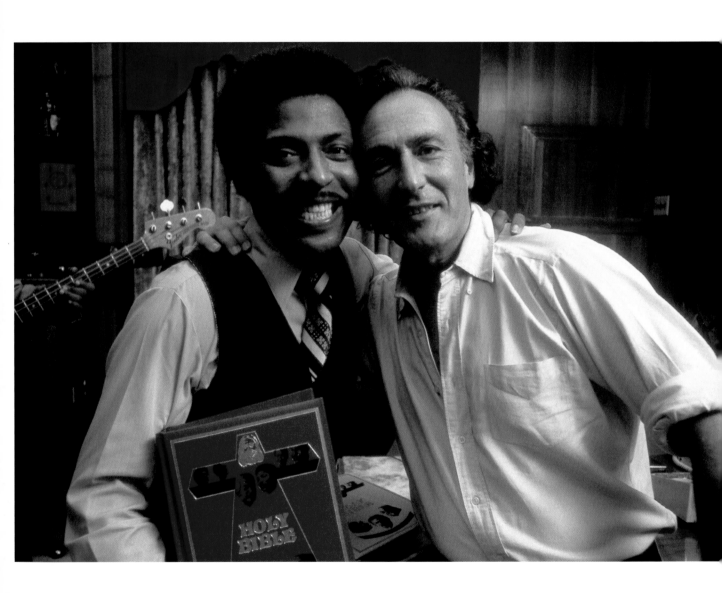

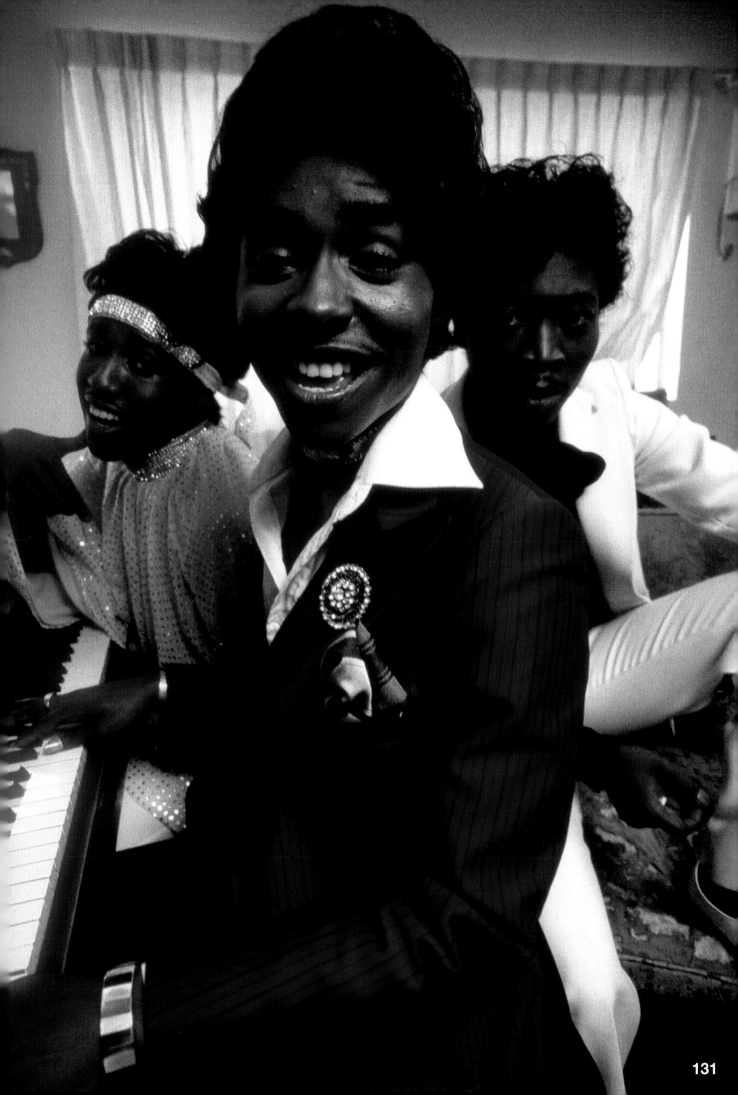

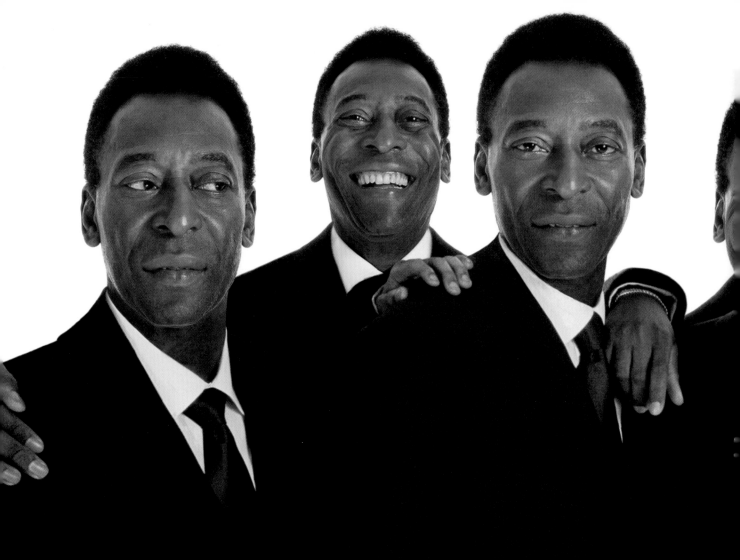

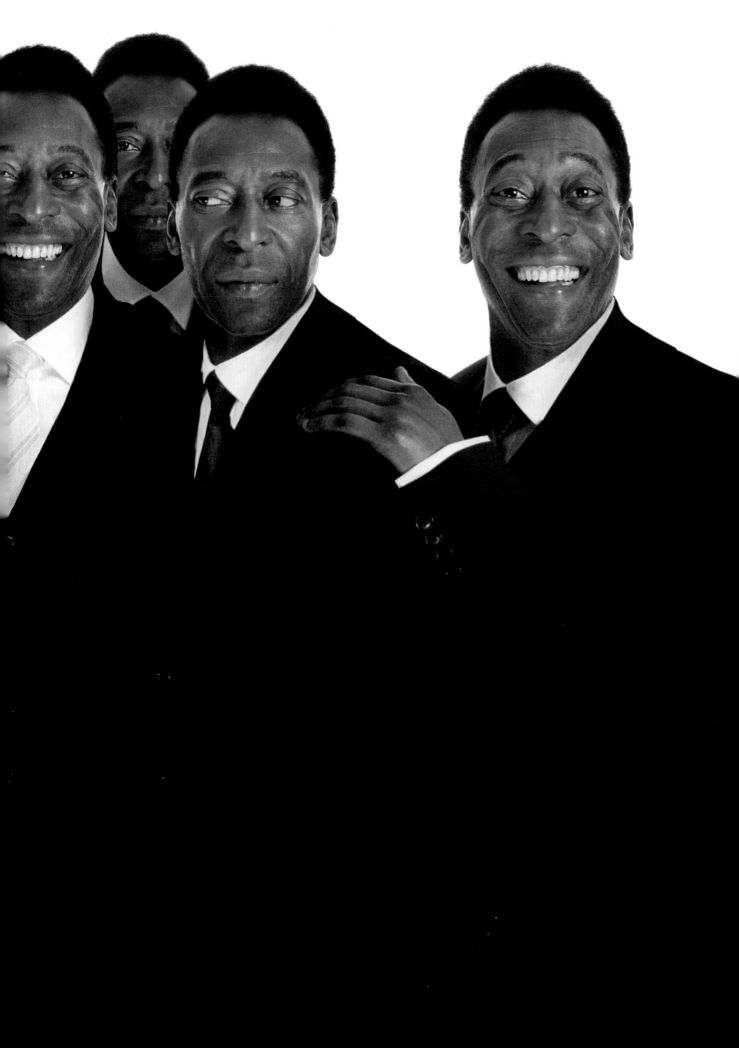

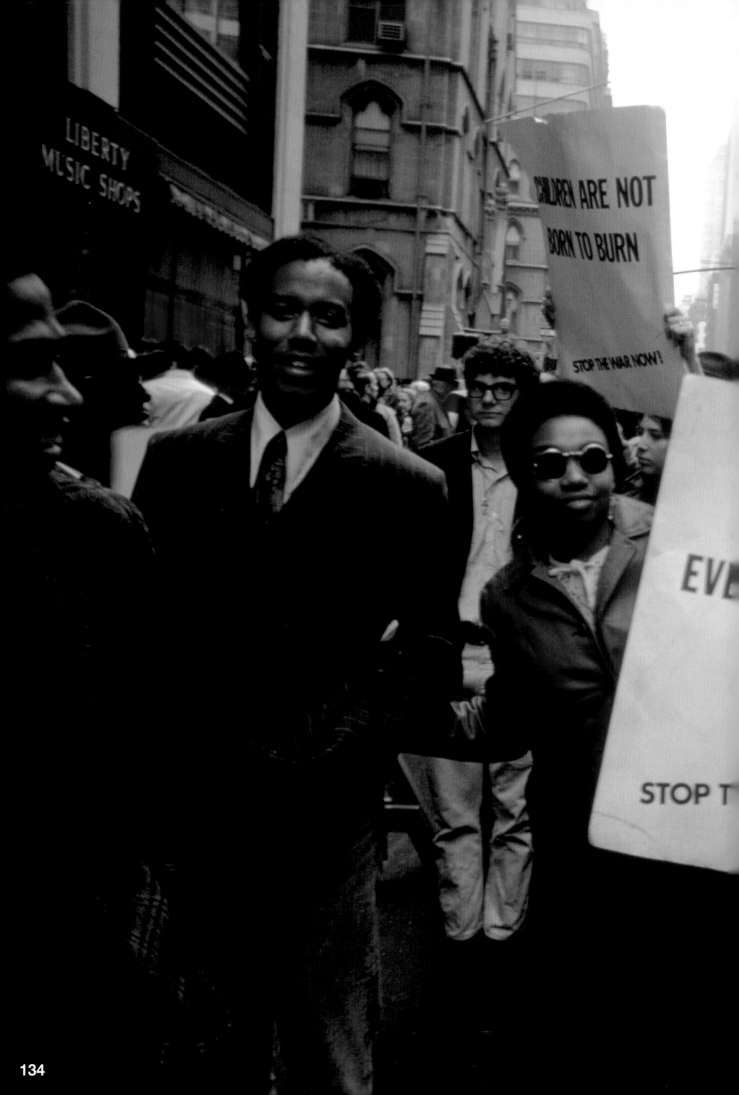

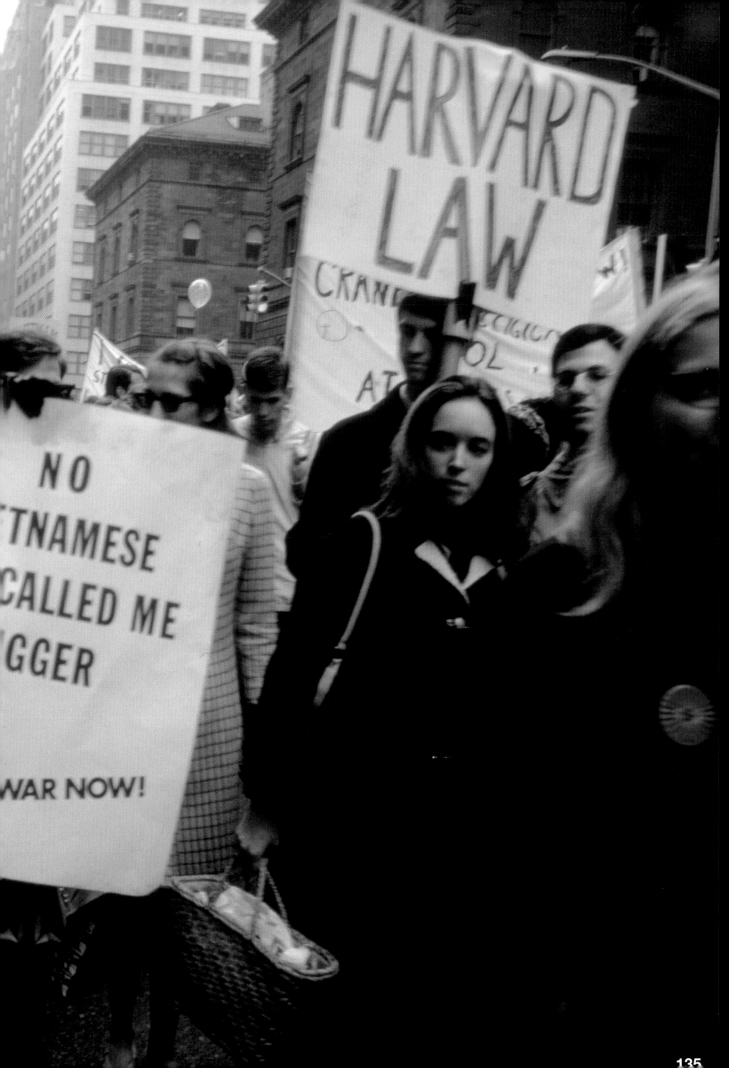

GRANDS SOIRS & PETITS MATINS.

-Mai 68 au Quartier Latin-

Un film de: William KLEIN

✳✳✳✳✳✳✳✳✳✳✳✳✳✳✳✳✳

Production: FILMS PARIS NEW YORK et l'INA

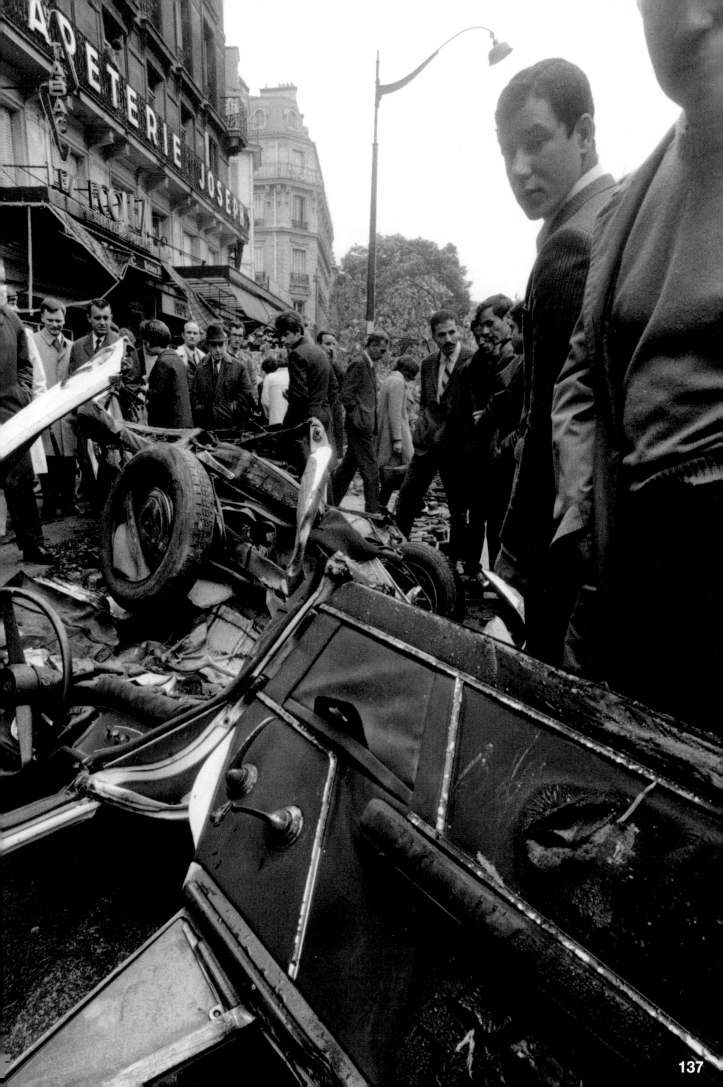

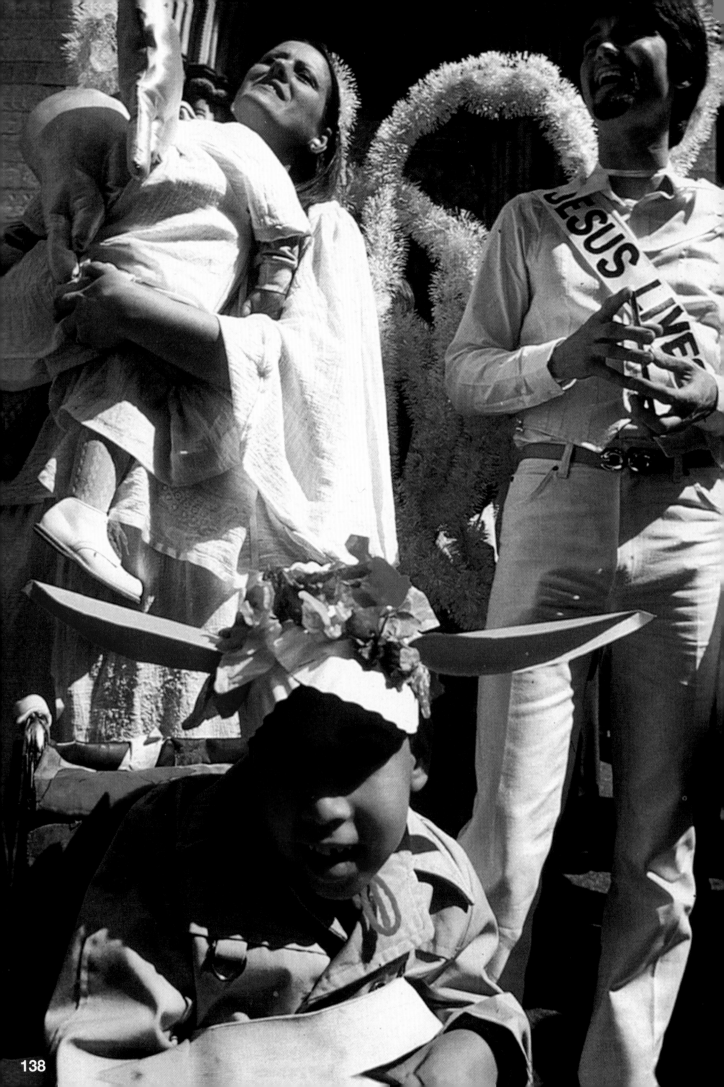

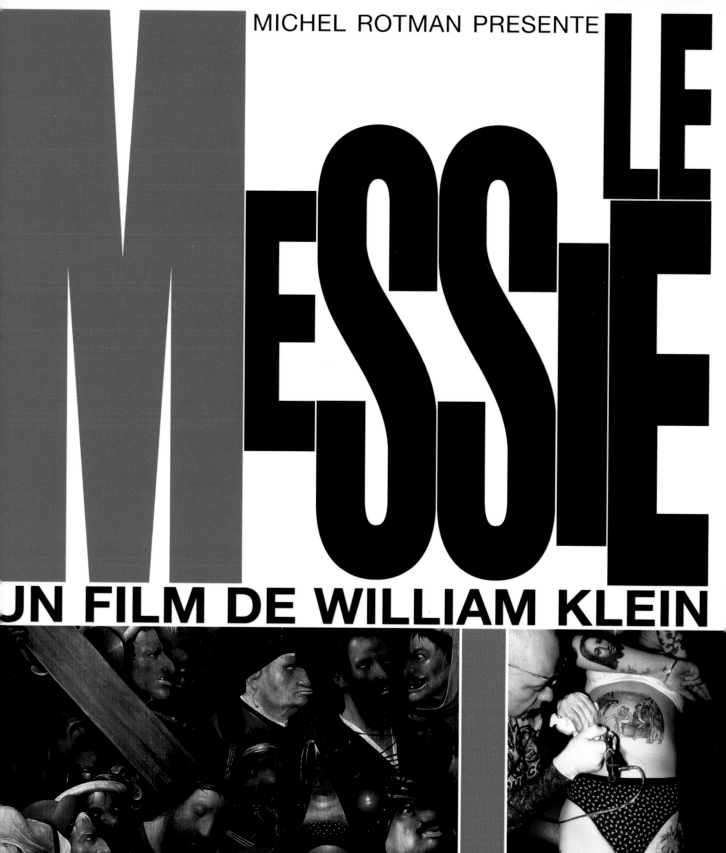

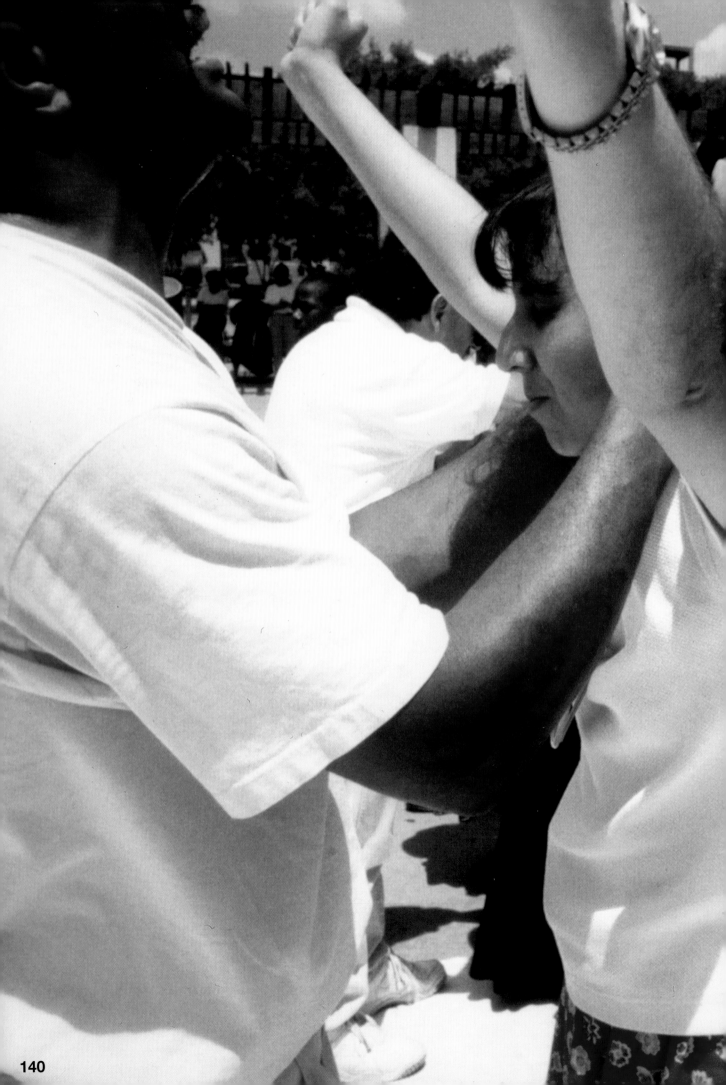

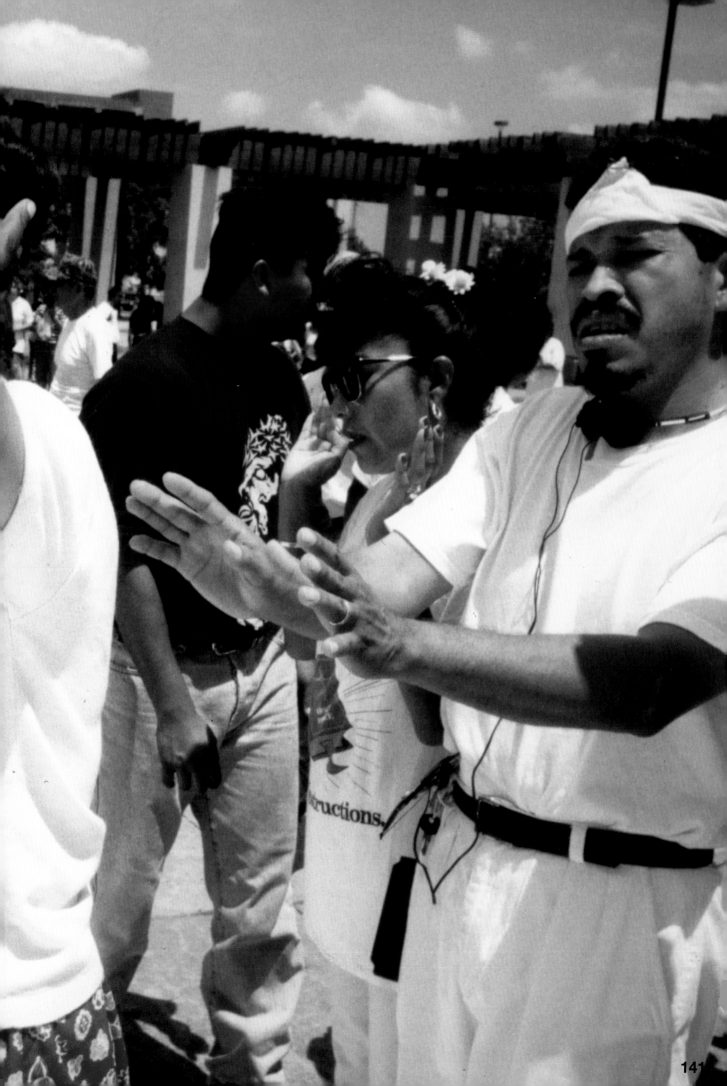

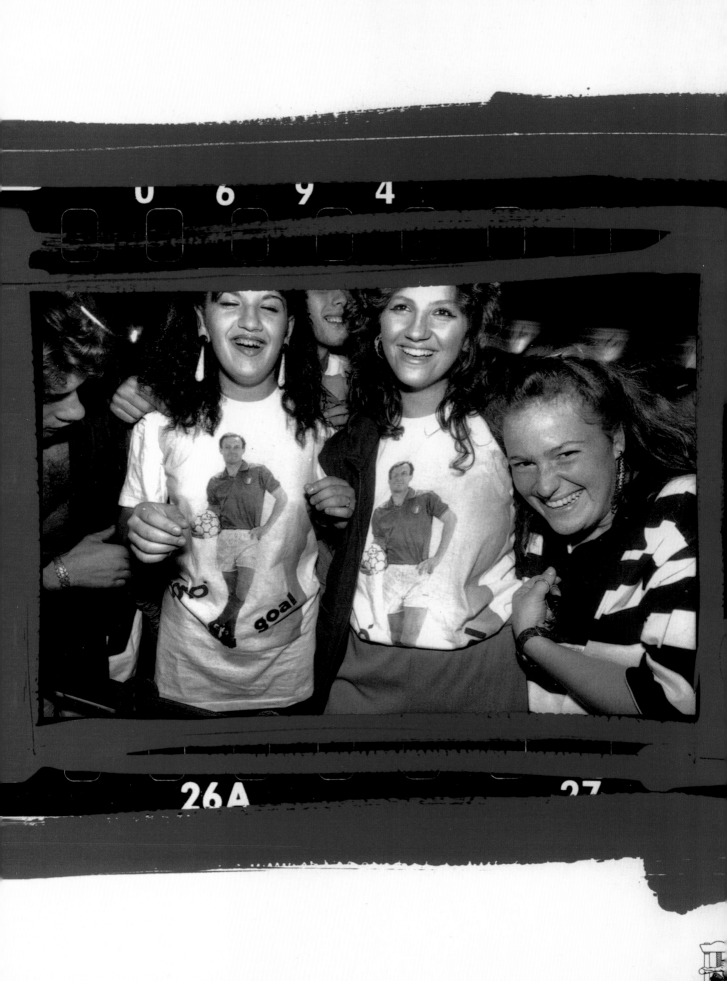

William Klein

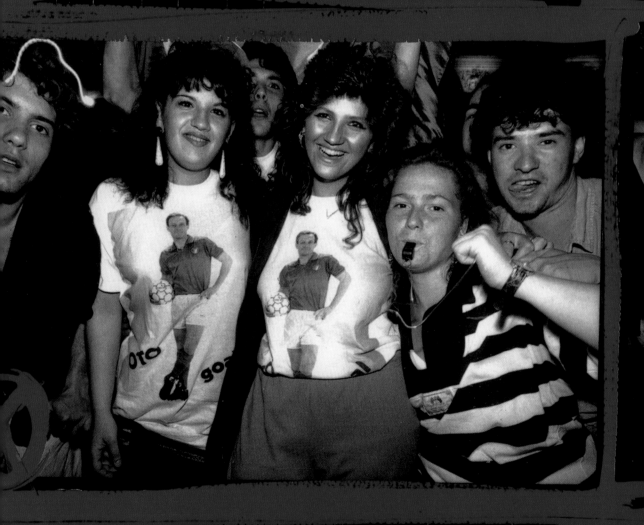

FORD HP5 PLUS

27A 28

Federico Motta Editore

Torino '90

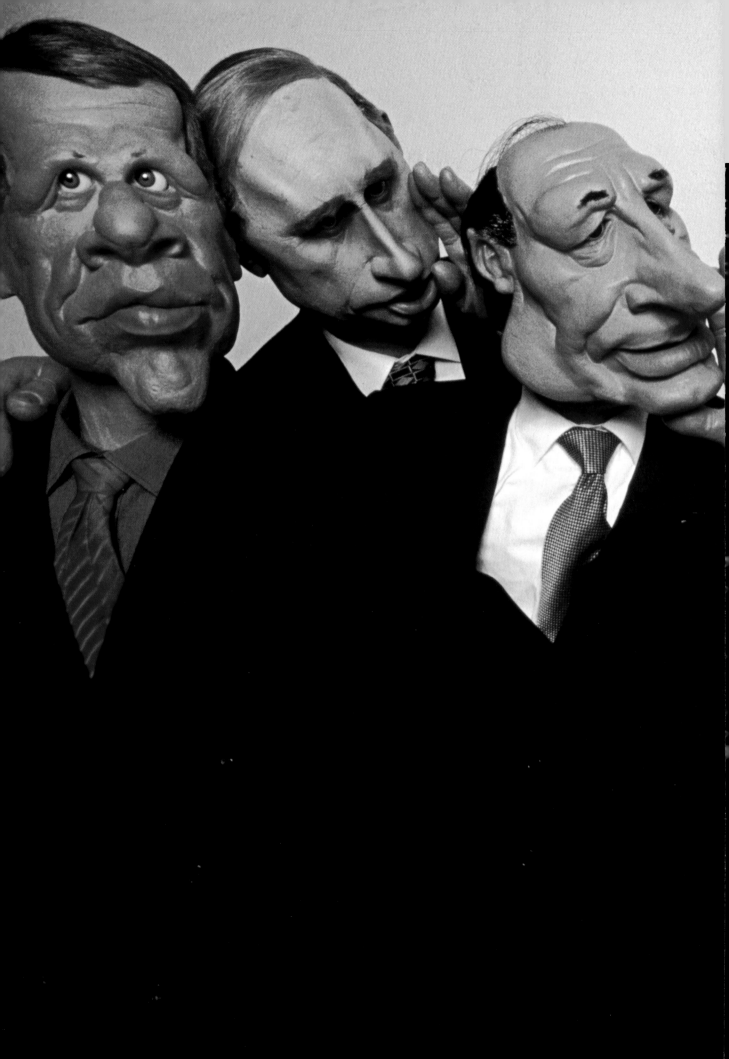

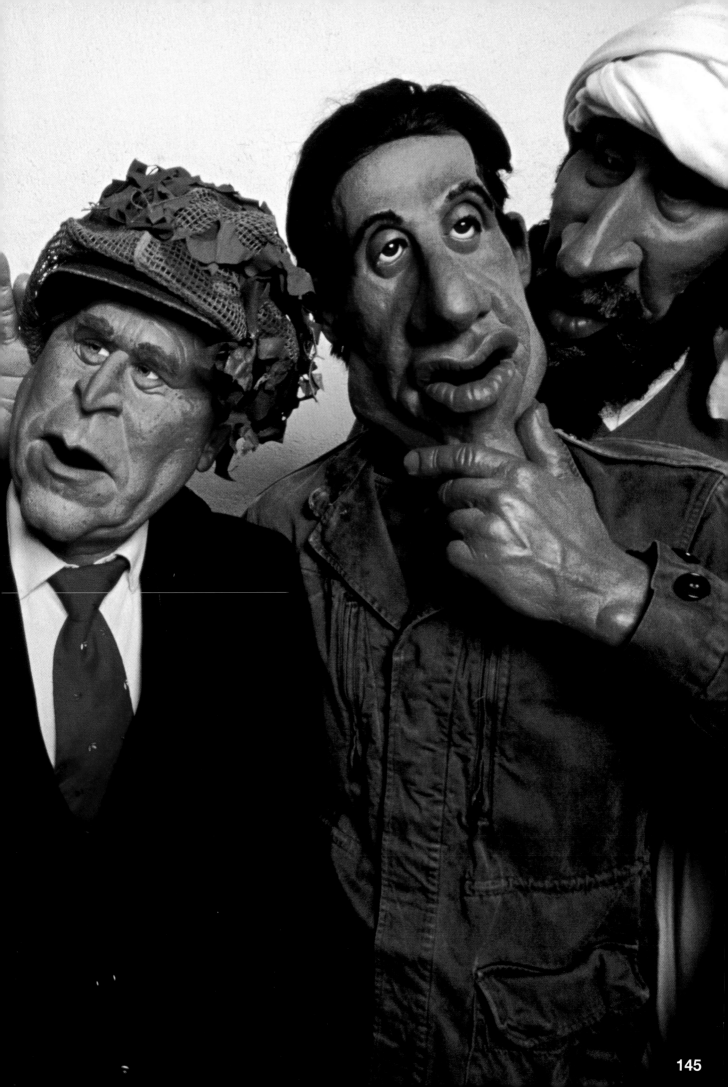

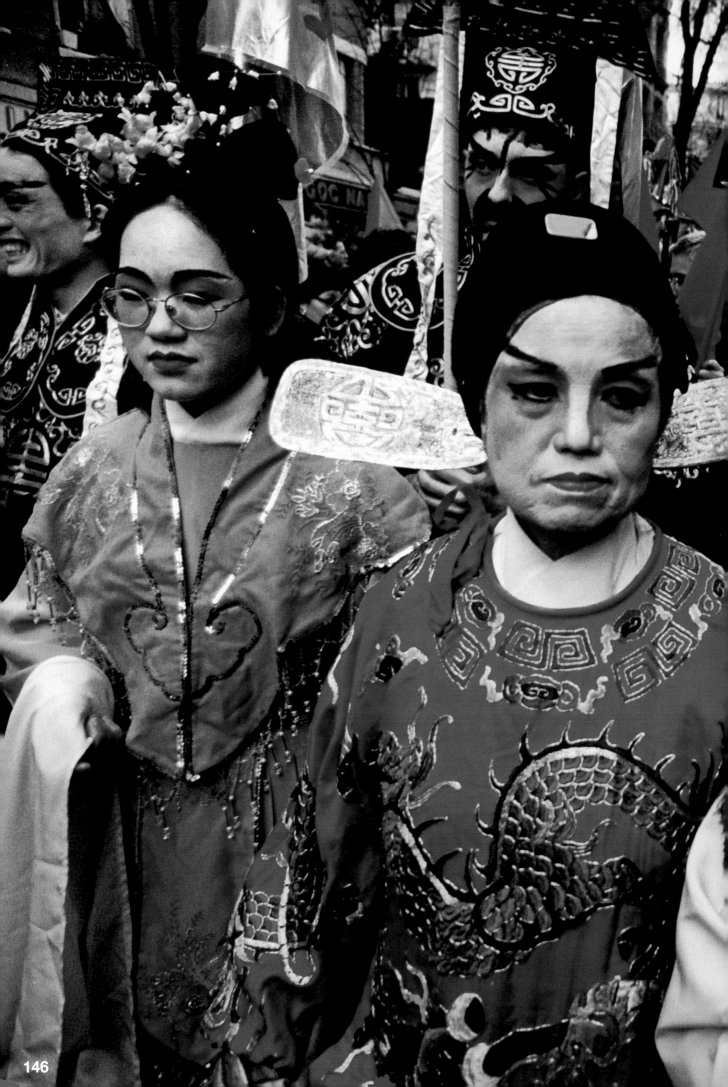

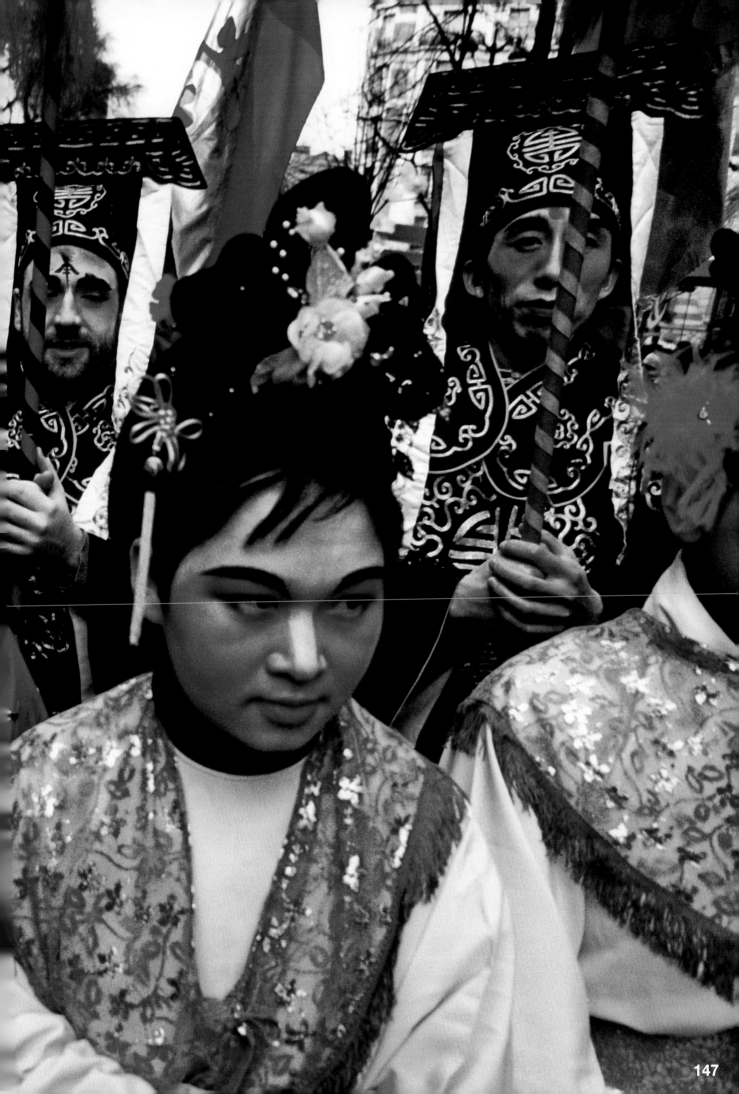

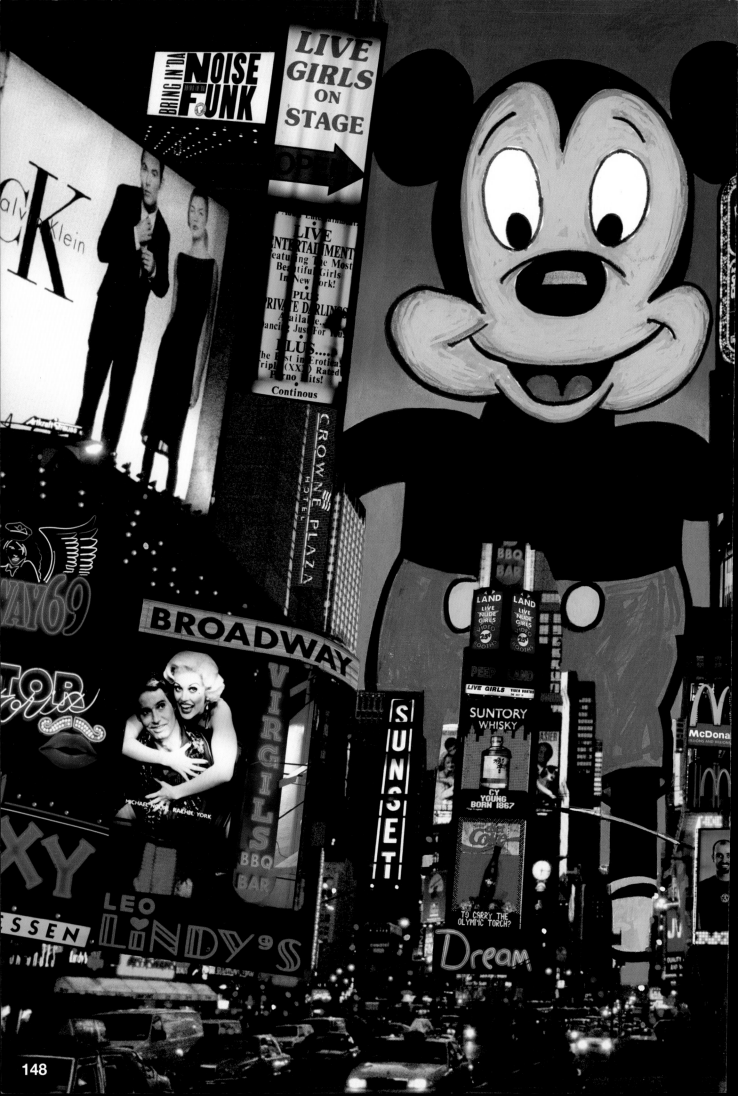

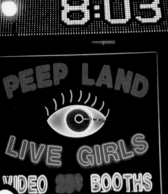
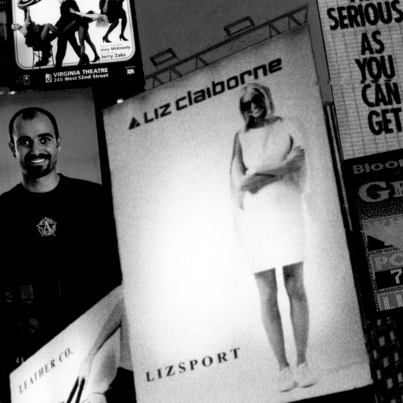

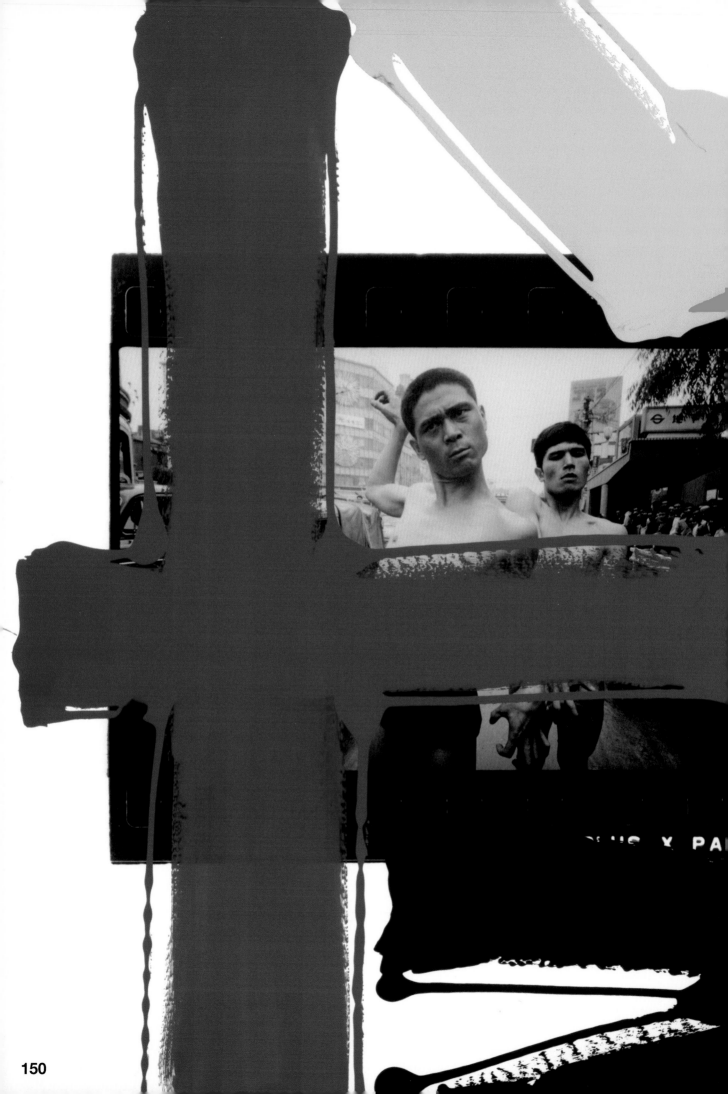

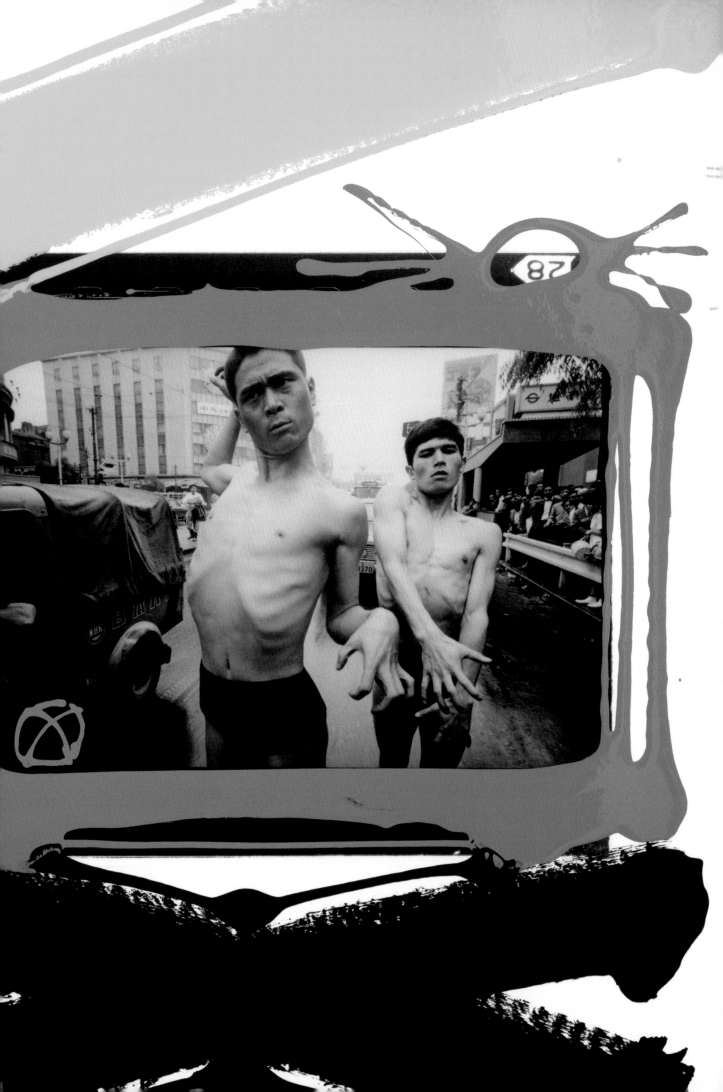

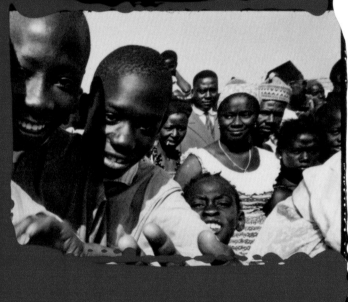

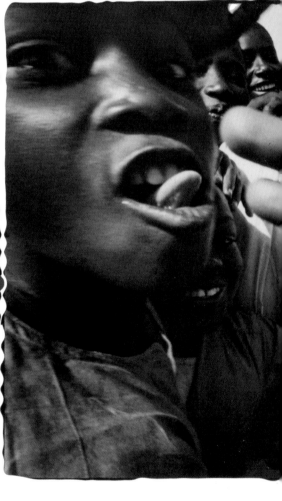

KODAK

34

34A

LUS-X PAN FIL

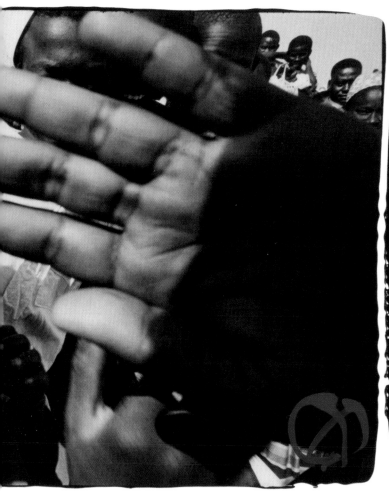

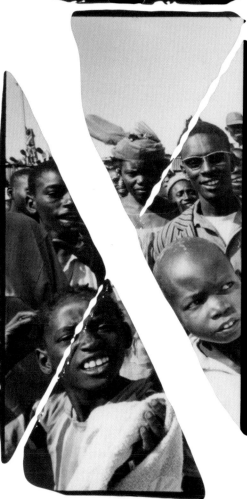

35

35A

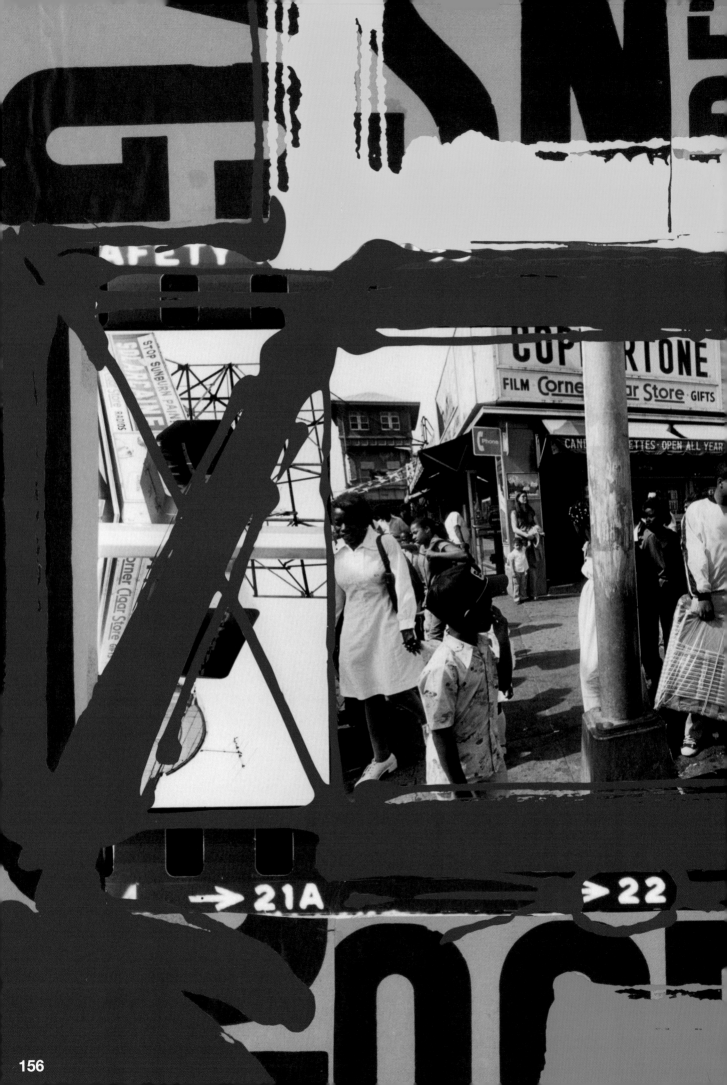

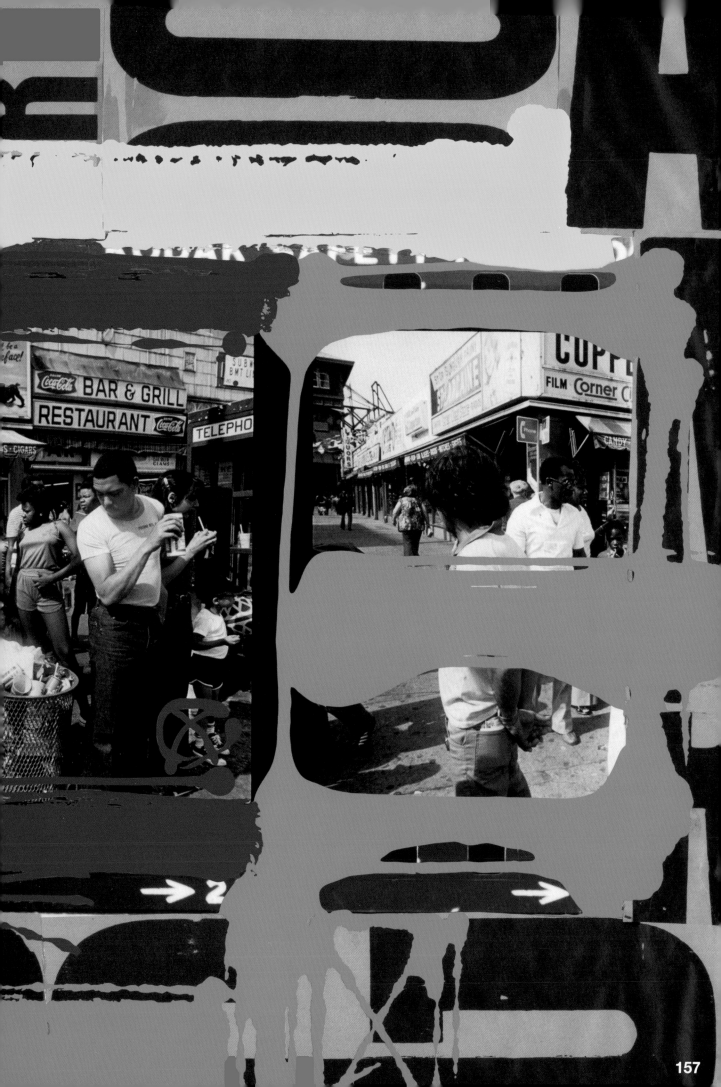

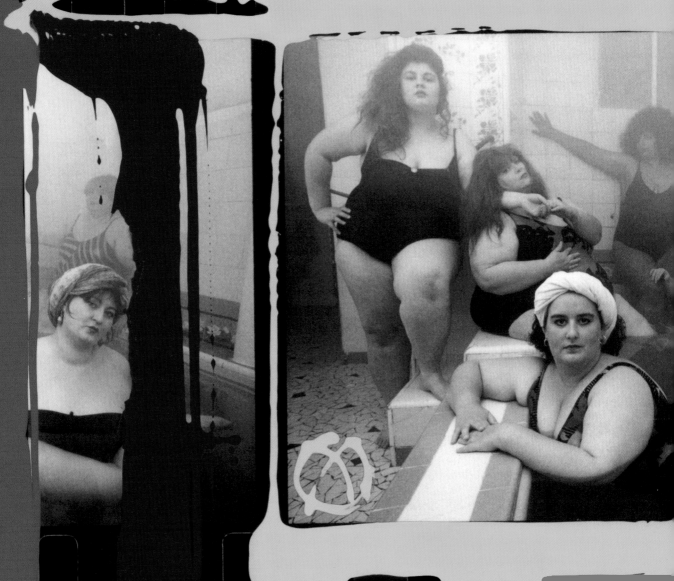

K 5053 TM 32 K

32

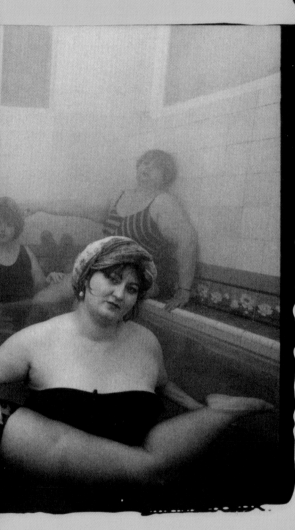

DAK 5053 TMY 33

▷ 32A 33

161

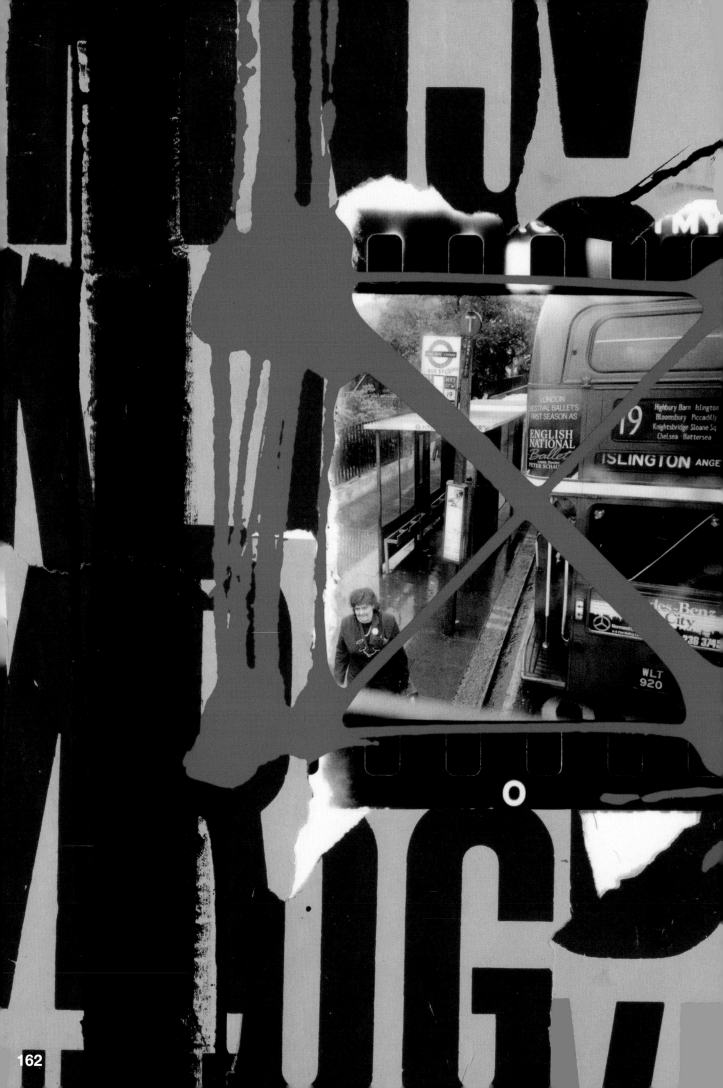

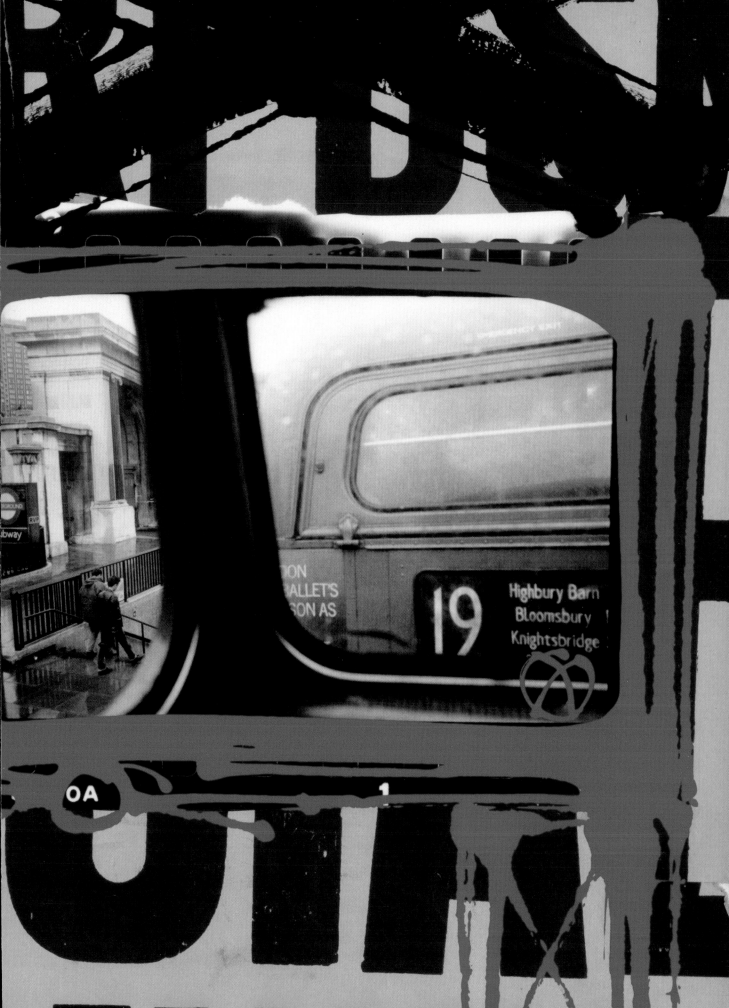

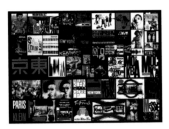

Front endpaper Graphic work by WK for book covers, film posters and magazines 1952–2005

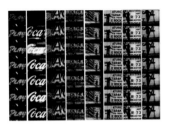

Rear endpaper Filmstrips, *Broadway by Light* 1958

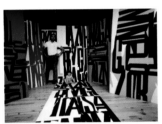

14–15 WK in his studio with his two-year old son, Paris 1965

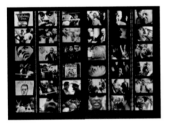

16–17 Filmstrips, *Muhammad Ali, the Greatest* 1964–74

18–19 Moving Diamonds 1953

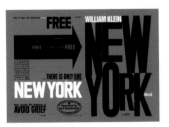

20–21 Covers of book *New York 1954–55*, Marval edition 1995

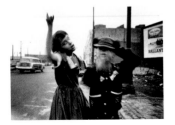

22–23 Dance in Brooklyn, New York 1955

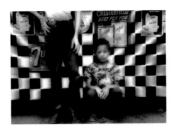

24–25 Candy store, Amsterdam Avenue, New York 1955

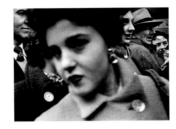

26–27 Big face in crowd, New York 1955

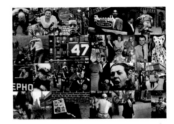

28–29 Montage of photos taken in New York 1955

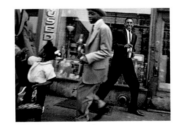

30–31 Blacks + Pepsi, Harlem 1955

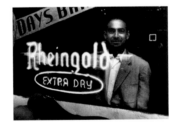

32–33 Rheingold, New York 1955

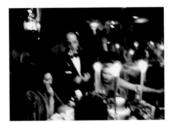

34–35 Elsa Maxwell's Toy Ball, silent movie, Waldorf Hotel, New York 1955

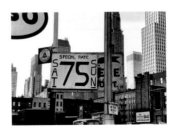

36–37 75 + Fight Communism, New York 1955

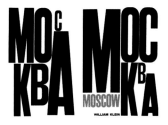

38–39 Covers of book, *Moscow* 1964

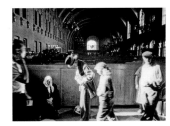

52–53 Kiev railway station, Moscow 1959

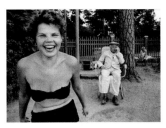

40–41 Bikini, Moscow 1959

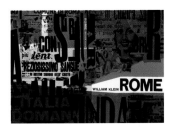

54–55 Covers of book *Rome*, 1959

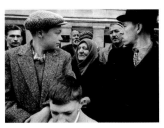

42–43 Spectators, 1 May parade, Moscow 1961

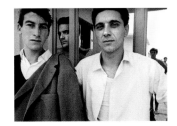

56–57 Entrance to Ostia beach, Rome 1956

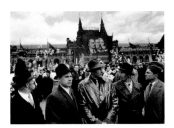

44–45 KGB in crowd, 1 May parade, Moscow 1961

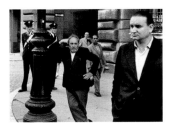

58–59 Mystery, Via del Corso, Rome 1956

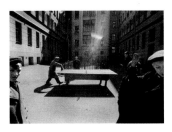

46–47 Ping pong in a courtyard, Moscow 1960

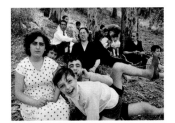

60–61 Picnic at Three Fountains, site of apparition of the Virgin, Rome 1956

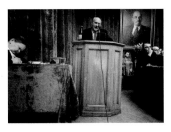

48–49 Meeting of the Union of Actors, Moscow 1960

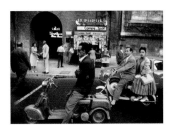

62–63 Red light, Piazzale Flaminia, Rome 1956

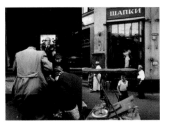

50 Lenin in store window, Moscow 1960
51 Soda stall + fashion boutique, Moscow 1960

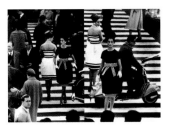

64, 65 Simone + Nina, Piazza di Spagna, 1960

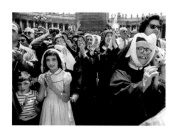

66–67 Nuns see Pope, Rome 1956

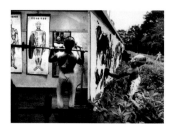

68–69 Covers of *Tokyo* book 1962

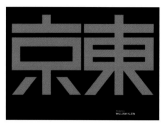

70 Bodybuilder, Tokyo 1961
71 Shinohara fighter painter, Tokyo 1961

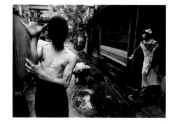

72–73 Dance happening with Kazuo Ohno and Company, Tokyo 1961

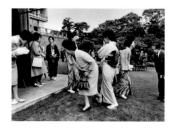

74–75 Bowing ceremony, Tokyo 1961

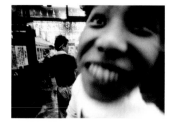

76–77 Porter, Pachinko Palace, Tokyo 1961

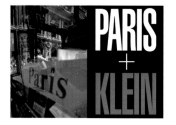

78–79 Covers of *Paris + Klein* book 2002

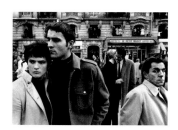

80–81 Le Petit Magot, 11 November, Paris 1968

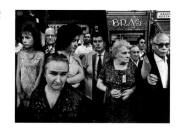

82, 83 On the pavement, Funeral of Thorez, Paris 1964

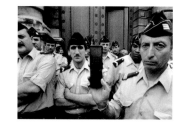

84–85 Police in front of the Senate, Paris 1989

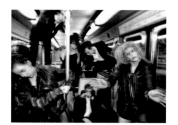

86–87 Dance group La La La Human Steps in Metro, Paris 1991

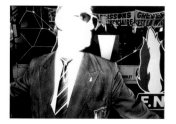

88–89 Le Pen at extreme right rally, Paris 1980

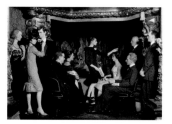

90–91 Musée Grevin, models + waxworks, Paris 1963 (*Vogue*)

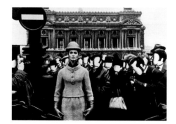

92–93 Isabella + Opéra, Paris 1967 (*Vogue*)

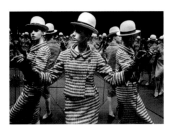

94–95 Antonia + mirrors, Paris 1963 (*Vogue*)

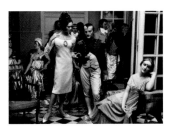

96–97 Musée Grevin, Isabella + Napoleon, Paris 1963 (*Vogue*)

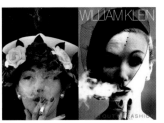

98–99 Covers of book *In & Out of Fashion*, Paris 1994

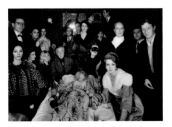

100–101 Surrealist group + three models + André Breton, Paris 1960 (*Vogue*)

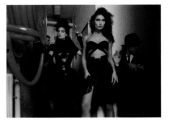

102–103 B-movies, fashion series, Paris 1986 (*Jardin des Modes*)

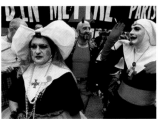

104–105 Nuns + Devil, Gay Pride parade, Paris 2001

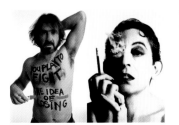

106 Eric Cantona 2004
107 Serge Gainsbourg 1984

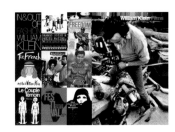

108 Posters for films by WK
109 WK filming Mr Freedom dying. Photo by Jeanne Klein, 1967

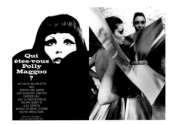

110 Poster for French release of film *Who Are You, Polly Maggoo?* 1966
111 Metal dresses in *Who Are You, Polly Maggoo?* 1965

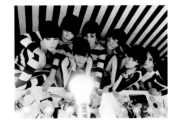

112–113 Models backstage in *Who Are You, Polly Maggoo?* 1965

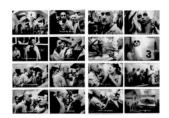

114–115 Images from *Who Are You, Polly Maggoo?* 1965

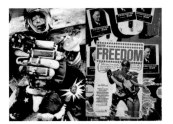

116 Mr Freedom dying in *Mister Freedom* 1967
117 Poster for film *Mister Freedom*

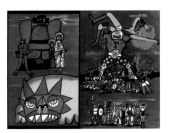

118, 119 Designs by WK for the end credits of *Mister Freedom* 1967

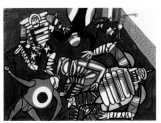
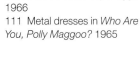

120–121 Drawing by WK for costumes for *Mister Freedom* 1967

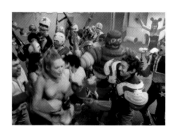

122–123 Celebration of a victory, *Mister Freedom* 1967

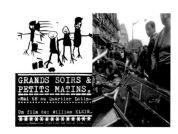

136 Poster for French release of film *Maydays* 1968
137 Latin Quarter, 11 May, Paris 1968

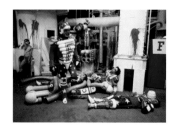

124–125 Images from *Mister Freedom* 1967

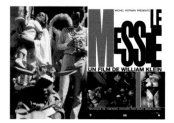

138 St Patrick's Cathedral, New York, Jesus lives, from the film *Messiah* 1999
139 Poster for French release of *Messiah* 1999

126–127 Mr Freedom surveys the death of freedom fighters, *Mister Freedom* 1967

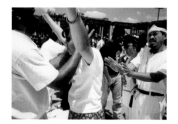

140–141 Induced trances, Houston, Texas, from *Messiah* 1999

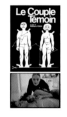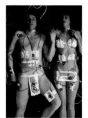

128, 129 Poster for French release + scenes from *The Model Couple*, Paris 1975

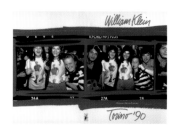

142–143 Covers of book *Torino '90* 1990

130 WK and Little Richard
131 Poster for film *The Little Richard Story* 1980

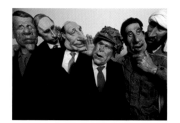

144–145 *Les Guignols de l'info*, satirical television, Paris 2002

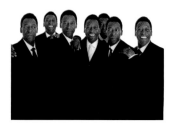

132–133 Pelé Pelé Pelé, London 2003

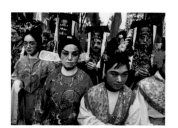

146–147 Chinese New Year parade, Paris 2001

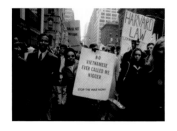

134–135 Scene from film *Far from Vietnam* 1967

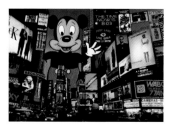

148–149 Montage, Mickey takes over Times Square, New York 1998

150–151 Tokyo dancers 1961.
Painted contact 2002

152–153 School's out, Dakar
1963. Painted contact 1998

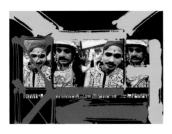

154–155 Tamil Tigers, Paris 1990.
Painted contact 2006

156–157 Coney Island 1989.
Painted contact 2003

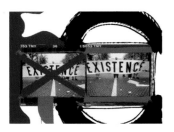

158–159 Existence,
demonstration, Paris 1985.
Painted contact 2000

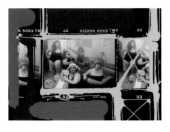

160–161 Club Allegro Fortissimo,
Paris 1990. Painted contact 2002

162–163 Bus 19, London 1980.
Painted contact 2004

WILLIAM KLEIN: FILMOGRAPHY

Compiled by Lucile Montagne

**FILMS DIRECTED BY
WILLIAM KLEIN**

1958
BROADWAY BY LIGHT (SHORT
FILM)
DIRECTED BY WILLIAM KLEIN,
PRODUCED BY ARGOS FILMS
AND WILLIAM KLEIN, PARIS.
COLOUR, 35MM, 14 MINUTES.

1959
HOW TO KILL A CADILLAC
(SHORT FILM)
DIRECTED AND PRODUCED BY
WILLIAM KLEIN, PARIS.
COLOUR, 35MM, 14 MINUTES.

1960
ZAZIE DANS LE MÉTRO (*ZAZIE IN
THE UNDERGROUND*) (FEATURE
FILM)
ADAPTED FROM THE 1959
NOVEL BY RAYMOND QUENEAU.
DIRECTED BY LOUIS MALLE,
ARTISTIC DIRECTOR WILLIAM
KLEIN, PRODUCED BY NEF
PRODUCTIONS, PARIS.
COLOUR, 35MM, 105 MINUTES.

1962
FIVE DOCUMENTARY FILMS
FOR THE FRENCH TELEVISION
PROGRAMME *CINQ COLONNES
À LA UNE* (*FRONT PAGE*):
LE BUSINESS ET LA MODE
(*BUSINESS AND FASHION*)
(ON THE FIRST COLLECTION
OF YVES SAINT LAURENT), 15
MINUTES.
LA GARE DE LYON, 15 MINUTES.
*LES TROUBLES DE LA
CIRCULATION* (*TRAFFIC
CONGESTION*), 15 MINUTES.
INONDATION CATALANE
(*CATALAN FLOOD*), 15 MINUTES.
LES FRANÇAIS ET LA POLITIQUE
(*THE FRENCH AND POLITICS*)
(CENSORED), 90 MINUTES.
DIRECTED BY WILLIAM KLEIN,
PRODUCED BY ORTF, PARIS.
BLACK AND WHITE, 16MM.

1963
AUX GRANDS MAGASINS
(*THE DEPARTMENT STORE*)
(DOCUMENTARY)
FOR FRENCH TELEVISION,
FEATURING SIMONE SIGNORET.
PRODUCED BY ORTF, PARIS.
PILOT FOR THE FRENCH
PROGRAMME *LES FEMMES
AUSSI* (*WOMEN TOO*).
BLACK AND WHITE, 16MM, 90
MINUTES.
FRENCH WITH ENGLISH
SUBTITLES.

1964
CASSIUS LE GRAND (*CASSIUS
THE GREAT*) (DOCUMENTARY
FEATURE)
DIRECTED AND FILMED BY
WILLIAM KLEIN, PRODUCED BY
DELPIRE PRODUCTIONS, PARIS.
BLACK AND WHITE, 35MM
(FROM 16MM), 100 MINUTES.
AWARDED GRAND PRIX DU
FESTIVAL INTERNATIONAL DE
TOURS.

1966
*QUI ÊTES-VOUS, POLLY
MAGGOO?* (*WHO ARE YOU,
POLLY MAGGOO?*)
WRITTEN, DESIGNED AND
DIRECTED BY WILLIAM KLEIN,
PRODUCED BY DELPIRE
PRODUCTIONS, PARIS.
BLACK AND WHITE, 35MM, 105
MINUTES.
ENGLISH AND FRENCH,
ENGLISH SUBTITLES.
AWARDED PRIX JEAN VIGO.

1967
LOIN DU VIETNAM (*FAR FROM
VIETNAM*) (DOCUMENTARY
FEATURE)
COLLABORATIVELY DIRECTED
BY JEAN-LUC GODARD, JORIS
IVENS, WILLIAM KLEIN (US
SEQUENCE), CLAUDE LELOUCH,
CHRIS MARKER AND ALAIN
RESNAIS, PRODUCED BY
SOFRACIMA, PARIS.
COLOUR, 35MM (FROM 16MM),
120 MINUTES.
FRENCH WITH ENGLISH
SUBTITLES.

1969
MISTER FREEDOM (FEATURE
FILM)
WRITTEN, DESIGNED AND
DIRECTED BY WILLIAM KLEIN,
PRODUCED BY O.P.E.R.A.,
PARIS, AND FILMS PARIS NEW
YORK.
COLOUR, 35MM, 100 MINUTES.
FRENCH AND ENGLISH WITH
ENGLISH SUBTITLES.

1969
*FESTIVAL PANAFRICAIN
D'ALGER* (*PAN-AFRICAN
FESTIVAL OF ALGIERS*)
(DOCUMENTARY)
DIRECTED BY WILLIAM KLEIN,
PRODUCED BY THE ALGERIAN
NATIONAL FILM BOARD (ONCIC),
ALGIERS.
COLOUR, 35MM (FROM 16MM),
120 MINUTES.
FRENCH WITH ENGLISH
SUBTITLES.

1970
*ELDRIDGE CLEAVER, BLACK
PANTHER* (DOCUMENTARY)
DIRECTED AND FILMED BY
WILLIAM KLEIN, PRODUCED BY
THE ALGERIAN NATIONAL FILM
BOARD (ONCIC), ALGIERS.
COLOUR, 35MM (FROM 16MM),
75 MINUTES.
ENGLISH.

1972
LE GRAND CAFÉ (*THE BIG CAFÉ*)
(TELEVISION)
DIRECTED AND FILMED BY
WILLIAM KLEIN FOR THE
FRENCH SERIES *LES CINÉASTES
TÉMOINS DE LEUR TEMPS* (*FILM
MAKERS: WITNESSES OF THEIR
TIME*), PRODUCED BY PARC
FILMS, PARIS.
COLOUR, 16MM, 60 MINUTES.
FRENCH WITH ENGLISH
SUBTITLES.

1972–1989
DIRECTS MORE THAN 250
ADVERTISEMENTS FOR
VARIOUS COMPANIES
INCLUDING DIM, RENAULT,
CITROËN, FIAT AND BOLINO.

1974
*MUHAMMAD ALI, THE
GREATEST* (DOCUMENTARY)
RE-EDITED VERSION OF THE
1964 DOCUMENTARY *CASSIUS
THE GREAT*, WITH THE 1974
MUHAMMAD ALI AND GEORGE
FOREMAN MATCH IN ZAIRE.
FILMED BY WILLIAM KLEIN,
PRODUCED BY FILMS PARIS
NEW YORK AND DELPIRE
ADVICO, PARIS.
BLACK AND WHITE AND
COLOUR, 35MM, 120 MINUTES.
ENGLISH.

1974
L'ANNIVERSAIRE DE CHARLOTTE
(*CHARLOTTE'S BIRTHDAY*)
(SHORT FILM)
DIRECTED BY WILLIAM KLEIN
FOR THE FILM FESTIVAL SUPER
8, PARIS.
BLACK AND WHITE, SUPER 8, 30
MINUTES.
FRENCH WITH ENGLISH
SUBTITLES.

1975
LE COUPLE TÉMOIN (THE
MODEL COUPLE) (FEATURE
FILM)
WRITTEN, DESIGNED, DIRECTED
AND FILMED BY WILLIAM KLEIN,
CO-PRODUCED BY FILMS PARIS
NEW YORK AND THE MINISTRY
OF CULTURE, PARIS.
COLOUR, 35MM, 100 MINUTES.
FRENCH, GERMAN AND
ENGLISH WITH ENGLISH
SUBTITLES.

1977
*HOLLYWOOD, CALIFORNIA:
A LOSER'S OPERA*
WRITTEN AND DIRECTED BY
WILLIAM KLEIN, PRODUCED BY
OKO PRODUCTIONS, MUNICH.
COLOUR, 16MM, 60 MINUTES.
ENGLISH.

1978
*GRANDS SOIRS ET PETITS
MATINS* (*MAYDAYS*)
(DOCUMENTARY)
SHOT IN 1968, ABOUT THE
SOCIAL PROTESTS OF MAY
1968. DIRECTED AND FILMED
BY WILLIAM KLEIN, PRODUCED
BY FILMS PARIS NEW YORK.
BLACK AND WHITE, 16MM, 105
MINUTES.
FRENCH WITH ENGLISH
SUBTITLES.

1978
MUSIC CITY, USA
(DOCUMENTARY)
WRITTEN AND DIRECTED BY
WILLIAM KLEIN, PRODUCED BY
OKO PRODUCTIONS, MUNICH.
COLOUR, 16MM, 75 MINUTES.
ENGLISH.

1980
THE LITTLE RICHARD STORY
(DOCUMENTARY)
WRITTEN AND DIRECTED BY
WILLIAM KLEIN, PRODUCED BY
OKO PRODUCTIONS, MUNICH.
COLOUR, 16MM, 90 MINUTES.
ENGLISH.

1981
ROLAND GARROS (THE FRENCH)
(DOCUMENTARY)
FILM ABOUT THE FRENCH
OPEN. WRITTEN AND DIRECTED
BY WILLIAM KLEIN, PRODUCED
BY FILMS PARIS NEW YORK.
COLOUR, 16MM, 135 MINUTES.
ENGLISH AND FRENCH,
FRENCH SUBTITLES.

1984
RALENTIS (SLOW MOTION)
DIRECTED AND FILMED BY
WILLIAM KLEIN, PRODUCED BY
GRANDE HALLE DE LA VILLETTE,
PARIS.
COLOUR, 35MM, 30 MINUTES.

1985
*MODE EN FRANCE (FASHION IN
FRANCE)* (DOCUMENTARY)
DIRECTED BY WILLIAM KLEIN
AND PRODUCED BY KUIV
PRODUCTIONS, TF1 AND THE
MINISTRY OF CULTURE, PARIS.
COLOUR, 35MM, 90 MINUTES.
FRENCH.

1986
CONTACTS (SHORT)
PILOT FOR A TELEVISION SERIES
ON PHOTOGRAPHY. DIRECTED
BY WILLIAM KLEIN, PRODUCED
BY THE CENTRE NATIONAL DE
LA PHOTOGRAPHIE, PARIS.
BLACK AND WHITE, 35MM, 15
MINUTES.
FRENCH.

1989
FOUR SHORT FILMS:
CARTE D'IDENTITÉ (*ID*)
ÉTAT DES LIEUX (*EVIDENCE*)
LA GRANDE ARCHE (*THE GREAT
ARCH*)
CINÉ DÉFENSE
WRITTEN AND DIRECTED BY
WILLIAM KLEIN, PRODUCED BY
GRANDE HALLE DE LA VILLETTE,
PARIS.
COLOUR, VIDEO, 60 MINUTES.

1991
BABILÉE '91 (DOCUMENTARY)
DIRECTED BY WILLIAM KLEIN
AND PRODUCED BY LIEURAC
PRODUCTIONS.
BLACK AND WHITE, 16MM, 60
MINUTES.
FRENCH.

1993
IN AND OUT OF FASHION
(DOCUMENTARY)
MONTAGE FILM USING
EXTRACTS FROM KLEIN'S
FILMS, AS WELL AS HIS
PHOTOGRAPHS AND
PAINTINGS. PRODUCED BY
LES FILMS PARIS NEW YORK,
LIEURAC PRODUCTIONS,
LES RENCONTRES
INTERNATIONALES D'ARLES,
PARIS PREMIÈRE.
COLOUR AND BLACK AND
WHITE, 35MM, 88 MINUTES.
ENGLISH AND FRENCH WITH
ENGLISH SUBTITLES.

1999
LE MESSIE (*MESSIAH*)
(DOCUMENTARY FILMED IN
FRANCE, SPAIN, MOSCOW AND
THE UNITED STATES)
A MIX OF AMATEUR CHOIRS,
PROFESSIONAL ENGLISH
SOLOISTS, AND THE CHOIR AND
ORCHESTRA OF LES MUSICIENS
DU LOUVRE-GRENOBLE
PERFORM GEORGE FRIDERIC
HANDEL'S ORATORIO *MESSIAH*.
MUSICAL DIRECTION BY MARC
MINKOWSKI. PRODUCED BY
MICHEL ROTMAN AND KUIV,
PARIS. CAMERA AND EDITING
BY WILLIAM KLEIN. COLOUR,
35 MM, 117 MINUTES.
ENGLISH AND FRENCH.

FILMS ABOUT WILLIAM KLEIN

1980
WILLIAM KLEIN
DIRECTED BY JEAN-DANIEL
VERHAEGHE FOR THE
TELEVISION SERIES *GREAT
PHOTOGRAPHERS* (BY
CATHERINE IKAM), PRODUCED
BY ANTENNE 2, PARIS.
COLOUR, 52 MINUTES.
FRENCH.

1984
WILLIAM KLEIN
DIRECTED BY FREDDY
COPPENS, PRODUCED BY RTB,
BRUSSELS.
COLOUR, 45 MINUTES.
FRENCH.

1991
WILLIAM KLEIN
DIRECTED BY CLAUDE JAGET,
PRODUCED BY CAMÉRA, LYON.
COLOUR, 45 MINUTES.
FRENCH.

1994
WILLIAM KLEIN
DIRECTED BY DAVID BRITTAIN,
PRODUCED BY THE BBC.
COLOUR, 30 MINUTES.
ENGLISH.

2002
BONUS WITH THE DVDS
*MUHAMMAD ALI, THE
GREATEST* AND *GRANDS SOIRS
ET PETITS MATINS*
DIRECTED BY PHILIPPE
TRUFFAULT, PRODUCED BY
ARTE, PARIS.
COLOUR, 45 MINUTES.
FRENCH.

2003
WILLIAM KLEIN
DIRECTED BY MICHAEL
GAVSHON FOR CBS.
COLOUR, 30 MINUTES.
ENGLISH.

2005
BONUS WITH THE DVDS *WHO
ARE YOU POLLY MAGGOO?*,
MISTER FREEDOM AND *IN AND
OUT OF FASHION*
DIRECTED BY PHILIPPE
TRUFFAULT, PARIS.
COLOUR, 60 MINUTES.
FRENCH.

WILLIAM KLEIN: CHRONOLOGY

Compiled by Lucile Montagne
All quotations are by William Klein, unless otherwise stated.

1928
WILLIAM KLEIN BORN 19 APRIL IN NEW YORK, TO A FAMILY OF HUNGARIAN JEWISH IMMIGRANTS. GROWS UP IN AN IRISH NEIGHBOURHOOD, IN THE 'MEAN STREETS OF MANHATTAN'.

1929
HIS FATHER LOSES HIS CLOTHING STORE DURING THE WALL STREET CRASH.

1938–1942
GOES TO TOWNSEND HARRIS, NEW YORK CITY, AN EXPERIMENTAL HIGH SCHOOL WHERE STUDENTS COULD TAKE FOUR-YEAR COURSES IN TWO. KLEIN BECOMES THE ARTISTIC DIRECTOR OF THE SCHOOL NEWSPAPER. BEGINS TO DRAW, HIS FAVOURITE DRAUGHTSMEN BEING GEORGE PRICE, HONORÉ DAUMIER AND SAUL STEINBERG. READS GOGOL, DOSTOYEVSKY, ISAAC BABEL, DREISER, UPTON SINCLAIR, JACK LONDON, BALZAC, QUENEAU. ALTHOUGH HIS SCHOOL ENCOURAGES DEBATES SUCH AS STALIN VERSUS TROTSKY, KLEIN HAS NO POLITICAL INVOLVEMENT AT THE TIME. HE IS MORE INTERESTED IN ART AND CONSIDERS THE MUSEUM OF MODERN ART (MOMA) IN NEW YORK AS A 'SECOND HOME':

'A TINY GROUP OF US WERE WORRIED ABOUT ART, AND ABOUT ESSENTIAL QUESTIONS LIKE WAS GAUGUIN RIGHT TO LEAVE HIS WIFE AND KIDS FOR PAINTING IN TAHITI.'

THANKS TO MOMA'S FILM PROGRAMMES, HE DISCOVERS THE FILM DIRECTORS ERICH VON STROHEIM, FRITZ LANG AND CHARLIE CHAPLIN, CHAPLIN'S *MODERN TIMES* (1936) AS WELL AS LANG'S *M* (1931) BEING MODELS TO HIM.

1942
AGED FIFTEEN, HE ENROLS AT CITY COLLEGE OF NEW YORK TO STUDY SOCIOLOGY; HE GRADUATES AT EIGHTEEN. BECOMES A COURIER FOR HIS UNCLE, A LAWYER AT PARAMOUNT PICTURES.

1946
SPENDS SIX MONTHS DURING THE OCCUPATION IN GERMANY AS A US ARMY RADIO OPERATOR ON HORSEBACK. WHILE IN THE ARMY, HE PARTICIPATES IN BOXING MATCHES IN ORDER TO BE GRANTED WEEKEND LEAVE, PLAYS POKER, WHERE HE WINS HIS FIRST CAMERA, A ROLLEIFLEX, AND DRAWS CARTOONS FOR *THE STARS AND STRIPES*, THE ARMY NEWSPAPER.

1947
STILL A SOLDIER, HE COMES TO PARIS AND BENEFITS FROM A FRENCH–AMERICAN CULTURAL-EXCHANGE PROGRAMME TO STUDY FOR A YEAR AT THE SORBONNE. DECIDES TO STAY IN PARIS, WHERE HE HAS SINCE LIVED AND WORKED. ON DISCHARGE ON 13 JULY, TWO DAYS AFTER HIS ARRIVAL IN PARIS, HE MEETS JEANNE FLORIN, HIS FUTURE WIFE.

1948
MARRIES JEANNE, WHO WILL BECOME HIS COLLABORATOR AND PARTNER, PAINTING, DESIGNING COSTUMES AND PRODUCING SOME OF HIS FILMS.

1949
WORKS FOR TWO WEEKS IN THE STUDIO OF ANDRÉ LHOTE, WHOM HE FINDS 'POMPOUS AND BORING'.

STUDIES IN THE STUDIO OF FERNAND LÉGER FOR A FEW WEEKS. HE BECOMES FRIENDS WITH HIS COMPATRIOTS JACK YOUNGERMAN AND ELLSWORTH KELLY. INSPIRED BY LÉGER'S IDEAS MORE THAN HIS WORK, HE FOLLOWS HIS ADVICE: 'GET OUT OF THE STUDIO, THE ART IS IN THE STREET.'

'MY CHILDHOOD DREAM WAS TO COME TO PARIS AND BE AN ARTIST.'
'I ALWAYS PLANNED TO WORK IN PARIS, TO GO TO LA COUPOLE AND SLAP PICASSO AND GIACOMETTI ON THE SHOULDER. AND THERE I WAS!'

CREATES GEOMETRIC, HARD EDGE PAINTINGS, INFLUENCED BY THE BAUHAUS STYLE, INCLUDING THE WORK OF MONDRIAN AND MAX BILL. IS FRUSTRATED BY THE LACK OF A GREAT ART SCHOOL IN PARIS, SUCH AS THE BAUHAUS.

'A COUPLE OF US MADE THE PILGRIMAGE TO ZURICH TO SEE MAX BILL AND RICHARD LOHSE. PITY, NO BAUHAUS IN PARIS – ARCHITECTURE PLUS TYPOGRAPHY PLUS DESIGN-FOR-LIFE PLUS CINEMA PLUS PHOTOGRAPHY WERE RIGHT UP MY ALLEY.'
'THE IDEA OF BEING MULTI-DISCIPLINARIAN, DOING DIFFERENT THINGS, NOT ONLY IN PAINTING, BUT TYPOGRAPHY DESIGN, ARCHITECTURE, MOVIES AND PHOTOGRAPHY, WAS SOMETHING THAT WAS IN MY MIND, IF IT WASN'T IN EVERYBODY ELSE'S.'

READS LÁSZLÓ MOHOLY-NAGY'S *VISION IN MOTION* (1947). SELLS HIS CARTOONS TO PARISIAN MAGAZINES.

1951
EXHIBITS AT GALERIES DIETRICH AND LOU COSYN, BRUSSELS.

1952
FIRST EXHIBITION IN MILAN AT THE PICCOLO TEATRO, WHERE HE IS INVITED BY THE GREAT THEATRE DIRECTOR GIORGIO STREHLER. HE PAINTS A SERIES OF ABSTRACT MURALS FOR ITALIAN ARCHITECTS, FOLLOWING LÉGER'S ADVICE TO WORK LIKE PAINTERS OF THE QUATTROCENTO AND COLLABORATE WITH ARCHITECTS.

EXHIBITS IN MILAN AT THE GALLERIA DEL MILIONE. THE ARCHITECT ANGELO MANGIAROTTI COMMISSIONS HIM TO PAINT MURALS IN HIS BLACK AND WHITE STYLE. HE PAINTS THEM ON REVOLVING PANELS, MOUNTED ON RAILS SO THEY CAN BE COMBINED IN MANY DIFFERENT WAYS. TAKING PHOTOGRAPHS OF THESE PANELS AS THEY TURN, HE DISCOVERS HOW A BLURRING EFFECT CAN CHANGE GEOMETRICAL FORMS.

'THEY WERE ON RAILS, YOU COULD CHANGE THE ARRANGEMENT OF PANELS SOMETHING LIKE 2,000 DIFFERENT WAYS. I PHOTOGRAPHED THE ABSTRACT GEOMETRICAL PAINTINGS I'D DONE ON THESE PANELS AND HAD SOMEBODY TURN THEM DURING THE LONG EXPOSURE, SO THEY BLURRED. AND I REALISED THAT THERE MIGHT BE SOMETHING THAT COULD BE DONE WITH BLUR IN THE DARKROOM. THAT WAS MY FIRST REAL CONTACT WITH PHOTOGRAPHY.'

INFLUENCED BY MOHOLY-NAGY'S CREATIONS, HE STARTS EXPERIMENTING WITH ABSTRACTION AND PHOTOGRAPHY.

'THE FIRST STRAIGHT PHOTOGRAPHS THAT INTERESTED ME WERE THOSE OF THE FSA [THE US GOVERNMENT'S FAMILY SUPPORT ADMINISTRATION] SHOWING A *GRAPES OF WRATH* AMERICA.'

'MY REFERENCES? AUGUST SANDER, MAN RAY, RAOUL HAUSMANN, BILL BRANDT, JACOB RIIS, MOHOLY-NAGY, ALEXANDER RODCHENKO, ÉTIENNE-JULES MAREY, WALKER EVANS, EADWEARD MUYBRIDGE, LEWIS HINE, JOHN HEARTFIELD – AS WELL AS CHARLIE CHAPLIN, ERICH VON STROHEIM, ORSON WELLES, AND ALWAYS DZIGA VERTOV.'

GOES TO HOLLAND, ON THE ISLAND OF WALCHEREN, FOLLOWING IN THE STEPS OF MONDRIAN WHO STAYED THERE DURING THE FIRST WORLD WAR, AND TAKES BLACK AND WHITE PHOTOGRAPHS OF BARNS AND HOUSES WITH WHITE GRIDS.
IN NOVEMBER, HE DESIGNS HIS FIRST COVER FOR THE ITALIAN MAGAZINE *DOMUS*, AND WILL GO ON TO DO FIFTEEN OTHER ISSUES OF THE MAGAZINE FROM 1953 TO 1961.

1953
IN AUGUST, THE ARTICLE 'GRAPHIC ART THROUGH PHOTOGRAPHY – WILLIAM KLEIN' IS PUBLISHED IN *DOMUS*.
SPENDS MANY EVENINGS AT THE CINÉMATHÈQUE FRANÇAISE IN PARIS.

'THERE WAS NO BAUHAUS IN PARIS, BUT THERE WAS THE CINÉMATHÈQUE, THE MOST ACTIVE IN THE WORLD. FIVE DIFFERENT CLASSICS A DAY, LINES OF SEVERAL HUNDRED EVERY NIGHT, SOME WEEKS I WENT EVERY DAY. AND ONE FILM I WOULD SEE EVERY TIME AROUND WAS DZIGA VERTOV'S *MAN WITH A CAMERA* [1929].'

EXHIBITS AT GALLERY APOLLO, BRUSSELS.
EXHIBITION OF HIS ABSTRACT PHOTOGRAPHS AT THE SALON DES RÉALITÉS NOUVELLES IN PARIS.

1954
IN MARCH, AMERICAN *VOGUE* RUNS A PIECE ON CONTEMPORARY ROME THAT INCLUDES ONE OF KLEIN'S COVER DESIGNS FOR *DOMUS* MAGAZINE.
THE MONDRIAN-ESQUE PHOTOGRAPHS HE MADE OF HOUSES AND BARNS ON THE ISLAND OF WALCHEREN ARE PUBLISHED IN *VOGUE* ON 1 APRIL 1954.
BUYS A LEICA AND TWO LENSES IN PARIS FROM A MEMBER OF MAGNUM PHOTOS, WHO TURNS OUT TO BE HENRI CARTIER-BRESSON.
HIS LARGE ABSTRACT MURAL PANELS ARE PRESENTED IN SAARBRUCKEN, GERMANY, AT THE EXHIBITION *SUBJEKTIVE FOTOGRAFIE 2*.
RETURNS TO NEW YORK FOR EIGHT MONTHS AND ALEXANDER LIBERMAN, EDITOR OF AMERICAN *VOGUE*, WHO HAD SEEN HIS ABSTRACT PHOTOGRAPHS AT THE SALON DES RÉALITÉS NOUVELLES IN PARIS, OFFERS HIM A CONTRACT WITH THE MAGAZINE.

HE SAID TO KLEIN: 'IF YOU COME TO NEW YORK, COME TO SEE ME AND YOU CAN BECOME, LIKE, AN ART DIRECTOR OR SOMETHING IN THE MAGAZINE. IT WILL GIVE YOU A WAY OF MAKING A LIVING. MY OWN PREOCCUPATION IS PAINTING AND SCULPTURE, BUT I MAKE A LIVING AT *VOGUE*, WHICH GIVES ME FREE TIME TO WORK. IT'S SOMETHING MAYBE YOU COULD DO.'

KLEIN ANSWERED: 'WHY NOT? I DIDN'T LIKE THE IDEA OF TRYING TO SELL ONESELF AS A PAINTER, BUTTERING UP TO COLLECTORS AND CURATORS … I LIKED THE IDEA OF MAKING A LIVING WITH ONE HAND AND DOING EXACTLY WHAT I WANTED WITH THE OTHER.'

KLEIN COMES UP WITH THE IDEA OF MAKING A BOOK, A PHOTOGRAPHIC DIARY OF HIS RETURN TO NEW YORK, 'WITH ONE AMERICAN EYE AND ONE EUROPEAN'.

ALL THE EXPENSES FOR CHEMICALS, FILMS, PRINTING PAPER OR ENLARGER ARE PAID FOR BY *VOGUE*, FINANCING PHOTOGRAPHS WHICH, FOR KLEIN, 'WERE PROBABLY THE FUNKIEST AND MOST UNPUBLISHABLE OF THE DAY'.

'I WAS A MAKE-BELIEVE ETHNOGRAPHER – TREATING NEW YORKERS LIKE AN ANTHROPOLOGIST WOULD TREAT ZULUS – SEARCHING FOR THE RAWEST SNAPSHOT, THE ZERO DEGREE OF PHOTOGRAPHY.'

HE USES HIS SECONDHAND LEICA WITH THREE LENSES.

'AT ONE POINT, I DISCOVERED IN A CAMERA STORE THE WIDE-ANGLE LENS, RELATIVELY NEW AT THE TIME. IT WAS LOVE AT FIRST SIGHT. I RUSHED OUT IN THE STREET AND SHOT AWAY, AIMING, NOT AIMING, IT DIDN'T MATTER. I COULD NEVER GET ENOUGH INTO THE CAMERA. I WANTED IT ALL IN A GLUTTONOUS RAGE – THE WIDE ANGLE WAS THE SOLUTION. THE 28MM BECAME MY NORMAL LENS.'

EVEN THOUGH LIBERMAN ENCOURAGED HIM TO PRODUCE THIS PORTFOLIO FOR *VOGUE*, IT IS NOT PUBLISHED AND WILL NOT BE PUBLISHED IN AMERICA IN BOOK FORM UNTIL 1995, WITH THE TITLE *NEW YORK 1954–55*.
NEVERTHELESS, IN THE 15 NOVEMBER ISSUE OF *VOGUE*, A DOUBLE-PAGE SPREAD IS DEVOTED TO PHOTOGRAPHS BY KLEIN, WITH THE TITLE 'A NEW PHOTO GRAPHIC EYE'.
PRODUCES FASHION PHOTOGRAPHS FOR *VOGUE* UNTIL 1965 TO FINANCE HIS FILMS AND PHOTOGRAPHIC PROJECTS.
HE REVOLUTIONISES FASHION PHOTOGRAPHY, TAKING PICTURES OF MODELS IN THE STREET AND INTRODUCING MANY TECHNICAL INNOVATIONS SUCH AS THE USE OF LONG-FOCUS, WIDE-ANGLE LENSES OR OPEN FLASH.
WHILE IN NEW YORK, HE EXPERIMENTS WITH TRANSFERRING HIS ABSTRACT PHOTOGRAPHS 'INTO' GLASS, WORKING WITH THE CORNING GLASS FIRM. A SERIES OF SMALL PANELS IS CREATED BUT THE PROJECT TO PRODUCE LARGE STAINED-GLASS WINDOWS IS ABORTED, SINCE THE MANUFACTURERS WILL NOT CREATE LARGE NEW OVENS FOR INDUSTRIAL PRODUCTION.

'IN 1953, I LEARNED ABOUT A NEW PROCESS DEVELOPED BY CORNING GLASS WHERE PHOTOGRAPHS COULD BE TRANSFERRED INTO, NOT ON THE SURFACE OF, BUT INTO THE MASS OF GLASS. UP TO THEN, IT HAD ONLY BEEN USED TO PUT YOUR GRANDMOTHER'S FACE INTO A LOCKET. BUT I THOUGHT, WAIT, MY ABSTRACT PHOTOS COULD BECOME GLASS MURALS, FAÇADES, A NEW KIND OF STAINED-GLASS WINDOW. OKAY, NEW VISION, NEW MATERIALS, LET'S GO TO NEW YORK AND SEE.'

1956

TRIES WITHOUT LUCK TO PUBLISH HIS NEW YORK PHOTOGRAPHS IN AMERICA:

'THE PRINTS ACCUMULATED. I SAW A BOOK BUT EDITORS DIDN'T … "THIS ISN'T PHOTOGRAPHY", "THIS IS SHIT", "THIS IS NOT NEW YORK, TOO BLACK, TOO ONE-SIDED, THIS IS A SLUM".'

THANKS TO THE FILMMAKER CHRIS MARKER, WHO WAS ALSO AN EDITOR AT THE PUBLISHING HOUSE ÉDITIONS DU SEUIL AND IS KNOWN TO HAVE SAID 'THIS IS GOING TO BE A BOOK OR I QUIT', KLEIN'S FIRST BOOK, *LIFE IS GOOD & GOOD FOR YOU IN NEW YORK: TRANCE WITNESS REVELS*, IS PUBLISHED IN FRANCE BY LE SEUIL AND SIMULTANEOUSLY IN LONDON AND MILAN.

'I KNEW WHAT KIND OF BOOK I WANTED TO DO BUT ONLY GUESSED HOW TO GO ABOUT IT. I HAD TO FIND WAYS OF PHOTOGRAPHING – USING LUCK, ACCIDENTS, BASIC MATERIAL: ONE CAMERA, TWO LENSES, BASTA, *FOTOGRAFIA POVERA*. POOR. ACTUALLY, I HAD NO CHOICE BUT FELT THAT'S THE WAY IT SHOULD BE. THE SUB-TITLE WAS, IN TABLOID-SPEAK, "TRANCE WITNESS REVELS". IN THREE WORDS, IT WAS ALL I HAD TO SAY ABOUT PHOTOGRAPHY, AT LEAST THE KIND I DID THEN. TRANCE + CHANCE, WITNESS = WITNESS, REVELS + REVEALS.'

HAVING HAD NO FORMAL TRAINING IN PHOTOGRAPHY, HE INVENTS NEW WAYS OF TAKING PICTURES. INFLUENCED BY THE GRAPHIC DESIGN OF THE NEW YORK *DAILY NEWS* AND THE TABLOIDS, AS THE TITLE REVEALS, HE PRODUCES RAW, 'CONTRASTY' AND SOMETIMES BLURRED IMAGES, REVOLUTIONISING THE ESTABLISHED ORDER OF THE PHOTOGRAPHY WORLD. HE EXPERIMENTS WITH FLASHES, WIDE-ANGLE OR HIGH-GRAIN FILM AND PRODUCES A MORE VIOLENT IMAGE THAN ROBERT FRANK DID, IN HIS BOOK *THE AMERICANS*, PUBLISHED IN 1958.
KLEIN EXPERIMENTS WITH NEW GRAPHIC PRESENTATION AND PRINTS HIS BOOK WITH A HIGH CONTRAST, PARTLY DUE TO THE ROTOGRAVURE PRINTING PROCESS USED FOR THE BOOK AT ROTO-SADAGIN GENEVA, WHICH OFFERS HIM A CHOICE OF EITHER GREYS OR BLACK AND WHITE. HE CHOOSES THE LATTER. HE PAYS ATTENTION TO THE WHOLE PROCESS, FROM PHOTOGRAPHING TO PRINTING THE BOOK, AND CONSIDERS THAT PHOTOGRAPHERS WHO LET OTHERS DO IT ARE 'NOT DOING THEIR JOB'.

'MY AESTHETIC WAS THE NEW YORK *DAILY NEWS*. I SAW THE BOOK I WANTED TO DO AS A TABLOID GONE BERSERK, GROSS, GRAINY, OVER-INKED, WITH A BRUTAL LAYOUT, BULL-HORN HEADLINES. THIS IS WHAT NEW YORK DESERVED AND WOULD GET.

'IT SEEMS TO ME THAT THE PHOTOGRAPHIC PROCESS IS SOMETHING THAT'S COMPLETE. YOU TAKE THE PHOTOGRAPHS, YOU CHOOSE THEM, YOU LAY THEM OUT, YOU DO THE BOOK, YOU DO THE TYPOGRAPHY, YOU DO EVERYTHING, YOU DO THE TEXT, AND THEN IT BECOMES YOUR BOOK. I DO THE SAME THING WITH MOVIES. I'VE NEVER BEEN ABLE TO DO A FILM WITH ANYBODY ELSE'S SCENARIO.'

KLEIN'S BOOK IS TO BECOME HIGHLY INFLUENTIAL FOR MANY PHOTOGRAPHERS. ACCORDING TO THE JAPANESE PHOTOGRAPHER DAIDO MORIYAMA, 'KLEIN'S IMAGES, WHICH WERE ROUGH, SIMPLE, AND EVEN VIOLENT AT FIRST GLANCE, MADE ME REALIZE THE LIMITLESS FREEDOM, BEAUTY, AND TENDERNESS OF PHOTOGRAPHIC ART.' AND FOR MARTIN PARR: 'TO MY MIND, THE MOST INFLUENTIAL AND RADICAL PHOTO BOOK PUBLISHED IN THE LAST CENTURY WAS WILLIAM KLEIN'S *NEW YORK*. UNLIKE ROBERT FRANK'S EQUALLY INFLUENTIAL *THE AMERICANS*, KLEIN SUCCEEDED IN CHANGING THE WAY PHOTOGRAPHERS CREATED BOOKS. HIS RADICAL APPROACH TO DESIGN, HIS ABILITY TO CAPTURE ENERGY AND DYNAMISM IN HIS PHOTOGRAPHY, ALL THE EFFECTS OF HIS WORK RIPPLED ACROSS THE WORLD; YOU COULD SEE IT IN ARGENTINA, IN SPAIN, ALL THE WAY TO JAPAN.'

FEDERICO FELLINI SEES THE BOOK AND HIRES KLEIN AS AN ASSISTANT FOR HIS NEXT FILM, *NIGHTS OF CABIRIA* (1957). ONCE IN ROME, DELAYS IN THE FILMING LEAD KLEIN TO GO AND PLUNDER THE STREETS TO TAKE PICTURES. HE MEETS PIER PAOLO PASOLINI, WHO WILL WRITE TEXTS FOR HIS BOOK ON ROME.

1957

THE *NEW YORK* BOOK WINS THE FRENCH PHOTOGRAPHY BOOK PRIZE, THE PRIX NADAR.

1958

ENCOURAGED BY THE FILMMAKER CHRIS MARKER, WHO INTRODUCES HIM TO ALAIN RESNAIS, MEMBER OF THE FRENCH NEW WAVE GROUP 'LEFT BANK', KLEIN BEGINS TO WORK WITH FILM. DIRECTS THE EXPERIMENTAL SHORT *BROADWAY BY LIGHT*, OF TIMES SQUARE'S NEON AND TUNGSTEN SIGNS, WHICH WAS, FOR ORSON WELLES, 'THE FIRST FILM [HE HAS] SEEN IN WHICH COLOUR WAS ABSOLUTELY NECESSARY'. WHAT KLEIN CALLS A 'READY-MADE' OR THE FIRST POP FILM, IT ILLUSTRATES PERFECTLY HIS TRANSITION FROM PHOTOGRAPHER TO FILMMAKER.

1959

HIS BOOK *ROME* IS PUBLISHED IN MILAN BY FELTRINELLI, IN PARIS BY LES ÉDITIONS DU SEUIL, AND IN NEW YORK BY VIKING. DIRECTS AND PRODUCES THE SHORT FILM *HOW TO KILL A CADILLAC*.

1959–1960

TRAVELS TO RUSSIA TO WORK ON A PHOTOGRAPHIC BOOK OF MOSCOW (PUBLISHED 1964).

1960

KLEIN IS THE ARTISTIC DIRECTOR FOR LOUIS MALLE'S *ZAZIE DANS LE MÉTRO* (*ZAZIE IN THE UNDERGROUND*), AN ADAPTATION OF RAYMOND QUENEAU'S NOVEL PUBLISHED A YEAR EARLIER.

1961

ZOKEISHA PUBLICATIONS IN TOKYO INVITES KLEIN TO DO A BOOK ON TOKYO AND IS WILLING TO PUBLISH HIS PHOTOGRAPHS OF MOSCOW. TRAVELS TO JAPAN DURING THE SPRING. EXHIBITION AT THE FUJI GALLERY, TOKYO.

'GOING TO TOKYO KNOCKED ME OUT ... I WOULD PHOTOGRAPH DAY AND NIGHT AND BE SURPRISED BY EVERYTHING.'

1962
DIRECTS FIVE DOCUMENTARY FILMS FOR THE FRENCH TELEVISION PROGRAMME *CINQ COLONNES À LA UNE* (*FRONT PAGE*). ONE OF THEM, *THE FRENCH AND POLITICS*, A NEGATIVE PORTRAYAL OF THE WAY THE FRENCH VIEW THEIR POLITICIANS, IS CENSORED JUST BEFORE IT GOES ON AIR BY THE MINISTER OF INFORMATION AND GOVERNMENT REPRESENTATIVES.
PLAYS A CAMEO WITH HIS WIFE AS THE PEOPLE OF THE FUTURE IN CHRIS MARKER'S *LA JETÉE* (*THE JETTY*).

1963
DIRECTS THE DOCUMENTARY *AUX GRANDS MAGASINS* (*THE DEPARTMENT STORE*), STARRING SIMONE SIGNORET, FOR FRENCH TELEVISION.
BIRTH OF HIS SON PIERRE.

1964
THE PHOTOGRAPHY BOOKS *MOSCOW* AND *TOKYO* ARE PUBLISHED BY ZOKEISHA IN JAPAN.

ON 25 FEBRUARY, SHOOTS THE CHAMPIONSHIP FIGHT BETWEEN CASSIUS CLAY AND SONNY LISTON IN MIAMI FOR HIS FILM *CASSIUS LE GRAND* (*CASSIUS THE GREAT*).

KLEIN 'WANTED TO DO A FILM ON THE POLARISATION OF GOOD AND EVIL IN AMERICA AROUND A HEAVYWEIGHT CHAMPIONSHIP FIGHT'.

THE FILM, WHICH WILL LATER BE REVISED TO MAKE *MUHAMMAD ALI, THE GREATEST* IN 1974, IS AWARDED THE GRAND PRIX DU FESTIVAL INTERNATIONAL DE TOURS.

1965
SETS ASIDE PHOTOGRAPHY TO SPECIALISE IN FILMMAKING UNTIL THE EARLY 1980S.

1965–1966
DIRECTS HIS FIRST FEATURE FILM, *QUI ÊTES-VOUS, POLLY MAGGOO?* (*WHO ARE YOU, POLLY MAGGOO?*), A BITING SATIRE OF MEDIA AND THE FASHION INDUSTRY, RELATING THE STORY OF A YOUNG AMERICAN MODEL IN PARIS WHO GETS CAUGHT UP IN A SURREAL FASHION FAIRYTALE; IT IS RELEASED IN 1966.

1967
QUI ÊTES-VOUS, POLLY MAGGOO? IS A PUBLIC AND CRITICAL SUCCESS AND WINS THE PRIX JEAN VIGO.
CO-DIRECTS *LOIN DU VIETNAM* (*FAR FROM VIETNAM*), AN INDICTMENT OF THE US INVASION OF VIETNAM, ALONGSIDE JEAN-LUC GODARD, JORIS IVENS, CLAUDE LELOUCH, CHRIS MARKER, ALAIN RESNAIS AND AGNÈS VARDA.
BEGINS A SERIES OF MORE POLITICAL FILMS, SINCE 'A MID-LIFE CRISIS OF POLITICS GOT TO [HIM]'. HIS VIETNAM FILM DOES NOT HELP HIM TO FIND FINANCING FOR HIS NEXT PROJECTS AND EVEN CAUSES A SMALL SCANDAL.
AS HE RECALLS:

'A FASHION TABLOID, *WOMEN'S WEAR DAILY*, DID A FRONT-PAGE HEADLINE ON *FAR FROM VIETNAM*: "FAMOUS VOGUE PHOTOGRAPHER DOES ANTI-AMERICAN FILM." THE STORY MADE THE FRONT PAGE OF THE *WASHINGTON POST* AS WELL.'

BEGINS TO SHOOT THE FEATURE FILM *MISTER FREEDOM*, AN ANTI-AMERICAN COMIC-BOOK SATIRE STARRING A SUPERHERO SENT TO FRANCE, WHICH IS DEPICTED AS A THIRD-WORLD COUNTRY, TO FIGHT AGAINST THE COMMUNISTS AND MAOISTS; HALF THE COUNTRY ENDS UP BEING DESTROYED.

'FRUSTRATED BY THE LIMITED AUDIENCE A DOCUMENTARY REACHES, I THOUGHT A CARTOON + CIRCUS FILM MORE ACCESSIBLE. ALSO MORE IN KEEPING WITH OUR COMIC-STRIP POLITICIANS AND IDEOLOGY.'

EXHIBITION *WILLIAM KLEIN, SCHILDERIJEN, FOTO'S, FILMS* AT THE STEDELIJK MUSEUM IN AMSTERDAM.

1968
IN MAY, HE STOPS FILMING *MISTER FREEDOM* BECAUSE THE CINEMATOGRAPHIC INDUSTRY IS ON STRIKE. HE MEETS STUDENTS FROM THE SORBONNE WHO ARE LOOKING FOR A DIRECTOR TO MAKE A FILM ON THE SOCIAL PROTESTS, AND SHOOTS IN THE STREETS AND UNIVERSITY.

1969
MISTER FREEDOM IS FINALLY RELEASED, AFTER BEING CENSORED FOR NINE MONTHS BY THE FRENCH GOVERNMENT ON THE GROUNDS THAT THEY BELIEVED IT WAS ABOUT MAY 1968.
DIRECTS A COLLECTIVE DOCUMENTARY ON THE FIRST PAN-AFRICAN FESTIVAL OF ALGIERS IN JULY. THIS WORK, PRODUCED BY THE ALGERIAN NATIONAL OFFICE FOR CINEMATOGRAPHIC TRADE AND INDUSTRY (ONCIC), COVERS THE CULTURAL EXPLOSION OF LIBERATED AFRICAN COUNTRIES AS WELL AS THE LIBERATION MOVEMENTS. IT ENDS WITH THE WORDS 'AFRICAN CULTURE WILL BE REVOLUTIONARY OR WILL NOT BE'.

THE AMERICAN WRITER AND ACTIVIST ELDRIDGE CLEAVER, MEMBER OF THE REVOLUTIONARY ORGANISATION THE BLACK PANTHER PARTY FOR SELF-DEFENSE, WHO WAS IN EXILE IN ALGIERS AT THE TIME, SEES KLEIN WORKING AND ASKS HIM TO MAKE A MOVIE ABOUT HIM. KLEIN THEREFORE DIRECTS *ELDRIDGE CLEAVER, BLACK PANTHER*, A FILM FINANCED BY THE ALGERIAN NATIONAL FILM BOARD.

1971
PAN-AFRICAN FESTIVAL OF ALGIERS IS SELECTED AND SCREENED AT THE CANNES FILM FESTIVAL IN THE 'PARALLEL SECTION' OF INDEPENDENT DIRECTORS.

1972–1989
DURING THIS PERIOD, KLEIN PRODUCES MORE THAN 250 TV COMMERCIALS FOR CLIENTS INCLUDING RENAULT, CITROËN, FIAT, YVES ST LAURENT AND THE DIM HOSIERY FIRM. ACCORDING TO HIM,

'IT WAS A WAY OF LEARNING NEW TECHNIQUES [AND] FINANCING OTHER PROJECTS, BUT RATHER A WASTE OF TIME'.

1974
IN OCTOBER HE GOES TO KINSHASA, ZAIRE, TO FILM MUHAMMAD ALI'S FIGHT AGAINST GEORGE FOREMAN. HIS DOCUMENTARY *CASSIUS LE GRAND* IS THEN RE-EDITED AS *MUHAMMAD ALI, THE GREATEST*, A DEFINITIVE RETROSPECTIVE FILM OF ALI, INCLUDING THE RECOVERY OF HIS CROWN AND HIS LEGEND AT KINSHASA.

1975
EXHIBITION AND FILM RETROSPECTIVE AT THE CINÉMATHÈQUE QUÉBÉCOISE IN MONTREAL.

1975–1976
DIRECTS *THE MODEL COUPLE*, A FEATURE FILM ABOUT 'A MODEL COUPLE IN A MODEL APARTMENT WHO WERE BEING SPIED ON, MANIPULATED AND TESTED NIGHT AND DAY – A SCIENCE FICTION FARCE'. HE WANTED TO MAKE A FILM ABOUT THE CREATION OF NEW CITIES, BUT THE FILM COMPANY GAUMONT BACKED OUT OF THE PROJECT AND HE ONLY HAD ENOUGH MONEY TO FILM THE STORY OF A COUPLE CHOSEN BY THE FRENCH 'MINISTRY OF THE FUTURE' AS MODELS FOR THE FUTURE CITIZENS OF 2000.

'THE FRENCH HAD THESE DELUSIONS OF GRANDEUR, INHERITED FROM DE GAULLE. THEY WANTED TO MAKE, OUT OF NOTHING, NEW CITIES, AND I WANTED TO SHOW HOW RIDICULOUS ALL THIS WAS.'

1977
SHOOTS *HOLLYWOOD, CALIFORNIA: A LOSER'S OPERA*. SOLO EXHIBITIONS AT THE SAN FRANCISCO MUSEUM OF MODERN ART, THE CINCINNATI ART INSTITUTE, AND THE MUSEUM OF FINE ARTS IN ST PETERSBURG, FLORIDA.

1978
MAYDAYS, HIS DOCUMENTARY FILM ABOUT THE SOCIAL PROTESTS OF MAY 1968, IS RELEASED. DIRECTS *MUSIC CITY, U.S.A.* IN NASHVILLE, TENNESSEE. PARTICIPATES IN THE EXHIBITION *10 PHOTOGRAPHERS FROM ATGET TO KLEIN* AT THE MASSACHUSETTS INSTITUTE OF TECHNOLOGY, CAMBRIDGE, MASSACHUSETTS, AND HAS SOLO EXHIBITIONS AT THE PHOTOGRAPHER'S GALLERY IN LONDON, THE GALERIE FIOLET IN AMSTERDAM, CODA MUSEUM IN APELDOORN, THE NETHERLANDS, AND CANON GALLERY, BASEL. IS GUEST OF HONOUR AT THE 10TH INTERNATIONAL PHOTOGRAPHY FESTIVAL IN ARLES.

1979
RETROSPECTIVE OF HIS WORK AT THE FONDATION NATIONALE DE LA PHOTOGRAPHIE IN LYON.

1980s
HE CONTINUES TO WORK AS A FILMMAKER, BUT ALSO RETURNS TO PHOTOGRAPHY AND PRODUCES NEW BOOKS.

1980
AT THE BEGINNING OF JULY, MAKES A SERIES OF WHAT HE CALLS LIVING CORPSES ON THE BEACHES OF THE RIVIERA AND CONEY ISLAND, NEW YORK. SHOOTS *THE LITTLE RICHARD STORY*, A PORTRAIT OF THE ROCK AND ROLL LEGEND AND HIS FANS. KLEIN IS FORCED TO EMPLOY IMPERSONATORS OF LITTLE RICHARD AFTER THE REAL-LIFE CHARACTER LEAVES THE FILM SET FOR PERSONAL AND FINANCIAL REASONS. SOLO SHOWS AT THE MUSEUM OF MODERN ART IN NEW YORK, THE MINNEAPOLIS INSTITUTE OF ARTS, THE CALIFORNIA STATE UNIVERSITY IN LONG BEACH AND THE DELAWARE ART MUSEUM IN WILMINGTON.

1981
SHOOTS *ROLAND GARROS (THE FRENCH)*, A DOCUMENTARY ON THE FRENCH OPEN TENNIS CHAMPIONSHIP IN PARIS. EXHIBITS HIS WORK IN PARIS AT THE GALERIE ZABRISKIE, THE AMERICAN CULTURAL CENTRE AND THE CINÉMATHÈQUE; THE PHOTOGRAPHERS' GALLERY IN LONDON; THE NEW YORK AND LOS ANGELES BRANCHES OF THE LIGHT GALLERY; AND THE IKONA GALLERY IN VENICE.

1982
SHOWS HIS WORK AT THE MUNICIPAL GALLERY IN ALBI, IN SOUTHERN FRANCE, AT THE INTERNATIONAL FESTIVAL OF MALMÖ, SWEDEN, AND AT THE GALERIE MUNICIPALE DU CHÂTEAU D'EAU, TOULOUSE.

1983
KLEIN DECONSTRUCTS HIS TECHNIQUE IN THE PILOT OF THE TELEVISION SERIES ON PHOTOGRAPHY, *CONTACTS*. SOLO EXHIBITION *WILLIAM KLEIN: PHOTOGRAPHE, ETC.*, AT THE CENTRE GEORGES POMPIDOU IN PARIS.

1984
SHOOTS THE SHORT FILM *RALENTIS (SLOW MOTION)*, A STUDY ON THE MOVEMENT OF ATHLETES. SOLO EXHIBITIONS AT THE MUNICIPAL GALLERIES IN ZAGREB AND BELGRADE. HIS WORK IS INCLUDED IN THE GROUP EXHIBITIONS *SUBJEKTIVE FOTOGRAFIE: IMAGES OF THE FIFTIES*, MUSEUM FOLKWANG, ESSEN.

1985
JACK LANG, THE FRENCH MINISTER OF CULTURE, COMMISSIONS KLEIN TO MAKE A FILM ABOUT NEW FASHION MOVEMENTS IN THE 1980S, *MODE EN FRANCE (FASHION IN FRANCE)*, COMPOSED OF THIRTEEN SEQUENCES, EACH IN A DIFFERENT MOVIE STYLE, FROM DOCUMENTARY TO THRILLER. KLEIN'S WORK IS INCLUDED IN *THE NEW YORK SCHOOL PHOTOGRAPHS, 1935–63, PARTS 1 AND 2*, CORCORAN GALLERY OF ART IN WASHINGTON, DC; AND *SHOTS OF STYLE* AT THE VICTORIA AND ALBERT MUSEUM, LONDON.

1986
AWARDED THE GRAND PRIX NATIONAL DE LA PHOTOGRAPHIE IN FRANCE. HIS WORK IS INCLUDED IN GROUP EXHIBITIONS INCLUDING THE FOTOFEST BIENNIAL IN HOUSTON, TEXAS; AND *THE NEW YORK SCHOOL PHOTOGRAPHS: 1935–63, PART 3* AT THE CORCORAN GALLERY OF ART IN WASHINGTON, DC.

1987
PARTICIPATES IN THE GROUP EXHIBITIONS *PHOTOGRAPHY AND ART 1946–1986*, LOS ANGELES COUNTY MUSEUM OF ART; AND *AMERICAN DREAMS*, CENTRO DE ARTE REINA SOFÍA, MADRID. SOLO SHOWS INCLUDE *WILLIAM KLEIN: AN AMERICAN IN PARIS* AT THE MUSEUM OF PHOTOGRAPHIC ARTS, SAN DIEGO; AND PRINTEMPS GINZA, TOKYO. RECEIVES THE KULTURPREIS IN GERMANY.

1988
KLEIN'S WORK IS SHOWN AT THE ÉLYSÉE MUSEUM AND SWISS CINÉMATHÈQUE, LAUSANNE. RECEIVES THE GUGGENHEIM FELLOWSHIP AWARD. SOLO EXHIBITIONS AT OSAKA MUSEUM, OSAKA, AND GALERIE ARENA, ARLES.

1989
CLOSE UP IS PUBLISHED, FEATURING THE POPE AT LOURDES AND THE 1988 DEMOCRATIC CONVENTION. DIRECTS FOUR SHORT DOCUMENTARIES: *CARTE D'IDENTITÉ (ID)*, *ÉTAT DES LIEUX (EVIDENCE)*, *LA GRANDE ARCHE (THE GREAT ARCH)* AND *CINÉ DÉFENSE*, FOR THE 200TH ANNIVERSARY OF THE FRENCH REVOLUTION. THE WALKER ART CENTER IN MINNEAPOLIS PRODUCES THE FIRST US TOUR OF KLEIN'S FILMS, *CINEMA OUTSIDER: THE FILMS OF WILLIAM KLEIN*. MADE COMMANDER OF ARTS AND LETTERS IN FRANCE. SOLO EXHIBITIONS AND FILM CYCLES AT THE MUSEUM FOLKWANG, ESSEN; THE MUSEUM OF THE MOVING IMAGE, LONDON; AND THE FINNISH FILM ARCHIVES, HELSINKI.

1990s

KLEIN EXPLORES THE LINKS BETWEEN PAINTING AND PHOTOGRAPHY IN HIS PAINTED CONTACT SHEETS. HE SAYS HE

'SAW THE POSSIBILITY OF INVENTING A NEW KIND OF ART OBJECT BY MARRYING ORGANICALLY, NOT ARBITRARILY, PAINTING AND PHOTOGRAPHY'.

KLEIN'S IDEA TO PAINT ON CONTACT SHEETS AROSE WHILE HE WAS MAKING THE PILOT FOR A SERIES OF FILMS ON PHOTOGRAPHY FOR TELEVISION. HIS CONCEPT FOR THE SERIES WAS BASED ON A CAMERA TRACKING OVER A CONTACT SHEET, WITH A COMMENTARY BY THE PHOTOGRAPHER. IT SHOWED HOW A PICTURE WAS TAKEN AND ALLOWED THE PHOTOGRAPHERS TO EXPLAIN HOW AND WHY. BY THIS TIME, THERE ARE FORTY FILMS ABOUT MAJOR PHOTOGRAPHERS. ACCORDING TO ROBERT DELPIRE, WRITING IN HIS INTRODUCTION TO THE BOOK *WILLIAM KLEIN: CONTACTS* (2008):

'FACED WITH THE SUCCESS OF THESE FILMS, WILLIAM KLEIN BEGAN TO LOOK AT CONTACTS THROUGH NEW EYES. AND HE SAW FURTHER AHEAD. HE WENT ON TO DEMONSTRATE THE IMPORTANCE HE ATTRIBUTED TO HIS CHOICES BY ISOLATING THE CHOSEN PICTURES, PRINTING THEM IN LARGE FORMATS, AND REPLACING THE GREASE PENCIL MARKS WITH THICK LINES OF PAINT, IN HIS DESIRE TO FORCE THE SPECTATOR TO CONSIDER NO LONGER JUST THE PICTURE AND ITS PERFECT COMPOSITION, BUT THE VIRTUOSITY OF ANOTHER ARCHITECTURE. THERE WAS NOTHING DECORATIVE ABOUT THIS APPROACH, BUT THE WILL TO CREATE A GRAPHIC BRIDGE BETWEEN PAINTING AND PHOTOGRAPHY THAT WAS TO BE APPRECIATED AS SUCH, A WORK THE LIKE OF WHICH HAD NEVER BEEN SEEN BEFORE.'

1990

PUBLISHES *TORINO '90* ON THE TRANSFORMATION OF THE POPULATION OF TURIN BY THE WORLD CUP.
SOLO EXHIBITION AT THE NATIONAL LIBRARY, TURIN.
RECEIVES THE HASSELBLAD PRIZE, THE INTERNATIONAL PHOTOGRAPHY AWARD, AND IS GIVEN A EXHIBITION IN RECOGNITION OF HIS ACHIEVEMENT AT THE HASSELBLAD CENTER, GOTHENBURG, WHICH THEN TOURS.

1991

DIRECTS A DOCUMENTARY, *BABILÉE'91*, ABOUT THE FAMOUS FRENCH DANCER JEAN BABILÉE, WHO AT THE AGE OF SIXTY-EIGHT RETURNS TO DANCE.

1992

SOLO EXHIBITIONS AT BEAUX-ARTS, ALMERÍA; MUNICH STADTMUSEUM, MUNICH; AND HOWARD GREENBERG GALLERY, NEW YORK.
PORTRAITS D'UNE CAPITALE: DE DAGUERRE À WILLIAM KLEIN. COLLECTIONS PHOTOGRAPHIQUES DU MUSÉE CARNAVALET, MUSÉE CARNAVALET, PARIS.

1993

IN AND OUT OF FASHION, A DOCUMENTARY USING EXTRACTS OF KLEIN'S FILMS, AS WELL AS HIS PHOTOGRAPHS AND PAINTINGS, IS RELEASED. AWARDED THE AGFA-BAYER/ HUGO ERFURT PRIZE.
SOLO EXHIBITION AT MUSEUM MORSBROICH, LEVERKUSEN, GERMANY.
KLEIN SHOWS AT THE PHOTOGRAPHY EXHIBITION *PRINTEMPS DE LA PHOTO*, CAHORS.

1994

HIS BOOK *IN AND OUT OF FASHION* IS PUBLISHED, FEATURING PHOTOGRAPHS PUBLISHED IN *VOGUE*, COSTUMES HE DESIGNED FOR HIS FILMS AND, FOR THE FIRST TIME, BACKSTAGE SHOTS OF PARIS'S COUTURE INDUSTRY.
SOLO EXHIBITIONS AT THE INTERNATIONAL CENTER OF PHOTOGRAPHY, NEW YORK; THE PRESIDENTIAL PALACE, PRAGUE (PRESENTED BY VÁCLAV HAVEL); SLOVENSKÁ NÁRODNÁ GALÉRIA, BRATISLAVA; AND HAMILTONS GALLERY, LONDON.

1995

A NEW EDITION OF HIS BOOK OF IMAGES OF NEW YORK, ENTITLED *NEW YORK 1954–55*, IS PUBLISHED, WITH A PREFACE BY THE ARTIST. ACCORDING TO KLEIN, 'THE FIRST BOOK WAS ABOUT GRAPHIC DESIGN, THE SECOND WAS ABOUT PHOTOGRAPHY'.
SOLO EXHIBITION, *LIFE IS GOOD & GOOD FOR YOU IN NEW YORK*, AT THE SAN FRANCISCO MUSEUM OF MODERN ART, MARKS THE OPENING OF THE NEW BUILDING.

1996

SOLO EXHIBITIONS AT HOWARD GREENBERG GALLERY, NEW YORK; CAIXA FOUNDATION, BARCELONA, MADRID AND THE CANARY ISLANDS; WALKER ART CENTER, MINNEAPOLIS; AND MAISON EUROPÉENNE DE LA PHOTOGRAPHIE, PARIS (*NEW YORK 1945–1955*).

1997

SOLO SHOWS OF HIS MOSCOW PHOTOGRAPHS AT THE PUSHKIN MUSEUM OF FINE ARTS, MOSCOW; SAINT-GERVAIS CENTER, GENEVA; AND THE NATIONAL FOUNDATION, MADRID.

1999

MESSIAH (LE MESSIE), A DOCUMENTARY DIRECTED BY KLEIN MIXING SACRED AND PROFANE, WITH G.F. HANDEL'S *MESSIAH* CONDUCTED BY MARC MINKOWSKI AND PERFORMED BY LES MUSICIENS DU LOUVRE-GRENOBLE, IS RELEASED.
WORK EXHIBITED AT THE FIAC CONTEMPORARY ART FAIR, PARIS.
SOLO EXHIBITION AT THE SCOTTISH NATIONAL GALLERY, EDINBURGH.
AWARDED THE MEDAL OF THE CENTURY BY THE ROYAL PHOTOGRAPHIC SOCIETY IN LONDON.

2000

THE EXHIBITION *WILLIAM KLEIN, HELMUT NEWTON, IRVING PENN* IS HELD AT THE MAISON EUROPÉENNE DE LA PHOTOGRAPHIE, PARIS.

2001

KLEIN'S WORK FEATURES IN *OPEN CITY: STREET PHOTOGRAPHS SINCE 1950*, THE MUSEUM OF MODERN ART, OXFORD; AND HIRSHHORN MUSEUM AND SCULPTURE GARDEN, WASHINGTON, DC. EXHIBITION OF KLEIN'S *PAINTED CONTACTS* AT THE CHARLES COWLES GALLERY, NEW YORK.

2002
ENCOURAGED BY THE MAISON EUROPÉENNE DE LA PHOTOGRAPHIE, KLEIN PRODUCES A SERIES OF PHOTOGRAPHS OF PARIS, WHICH RESULT IN THE BOOK *PARIS + KLEIN*, AND ARE SHOWN AT THE GALLERY IN THE EXHIBITION *PARIS + KLEIN*.

2004
SOLO EXHIBITION AT THE HOUSE OF PHOTOGRAPHY, MOSCOW.
KLEIN'S FILMS ARE INCLUDED AT THE LOCARNO FILM FESTIVAL, LOCARNO.
KLEIN PARTICIPATES, WITH A PORTRAIT OF LILLE, IN THE TRANSPHOTOGRAPHIQUES FESTIVAL IN LILLE.

2005
MAJOR RETROSPECTIVE OF KLEIN'S WORK, INCLUDING HIS PHOTOGRAPHS AND FILMS, CENTRE GEORGES POMPIDOU, PARIS.
RECEIVES THE GRAND PRIZE PHOTOESPAÑA AT THE EPONYMOUS INTERNATIONAL FESTIVAL OF PHOTOGRAPHY AND VISUAL ARTS.
KLEIN'S WORK IS INCLUDED IN THE EXHIBITION *EDITAT, EXPOSAT: LA FOTOGRAFIA, DEL LLIBRE AL MUSEU*, MUSEU NACIONAL D'ART DE CATALUNYA, BARCELONA.
HE IS THE 2005 RECIPIENT OF THE LUCIE AWARD FOR LIFETIME ACHIEVEMENT.

2007
SOLO EXHIBITIONS INCLUDE *WILLIAM KLEIN: PRINTS 1955–2007*, HOWARD GREENBERG GALLERY, NEW YORK; *ITALIE: DOUBLE VISION*, MAISON EUROPÉENNE DE LA PHOTOGRAPHIE, PARIS; *WILLIAM KLEIN*, ARTOTHÈQUE MUNICIPALE DE GRENOBLE. HIS FILMS ARE SCREENED AT THE 48TH THESSALONIKI INTERNATIONAL FILM FESTIVAL, ALONGSIDE AN EXHIBITION AT THE MACEDONIAN MUSEUM OF CONTEMPORARY ART, WITH PHOTOGRAPHS OF GREECE TAKEN FROM 1957 TO 1963, WHICH HAD NEVER BEEN SHOWN BEFORE.

RECEIVES THE 2007 INFINITY AWARD FOR LIFETIME ACHIEVEMENT FROM THE INTERNATIONAL CENTER OF PHOTOGRAPHY, NEW YORK.

2008
HIS PHOTOGRAPHS ARE SHOWN AT SOLO EXHIBITIONS IN PARIS INCLUDING *MAI 68*, AT THE COSMOS GALERIE; *PARIS EN COULEURS* AT THE HÔTEL DE VILLE; AND *RÉALITÉS* AT THE MAISON EUROPÉENNE DE LA PHOTOGRAPHIE.

2009
ROME + KLEIN, A TWO-VOLUME NEW EDITION OF HIS 1959 BOOK *ROME: THE CITY AND ITS PEOPLE*, IS PUBLISHED BY CONTRASTO IN ROME AND APERTURE IN NEW YORK.
RETROSPECTIVE OF HIS FILM WORK AT THE AUSTRALIAN CENTRE FOR MOVING IMAGES, MELBOURNE.
REVIVAL OF THE PAN-AFRICAN FESTIVAL IN ALGERIA, WHERE KLEIN'S 1969 MOVIE OF THE SAME NAME OPENS THE FESTIVAL.
SOLO EXHIBITION *KLEIN & CIE* AT THE POLKA GALERIE IN PARIS.

2010
AWARDED AN HONORARY DOCTORATE AT THE UNIVERSITY OF LIÈGE.
GROUP SHOW, *STREET SEEN: THE PSYCHOLOGICAL GESTURE IN AMERICAN PHOTOGRAPHY, 1940–1959*, AT MILWAUKEE ART MUSEUM.

2011
KLEIN'S PHOTOGRAPHIC MONTAGE OF CROWD SCENES CELEBRATING PRINCE WILLIAM AND KATE MIDDLETON'S WEDDING IN LONDON ON 29 APRIL IS PUBLISHED IN THE FRENCH MAGAZINE *POLKA*.
KLEIN'S 1950S PHOTOGRAPHS OF ROME ARE EXHIBITED IN *ROMA + KLEIN* AT THE MAISON EUROPÉENNE DE LA PHOTOGRAPHIE, PARIS.
AS PART OF THE LYON BIENNALE, THE EXHIBITION *KLEIN + 10 COLLECTIONNEURS* IS SHOWN AT THE GALERIE LE RÉVERBÈRE, AS WELL AS A RETROSPECTIVE OF HIS FILMS AT THE INSTITUT LUMIÈRE.
BEGINS WORK ON A NEW BOOK, *ANYWHERE*.

2012
IN MARCH, KLEIN EXHIBITS WORK AND SHOWS FILMS AT THE MULTI MEDIA ART MUSEUM, MOSCOW.
IN APRIL, RECEIVES THE OUTSTANDING CONTRIBUTION TO PHOTOGRAPHY AWARD AT THE SONY WORLD PHOTOGRAPHY AWARDS, WORLD PHOTOGRAPHY ORGANISATION.
SOLO EXHIBITION, *PAINTINGS, ETC.*, COMPOSED OF EARLY WORKS, AT HACKELBURY FINE ART, LONDON.
THE EXHIBITION *WILLIAM KLEIN / DAIDO MORIYAMA* OPENS IN OCTOBER AT TATE MODERN, LONDON.

WILLIAM KLEIN: BIBLIOGRAPHY

Compiled by Lucile Montagne

**PHOTOGRAPHY BOOKS
BY WILLIAM KLEIN**

WILLIAM KLEIN, *LIFE IS GOOD &
GOOD FOR YOU IN NEW YORK:
TRANCE WITNESS REVELS*,
ÉDITIONS DU SEUIL, PARIS 1956
(FELTRINELLI, MILAN; VISTA
BOOKS, LONDON).

WILLIAM KLEIN, *ROME: THE CITY
AND ITS PEOPLE*, FELTRINELLI,
MILAN 1959 (ÉDITIONS DU
SEUIL, PARIS; VIKING, NEW
YORK).

WILLIAM KLEIN, *TOKYO*,
ZOKEISHA PUBLICATIONS,
TOKYO 1964 (ÉDITIONS
DELPIRE, PARIS; CROWN
PUBLISHERS, NEW YORK).

WILLIAM KLEIN, *MOSCOW*,
ZOKEISHA PUBLICATIONS,
TOKYO 1964 (CROWN
PUBLISHERS, NEW YORK).

WILLIAM KLEIN, *MISTER
FREEDOM*, WITH STILL
PHOTOGRAPHS BY JÜRGEN
VOLLMAR, JEANNE AND
WILLIAM KLEIN, AND SCRIPT
EXCERPTS FROM THE FILM,
ÉDITIONS ÉRIC LOSFELD, PARIS
1970; REVISED EDN PUBLISHED
AS *MISTER FREEDOM: WILLIAM
KLEIN'S STAR-SPANGLED
ALLEGORY ABOUT 'CREEPING
FREEDOMISM'*, KORINSHA
PRESS, JAPAN 1998.

WILLIAM KLEIN, *CLOSE UP*,
THAMES AND HUDSON,
LONDON, NEW YORK AND
PARIS 1989.

WILLIAM KLEIN, *TORINO '90*,
FEDERICO MOTTA, MILAN 1990.

WILLIAM KLEIN, *IN AND OUT
OF FASHION*, RANDOM HOUSE,
NEW YORK AND LONDON 1994
(*MODE IN & OUT*, ÉDITIONS DU
SEUIL, PARIS).

WILLIAM KLEIN, *NEW YORK
1954–55*, REVISED EDN OF *LIFE
IS GOOD & GOOD FOR YOU IN
NEW YORK: TRANCE WITNESS
REVELS* (1956), MARVAL, PARIS
1995 (DEWI LEWIS, LONDON;
DISTRIBUTED ART PUBLISHERS,
NEW YORK; CONTRASTO
BOOKS, ROME).

WILLIAM KLEIN, *WILLIAM KLEIN
FILMS*, MARVAL, PARIS 1998
(POWERHOUSE, NEW YORK
AND LONDON).

WILLIAM KLEIN, *MMV ROMANI*,
CONTRASTO BOOKS AND
FENDI, ROME 2005.

*WILLIAM KLEIN:
RÉTROSPECTIVE*, TEXTS BY
QUENTIN BAJAC, WILLIAM KLEIN
AND ALAIN SAYAG, EXH. CAT.,
CENTRE GEORGES POMPIDOU,
PARIS 2005.

WILLIAM KLEIN, *CONTACTS*,
TEXTS BY ROBERT DELPIRE
AND WILLIAM KLEIN,
CONTRASTO BOOKS, ROME
2008 (ÉDITIONS DELPIRE,
PARIS).

WILLIAM KLEIN, *ROME + KLEIN*,
REVISED EDN OF *ROME: THE
CITY AND ITS PEOPLE* (1959), 2
VOLS., APERTURE, NEW YORK
2009 (CONTRASTO BOOKS,
ROME; ÉDITIONS DU CHÊNE,
PARIS).

WILLIAM KLEIN, *LIFE IS GOOD
& GOOD FOR YOU IN NEW
YORK*, REVISED EDN, ERRATA
EDITIONS, NEW YORK 2010.

**MONOGRAPHS (BOOKS,
JOURNALS AND PORTFOLIOS)**

*INCONTRI IN EUROPA:
MEETINGS IN EUROPE*, LA
COLLEZIONE APEM, WINTER
1961–2, COVER, PP.5–14,
PHOTOGRAPHS BY WILLIAM
KLEIN.

ALAIN JOUFFROY, J.M.
BUSTAMANTE AND BERNARD
SAINT-GENÈS, *NEW YORK
54–55*, PORTFOLIO OF 12
PHOTOGRAPHS, PARIS 1978.

JOHN HEILPERN, *WILLIAM
KLEIN: PHOTOGRAPHS*,
APERTURE, NEW YORK 1981.

ALAIN JOUFFROY, *WILLIAM
KLEIN*, 'THE GREAT
PHOTOGRAPHERS' SERIES ('I
GRANDI FOTOGRAFI'), GRUPPO
EDITORIALE FABBRI, MILAN
1982.

CHRISTIAN CAUJOLLE, *WILLIAM
KLEIN*, PHOTO POCHE NO.20,
CENTRE NATIONAL DE LA
PHOTOGRAPHIE, PARIS 1985.

WILLIAM KLEIN, TEXTS
BY HIROSHI HAMAYA,
IKKONARAHARA, DAIDO
MORIYAMA AND TATSUO
FUKUSHIMA (IN JAPANESE
AND ENGLISH), PACIFIC PRESS
SERVICES, TOKYO 1987.

WILLIAM KLEIN, TEXT BY
GUNTHER BRAUS, AGFA-
BAYER/ HUGO ERFURT PRIZE,
EDITION BRAUS, HEIDELBERG
1993.

WILLIAM KLEIN: FASHION,
VERLAGSVORSCHAU HERBST,
EDITION BRAUS, HEIDELBERG
1995.

WILLIAM KLEIN, PORTFOLIO
NO.7, STERN PORTFOLIO
LIBRARY, HAMBURG 1997.

JONATHAN ROSENBAUM,
'KLEIN BETWEEN STILLS AND
MOVIES', INTERVIEW WITH
KLEIN, *CREATIVE CAMERA*,
PETER TURNER, DAVID BRITTAIN
AND JONATHAN ROSENBAUM,
1997.

WILLIAM KLEIN AND CLAIRE
CLOUZOT, *WILLIAM KLEIN
FILMS*, MARVAL/ MAISON
EUROPÉENNE DE LA
PHOTOGRAPHIE, PARIS 1998.

'LIFE IS GOOD & GOOD FOR
YOU IN WILLIAM KLEIN', *STUDIO
VOICE*, VOL.285, TOKYO 1999.

ROBERT DELPIRE, *WILLIAM
KLEIN: FOR PRESS FREEDOM*,
REPORTERS WITHOUT
BORDERS, ÉDITIONS DELPIRE/
IDEODIS CREATION, PARIS 2001.

ERIC DAVIRON, *WILLIAM
KLEIN HABLA CON ERIC
DAVIRON*, CONVERSACIONES
CON FOTOGRAFOS
(CONVERSATIONS WITH
PHOTOGRAPHERS), VOL.11, LA
FABRICA, MADRID 2003.

WILLIAM KLEIN, *FOTOGRAFIE-
FILM*, SPECIAL ISSUE OF THE
FOTOMUSEUM OF ANTWERP'S
MAGAZINE WITH AN INTERVIEW
BY ERIC DAVIRON, ANTWERP,
JUNE 2004.

LAURENT VÉRAY, *LOIN DU
VIETNAM, 1967: FILM COLLECTIF
RÉALISÉ PAR JEAN-LUC
GODARD, JORIS IVENS, WILLIAM
KLEIN, CLAUDE LELOUCH,
CHRIS MARKER AND ALAIN
RESNAIS*, ÉDITIONS PARIS
EXPÉRIMENTAL, PARIS 2004.

WILLIAM KLEIN, 'ALI + KLEIN',
TEXT BY NORMAN MAILER,
POLKA, NO.11, NOV. 2010.

ANTHONY LANE, *WILLIAM
KLEIN: WITNESS*, MASTERS OF
THE CAMERA SERIES, FOLIO
PRESS, NEW YORK 2010.

**SOLO EXHIBITION
CATALOGUES AND
CINEMATOGRAPHIC
RETROSPECTIVES**

*WILLIAM KLEIN: SCHILDERIJEN,
FOTO'S, FILMS*, EXH. CAT.,
STEDELIJK MUSEUM,
AMSTERDAM 1967.

WILLIAM KLEIN, TEXT BY
ROBERT DAUDELIN, EXH.
CAT., LA CINÉMATHÈQUE
QUÉBÉCOISE, MUSÉE DU
CINÉMA, MONTREAL 1975.

WILLIAM KLEIN, TEXT BY ALAIN
JOUFFROY, EXH. CAT., CANON
PHOTO GALLERY, GENEVA 1979.

WILLIAM KLEIN, TEXT BY
CAROLE NAGGAR, EXH. CAT.,
FONDATION NATIONALE DE
LA PHOTOGRAPHIE AND
CONTREJOUR, LYON AND PARIS
1979.

*WILLIAM KLEIN: LE MAILLON
QUI MANQUAIT DANS LA
PHOTOGRAPHIE MODERNE*,
ED. JEAN DIEUZAIDE, EXH.
CAT., GALERIE MUNICIPALE DU
CHÂTEAU D'EAU, TOULOUSE
1982.

WILLIAM KLEIN, TEXT BY
CAROLE NAGGAR, EXH. CAT.,
GRADA GALLERY, ZAGREB 1983.

*WILLIAM KLEIN: PHOTOGRAPHE
ETC.*, PREFACE BY ALAIN
SAYAG, TEXT BY CAROLE
NAGGAR, EXH. CAT., CENTRE
GEORGES POMPIDOU, PARIS
1983.

*WILLIAM KLEIN: AN AMERICAN
IN PARIS*, TEXT BY ARTHUR
OLLMAN, EXH. CAT., MUSEUM
OF PHOTOGRAPHIC ARTS, SAN
DIEGO 1987.

WILLIAM KLEIN, ED. ALAIN
DESVERGNES, EXH.
CAT., GALERIE ARENA,
ÉCOLE NATIONALE DE LA
PHOTOGRAPHIE, ARLES 1988.

*CINEMA OUTSIDER: THE
FILMS OF WILLIAM KLEIN*,
TEXTS BY BRUCE JENKINS,
NANCY E. ROBINSON AND
JONATHAN ROSENBAUM, EXH.
CAT., WALKER ART CENTER,
MINNEAPOLIS 1989.

*WILLIAM KLEIN:
FOTOGRAFIER AV ARETS
HASSELBLADSPRISTAGARE*,
EXH. CAT., HASSELBLAD
CENTER, GOTHENBURG 1990.

WILLIAM KLEIN: FOTOGRAFIE,
ED. VLADIMIR BIRGUS, EXH.
CAT., PRESIDENTIAL PALACE,
PRAGUE 1994.

*LIFE IS GOOD & GOOD FOR
YOU IN NEW YORK*, TEXT BY
SANDRA PHILLIPS, EXH. CAT.,
SAN FRANCISCO MUSEUM OF
MODERN ART 1995.

PARIS + KLEIN, TEXTS BY HENRY
CHAPIER, ALAIN JOUFFROY AND
BERNARD PIERRE WOLF, EXH.
CAT., MAISON EUROPÉENNE
DE LA PHOTOGRAPHIE, PARIS
2002.

*WILLIAM KLEIN:
RÉTROSPECTIVE*, TEXTS BY
QUENTIN BAJAC, WILLIAM KLEIN
AND ALAIN SAYAG, EXH. CAT.,
CENTRE GEORGES POMPIDOU,
PARIS 2005.

WILLIAM KLEIN, 48TH
THESSALONIKI INTERNATIONAL
FILM FESTIVAL, 2007.

**GROUP EXHIBITION
CATALOGUES**

JONATHAN BAYER (ED.),
CONCERNING PHOTOGRAPHY,
EXH. CAT., PHOTOGRAPHERS'
GALLERY, LONDON 1977.

NANCY HALL-DUNCAN (ED.),
*THE HISTORY OF FASHION
PHOTOGRAPHY*, EXH. CAT.,
GEORGE EASTMAN HOUSE
INTERNATIONAL MUSEUM OF
PHOTOGRAPHY AND FILM,
ROCHESTER, NEW YORK 1977.

HELEN GEE (ED.),
*PHOTOGRAPHY OF THE FIFTIES:
AN AMERICAN PERSPECTIVE*,
EXH. CAT., CENTER FOR
CREATIVE PHOTOGRAPHY,
UNIVERSITY OF TUCSON,
TUCSON 1980.

*SUBJEKTIVE FOTOGRAFIE:
IMAGES OF THE FIFTIES*, TEXT
BY UTE ESKILDSEN, EXH. CAT.,
MUSEUM FOLKWANG, ESSEN
1984.

DAVID BAILEY AND MARTIN
HARRISON, *SHOTS OF
STYLE: GREAT FASHION
PHOTOGRAPHS CHOSEN
BY DAVID BAILEY*, EXH. CAT.,
VICTORIA AND ALBERT
MUSEUM, LONDON 1985.

GILLES MORA, *L'ACTE DU
PHOTOGRAPHE*, EXH. CAT.,
FRAC AQUITAINE, BORDEAUX
1985.

INGRIED BRUGGER (ED.),
*MODEFOTOGRAFIE VON
1900 BIS HEUTE*, EXH. CAT.,
KUNSTFORUM LÄNDERBANK,
VIENNA 1990.

MARTIN HARRISON,
*APPEARANCES: FASHION
PHOTOGRAPHY SINCE 1945*,
EXH. CAT., VICTORIA AND
ALBERT MUSEUM, LONDON
1991.

MARK HOLBORN (ED.), *BEYOND
JAPAN: A PHOTO THEATRE*, EXH.
CAT., BARBICAN ART GALLERY,
LONDON 1991.

PORTRAITS D'UNE CAPITALE:
DE DAGUERRE À WILLIAM
KLEIN, COLLECTIONS
PHOTOGRAPHIQUES DU MUSÉE
CARNAVALET, EXH. CAT., MUSÉE
CARNAVALET, PARIS 1992.

MANUEL FALCES (ED.), IMAGINA:
UN PROYECTO EN TORNO A
LA FOTOGRAFÍA, EXH. CAT.,
CLAUSTRO DE LA ESCUELA DE
ARTES, ALMERIA 1993.

VANITÉS: PHOTOGRAPHIES
DE MODE DES XIX^E ET XX^E
SIÈCLES, EXH. CAT., FONDATION
NATIONALE DES ARTS
GRAPHIQUES ET PLASTIQUES,
PARIS 1993.

RUNE HASSNER (ED.), THE
HASSELBLAD AWARDS 1980–
1995, EXH. CAT., HASSELBLAD
CENTRE, GOTHENBURG 1996.

CHORUS OF LIGHT:
PHOTOGRAPHS FROM THE SIR
ELTON JOHN COLLECTION, EXH.
CAT., HIGH MUSEUM OF ART,
ATLANTA 2000.

ROBIN DERRICK AND ROBIN
MUIR (EDS.), UNSEEN VOGUE:
THE SECRET HISTORY OF
FASHION PHOTOGRAPHY,
EXH. CAT., DESIGN MUSEUM,
LONDON 2002.

DES HOMMES DANS LA VILLE,
EXH. CAT., MUSÉE MALRAUX, LE
HAVRE 2002.

MAX KOZLOFF, NEW YORK:
CAPITAL OF PHOTOGRAPHY,
EXH. CAT., JEWISH MUSEUM,
NEW YORK 2002.

THE FIFA 100, EXH. CAT., ROYAL
ACADEMY OF ARTS, LONDON
2004.

STREET SEEN: THE
PSYCHOLOGICAL GESTURE
IN AMERICAN PHOTOGRAPHY,
1940–1959, EXH. CAT.,
MILWAUKEE ART MUSEUM 2010.

**ESSAYS IN MAGAZINES,
BOOKS AND EXHIBITION
CATALOGUES**

MINOR WHITE, 'NEW YORK
BY WILLIAM KLEIN', IMAGE
MAGAZINE, JOURNAL OF
PHOTOGRAPHY OF THE
GEORGE EASTMAN HOUSE,
VOL.6, NO.7, SEPT. 1957.

CARACTÈRE, NOËL 57, SPECIAL
ISSUE BY MAXIMILIEN VOX,
COMPAGNIE FRANÇAISE
D'ÉDITIONS, PARIS, 1957,
PP.69–80.

J.L. CURTIS, CINEMA: FROM
THE 'RED DESERT' TO 'POLLY
MAGGOO', JULLIARD, PARIS
1967, PP.205–11.

ABRAHAM SEGAL, 'ELDRIDGE
CLEAVER, BLACK PANTHER:
UN FILM DE WILLIAM KLEIN',
LA REVUE DU CINÉMA, NO.246,
JAN. 1971.

ALAIN JOUFFROY, 'WILLIAM
KLEIN', ZOOM, JULY–AUG. 1973.

CLAIRE CLOUZOT, 'WILLIAM
KLEIN', ÉCRAN, NO.38, JULY
1975.

CHRIS MARKER, 'WILLIAM
KLEIN, PAINTER/
PHOTOGRAPHER/ FILM-
MAKER', GRAPHIS, NO.94, 1978.

VOYONS VOIR, PHOTOGRAPHIC
PORTRAITS BY BERTHE JUDET,
CRÉATIS, PARIS 1980.
MAX KOZLOFF, 'WILLIAM KLEIN
AND THE RADIOACTIVE FIFTIES',
ARTFORUM, MAY 1980, COVER
AND PORTFOLIO.

ROLAND BARTHES, CAMERA
LUCIDA: REFLECTIONS ON
PHOTOGRAPHY, TRANS.
RICHARD HOWARD, HILL AND
WANG, NEW YORK 1981,
PP.28–9, 47.

BRYN CAMPBELL (ED.),
WORLD PHOTOGRAPHY: 25
CONTEMPORARY MASTERS
WRITE ABOUT THEIR WORK,
TECHNIQUES AND EQUIPMENT,
HAMLYN, LONDON, NEW YORK,
SYDNEY AND TORONTO 1981,
PP.284–95.

HERVÉ GUIBERT, 'IL Y A
TOUJOURS UN TÉMOIN QUI
RÉVÈLE. WILLIAM KLEIN', LE
MONDE, 5 MARCH 1981.

ALAN PORTER, 'WILLIAM KLEIN:
APOCALYPSE', CAMERA, MAY
1981.

DENIS ROCHE, 'ENTRETIEN
AVEC WILLIAM KLEIN',
LES CAHIERS DE LA
PHOTOGRAPHIE, NO.6, 1982.

JAN ZITZ GROVER, 'ANOTHER
STAR IS BORN', AFTERIMAGE,
JAN. 1982.

MICHEL NURIDSANY, 'WILLIAM
KLEIN', ART PRESS, APRIL 1983.

SYD SHELTON AND RED
SAUNDERS (EDS.), A DAY IN THE
LIFE OF LONDON, JONATHAN
CAPE, LONDON 1984.

PIERRE BORHAN (ED.), VOYONS
VOIR: 8 PHOTOGRAPHES,
CENTRE NATIONAL DE LA
PHOTOGRAPHIE, PARIS 1985.
PHILIPPE CHANCEL, 'ADOPTEZ
UN MULTI-CRÉATIF', CRÉATION,
NO.2, FEB. 1985.

CONSTANCE SULLIVAN
(ED.), CLOSE-UP, INCLUDING
PHOTOGRAPHS BY WILLIAM
KLEIN, VOL.15, NO.1, WINTER
1985.

SERGE COHEN, IM AUGENBLICK
DIE WAHRHEIT: DIE GROSSEN
PORTRÄT-INSZENIERUNGEN,
FRANKFURTER ALLGEMEINE
MAGAZIN, KEYSERSCHE
VERLAGS BUCHHDLG, MUNICH
1988.

FI MCGHEE, PHOTOGRAPHERS
AND THEIR IMAGES, CONRAN
OCTOPUS, LONDON 1988.

JONATHAN ROSENBAUM,
'AMERICAN IN PARIS: THE FILMS
OF WILLIAM KLEIN', CHICAGO
READER, 8 DEC. 1989.

JAMES LEWIS HOBERMAN,
'AFTER THE BELL', VILLAGE
VOICE, 21 NOV. 1990.

JAMES LEWIS HOBERMAN,
'INNOCENTS ABROAD', VILLAGE
VOICE, 8 DEC. 1990.

HILTON ALS, 'FILM: FRUTTI',
VILLAGE VOICE, 11 DEC. 1990.

KATHERINE DIECKMAN, 'FILM:
RAGING BILL', ART IN AMERICA,
VOL.78, NO.6, DEC. 1990.

TRIANGEL INDEX 3: THE
HASSELBLAD PRIZE WINNER
1990, WILLIAM KLEIN,
GOTHENBERG 1991.

JANE LIVINGSTONE, THE
NEW YORK SCHOOL:
PHOTOGRAPHS, 1936–1963,
STEWART, TABORI & CHANG,
NEW YORK 1992.

GUIDO VERGANI, LA SALA
BIANCA: NASCITA DELLA MODA
ITALIANA, ELECTA, MILAN 1992.

RUTH ANSEL, 'WILLIAM KLEIN',
INTERVIEW, OCT. 1992.

VICKI GOLDBERG,
'WILLIAM KLEIN: IMPOLITE
PHOTOGRAPHER', NEW YORK
TIMES, 18 OCT. 1992.

GINGER DANTO, 'WILLIAM
KLEIN: IN THE THICK OF THE
CROWD', ARTNEWS, MARCH
1993, COVER AND PORTFOLIO.

MARTIN HARRISON, 'SHOTS OF
SOUND', FRIEZE, NO.13, NOV.–
DEC. 1993, PP.38–41.

STEVE APPLEFORD, 'WILLIAM
KLEIN: IMAGES OF A LIFETIME',
LOS ANGELES TIMES, 4 DEC.
1994.

VINCE ALETTI, 'WILLIAM KLEIN:
OUTSIDER ART', VILLAGE VOICE,
20 DEC. 1994.
PETER HAY HALPERT,'WILLIAM
KLEIN: TIMELESSNESS IN
FASHION', AMERICAN PHOTO,
JAN.–FEB. 1995.

MARK HARRIS, 'WILLIAM KLEIN
IN YOUR FACE', CAMERA &
DARKROOM, AUG. 1995.

VINCE ALETTI, 'WILLIAM KLEIN'S
NEW YORK VÉRITÉ', VILLAGE
VOICE, 26 MARCH 1996.

BRET SENFT, 'WILLIAM KLEIN:
LIVING LEGEND', PHOTO
DISTRICT NEWS, JULY 1996.

JULIAN RODRIGUEZ, 'WILLIAM KLEIN ROCKED THE PHOTOGRAPHIC WORLD IN THE 1950'S WITH HIS BOOK *NEW YORK*', *BRITISH JOURNAL OF PHOTOGRAPHY*, NO.7114, MARCH 1997.

PARIS SOUS L'OBJECTIF 1885/1994: UN SIÈCLE DE PHOTOGRAPHIES À TRAVERS LES COLLECTIONS DE LA VILLE DE PARIS, HAZAN, PARIS 1998.

HERVÉ GUIBERT, *LA PHOTO INÉLUCTABLEMENT*, GALLIMARD, PARIS 1999.

MARY BLUME, 'WILLIAM KLEIN FILMS A "MESSIAH" WITH ATTITUDE', *HERALD TRIBUNE*, 18 DEC. 1999.

SARAH BROWN, 'VETERAN PHOTOGRAPHER WILLIAM KLEIN IS ONE OF THE MOST INFLUENTIAL FIGURES IN THE WORLD OF FASHION PHOTOGRAPHY', *BRITISH JOURNAL OF PHOTOGRAPHY*, NO.7259, FEB. 2000.

ANDREW ROTH (ED.), *THE BOOK OF 101 BOOKS: SEMINAL PHOTOGRAPHIC BOOKS OF THE TWENTIETH CENTURY*, PPP EDITIONS, NEW YORK 2001.

ANTHONY LANE, 'THE SHUTTERBUG ... WILLIAM KLEIN IS BACK IN TOWN', *NEW YORKER*, 21 MAY 2001.

ANTHONY LANE, 'WILLIAM KLEIN'S PARIS', *NEW YORKER*, 22 JULY 2002.

RICK WOODWARD, 'AN AMERICAN SKEPTIC IN PARIS', ARTS AND LEISURE SECTION, *NEW YORK TIMES*, 6 APRIL 2003.

GERRY BADGER, 'THE INDECISIVE MOMENT: FRANK, KLEIN, AND "STREAM-OF-CONSCIOUSNESS" PHOTOGRAPHY', IN *THE PHOTOBOOK: A HISTORY*, VOL.1, ED. MARTIN PARR AND GERRY BADGER, PHAIDON PRESS, NEW YORK 2004.

ANDREW ROTH (ED.), *THE OPEN BOOK*, HASSELBLAD CENTRE, GOTHENBURG 2004.

TRANSPHOTOGRAPHIQUES 4, TRANSFORMATION, ÉDITIONS TRANSPHOTOGRAPHIQUES, LILLE 2004.

ALISON SMITH, *FRENCH CINEMA IN THE 1970S: THE ECHOES OF MAY*, MANCHESTER UNIVERSITY PRESS, MANCHESTER 2005.

GUILLAUME MOREL, 'WILLIAM KLEIN DANS TOUS SES ÉTATS', *L'ŒIL*, NO.577, FEB. 2006, PP.46–51.

TIM LUCAS, 'DVD REVIEW: THE DELIRIOUS FICTIONS OF WILLIAM KLEIN', *SIGHT & SOUND*, MAY 2008.

ADRIAN MARTIN, 'WILLIAM KLEIN: WAITING FOR A PHOTOGRAPHER', ESSAY COMMISSIONED FOR FILM RETROSPECTIVE AT THE AUSTRALIAN CENTRE FOR THE MOVING IMAGE (ACMI), MELBOURNE, DEC. 2008.

WILLIAM KLEIN, 'PAS DE RÈGLES, PAS D'INTERDITS, PAS DE MILITES', TEXT BY ALAIN GENESTAR, *POLKA*, NO.5, MAY 2009.

ALESSANDRA MAURO, 'ROME & KLEIN: WILLIAM KLEIN'S 1956 PORTRAIT OF THE ETERNAL CITY AND ITS RAGAZZI', *APERTURE*, NO.196, AUTUMN 2009.

DAVID CAMPANY, 'WILLIAM KLEIN: TOKYO', *PHOTOWORKS*, NO.13, NOV. 2009, PP.14–17.

PANAYOTIS PAPADIMITROPOULOS, *LE SUJET PHOTOGRAPHIQUE ET SA REMISE EN QUESTION (ALFRED STIEGLITZ, ROBERT FRANK, WILLIAM KLEIN)*, L'HARMATTAN, PARIS 2010.

JONATHAN ROSENBAUM, *GOODBYE CINEMA, HELLO CINEPHILIA: FILM CULTURE IN TRANSITION*, UNIVERSITY OF CHICAGO PRESS, CHICAGO 2010.

OLIVIER HADOUCHI, '"AFRICAN CULTURE WILL BE REVOLUTIONARY OR WILL NOT BE": WILLIAM KLEIN'S FILM OF THE FIRST PAN-AFRICAN FESTIVAL OF ALGIERS (1969)', TRANS. CRISTINA JOHNSTON, *THIRD TEXT*, VOL.25, 1 JAN. 2011, PP.117–28.

NINA CAPLAN, 'WILLIAM KLEIN: EVERYTHING I DID, I DID FOR HER', *DAILY TELEGRAPH*, 4 APRIL 2011.

YASMINE YOUSSI, 'WILLIAM KLEIN: "LES FRANÇAIS ÉTAIENT ENCHANTÉS QU'UN AMÉRICAIN FASSE DES PHOTOS ANTIAMÉRICAINES"', *TÉLÉRAMA*, 22 SEPT. 2011.

FURTHER READING

FRITZ GRUBER (ED.), *BEAUTY: VARIATIONS ON THE THEME OF WOMEN BY MASTERS OF THE CAMERA, PAST AND PRESENT*, FOCAL PRESS, LONDON AND NEW YORK 1965.

PHILIP THOMPSON, JOHN WILLIAMS AND GERALD WOODS (EDS.), *ART WITHOUT BOUNDARIES: 1950–70*, THAMES AND HUDSON, LONDON 1972, PP.31, 138–9.

PETER TURNER (ED.), *HISTORY OF PHOTOGRAPHY*, HAMLYN PUBLISHING, BISON BOOKS, LONDON 1987.

JAMES GUIMOND, *AMERICAN PHOTOGRAPHY AND THE AMERICAN DREAM*, UNIVERSITY OF NORTH CAROLINA, CHAPEL HILL, AND LONDON 1991.

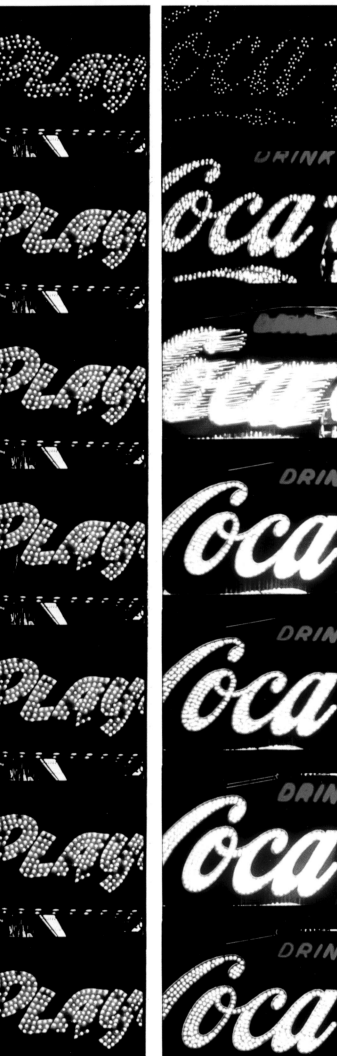

BETTER HOMES AND GARDENS® BOOKS

Editor: Gerald M. Knox
Art Director: Ernest Shelton
Managing Editor: David A. Kirchner
Copy and Production Editors: Marsha Jahns,
 Mary Helen Schiltz, Carl Voss, David A. Walsh

Food and Nutrition Editor: Nancy Byal
Department Head—Cook Books: Sharyl Heiken
Associate Department Heads: Sandra Granseth,
 Rosemary C. Hutchinson, Elizabeth Woolever
Senior Food Editors: Julia Malloy, Marcia Stanley,
 Joyce Trollope
Associate Food Editors: Barbara Atkins, Linda Foley,
 Linda Henry, Lynn Hoppe, Jill Johnson, Mary Jo Plutt,
 Maureen Powers, Martha Schiel
Recipe Development Editor: Marion Viall
Test Kitchen Director: Sharon Stilwell
Test Kitchen Photo Studio Director: Janet Pittman
Test Kitchen Home Economists: Jean Brekke, Kay Cargill,
 Marilyn Cornelius, Jennifer Darling, Maryellyn Krantz,
 Lynelle Munn, Dianna Nolin, Marge Steenson,
 Cynthia Volcko

Associate Art Directors: Linda Ford Vermie, Neoma Alt West,
 Randall Yontz
Assistant Art Directors: Lynda Haupert, Harijs Priekulis,
 Tom Wegner
Senior Graphic Designers: Mike Eagleton, Lyne Neymeyer,
 Stan Sams
Graphic Designers: Mike Burns, Sally Cooper, Darla Whipple-Frain,
 Brian Wignall

Vice President, Editorial Director: Doris Eby
Executive Director, Editorial Services: Duane L. Gregg

Senior Vice President, General Manager: Fred Stines
Director of Publishing: Robert B. Nelson
Vice President, Retail Marketing: Jamie Martin
Vice President, Direct Marketing: Arthur Heydendael

ANYTIME APPETIZERS

Editor: Linda Henry
Copy and Production Editor: Carl Voss
Graphic Designer: Lyne Neymeyer
Electronic Text Processor: Donna Russell
Contributing Photographer: Mike Dieter
Food Stylists: Jill Mead, Janet Pittman
Contributing Illustrator: Thomas Rosborough

On the cover: *Super Nachos*
(see recipe, page 20)